And the Healing
Has Begun . . .

And the Healing Has Begun . . .

*A Musical Journey towards Peace
in Northern Ireland*

Katrin Pietzonka

authorHOUSE®

AuthorHouse™ UK Ltd.
1663 Liberty Drive
Bloomington, IN 47403 USA
www.authorhouse.co.uk
Phone: 0800.197.4150

Published by AuthorHouse 12/10/2013

ISBN: 978-1-4918-8558-1 (sc)
ISBN: 978-1-4918-8559-8 (hc)
ISBN: 978-1-4918-8560-4 (e)

Contents

To Tony McAuley

Acknowledgements

There are a great many people to whom I owe my gratitude for helping me with the completion of this project. First I would like to thank all the songwriters and musicians who agreed to take part in this project. Thank you to everyone at the Institut fuer Anglistik in Leipzig for your encouragement and support throughout the last few years. I especially owe many thanks to Prof. Dr Joachim Schwend, who has provided me with a great deal of advice and support along with opportunities and challenges throughout the course of this project, for all of which I am very grateful.

A number of other people contributed in no small way to the completion of this project. A special thank you goes to Michael Smallman, arts librarian at Queen's University Belfast, for all his advice and photo material and for proofreading some of the chapters. John Gray and the staff at the Northern Ireland Political Collection of the Linen Hall Library Belfast were extremely helpful as were Nicholas Carolan and the staff at the Irish Traditional Music Archive in Dublin. Thanks also to photographer Bobby Hanvy, who generously provided me with a great number of tapes and CDs from his private music collection. I would also like to thank John Moulden of Ulstersongs for answering so many of my questions and for allowing me access to some rather interesting song material. During my research in Belfast, I met a great number of interesting people including George Newell from the Ballymacarrett Arts & Cultural Society (BACS), David Gilliland of Power to the People, musician Paddy Walsh, and songwriters Joe Mulheron and Brian Moore. They all encouraged me to complete this project and assisted me in every possible way they could. Thanks also to Colette Casey, my landlady in Belfast, for being a great listener and helping me in so many ways.

I would also like to thank Phil Coulter, Brian Kennedy, and Mickey MacConnell for making time to meet me for interviews. Thanks also to sound engineer Enda Walsh for arranging some of these interviews. Ciaran Wynne and Ronny Moore from Killarney, thank you for the music and all your support and advice. A special thank you also goes to Tommy, Colum, and Ben Sands. I am forever grateful for their friendship and assistance over the years.

I would also like to express my deep gratitude to Latte of fun(d) and Elisabeth Armstrong, in particular, for supporting me in the final stages of this publication process.

Closer to home I would like to thank my parents, Heinz and Helga Pietzonka, for their patience and understanding over the years. Thanks also to my sister, Simone Baumert, and to Ulrike Ludwig and Matthias and Eva-Maria Scholz for all their support. I would also like to thank Joanne Purser, for all her creative ideas and illustrations. A very special thank you goes to Denis and Sinead Greene for their love and humour and for believing in me.

Finally, during one of the many conversations I had with BBC broadcaster Tony McAuley while doing research for this project in Belfast in autumn 2002, McAuley recited Maurice Craig's poem, 'May the Lord in His Mercy Be Kind to Belfast'. In the early stages of writing this book, the poem sprang to my mind, and I soon decided to include it in this project. A study of the lines of the poem finally helped me to determine how to arrange the contents of this extensive examination. Chapter II, both parts of Chapter III, and finally Chapter IV are therefore each introduced by one of the four verses from the poem. By including this poem, I was also constantly reminded of the person who had first introduced these verses to me and had encouraged and guided me through most of my research in Northern Ireland.

This book is dedicated to Tony McAuley, who was not able to see it gradually taking shape; neither did he see its completion. The publication of this book marks the tenth anniversary of his death. It is my goal to enable every reader to gain a better understanding of Northern Ireland and its history while also being taken on a musical journey.

I

INTRODUCTION

1

A Musical Journey towards Peace in Northern Ireland

People from Ireland and Northern Ireland have always loved their songs and their rich musical heritage. Commenting on the subject in Paddy Logue's *Being Irish: Personal Reflections on Irish Identity Today*, Dana Rosemary Scallon from Derry, first Irish winner of the Eurovision Song Contest in 1970 and elected as a member of the European Parliament in 1999, made the following remarks:

> Irish people worldwide celebrate a passion for life in conversation, stories, laughter and song. Our Celtic past, which is rich and diverse, and the ability to overcome many hardships, have gifted Irish people with a unique sense of adaptability, humour and perseverance.[1]

Even though many of the older songs might no longer receive the same acknowledgement, travelling around Ireland and Northern Ireland today, one can still feel the same enthusiasm listening to the older and the younger generations singing along together to songs from their past and present. 'There's a tremendous joy and comfort to be experienced when people who are virtual strangers, save for national identity, are brought together, united in song, as they rekindle memories of their homeland.'[2]

In the introduction to the book *Being Irish*, editor Paddy Logue speaks about the hibernization of the world. In fact, Irish music, dance, films, and literature, to name but a few art forms, are no longer popular

[1] D.R. Scallon in Logue (ed.), 2000, 256/7
[2] ibid.

subjects for insiders only. Commercialism, means of communication, and travel have by now brought Irish music to non-Irish audiences for many years. After a number of successful Eurovision songs in the 1970s and 1980s, Ireland won the Eurovision Song Contest four times in the 1990s.[3] During the 1994 contest held in Ireland, Riverdance, featuring Irish step dancing, was created as intermission entertainment. Due to its enormous success, the show, directed by Moya Doherty with music by Bill Whelan and choreography by Michael Flatley, was soon recreated as a two-hour stage show and opened at the Point Theatre Dublin a year later. Since 1996, Riverdance has toured the world with three separate companies. This show and others that followed, like Michael Flatley's *Lord of the Dance* and *Feet of Flames*, have succeeded in broadening the popular appreciation of Irish music and dancing around the world.

Alongside an increasing influence of media and technology, Irish traditional music has taken many different directions. Since the 1970s, there has been a great succession of new musical liaisons between traditional Irish music and other musical genres such as rock, country, pop, electric folk, blues, and avant-garde. Looking at the present situation of Ireland's musical tradition, however, there is little doubt that it is, in fact, still very much alive:

> Ireland's musical tradition of both music and song is alive and well today for two main reasons. First, the almost fanatical sense of pride and nationalism we, as a nation, have in our music. There is a great determination in some quarters not to let this part of our culture disappear. This is achieved through the traditional route of classes and competitions. Secondly, Irish music has shown itself to be very versatile capable of blending with rock (Moving Hearts, Horselips), jazz (Nightnoise), funk (Stockton's Wing), rap (Marxman) and even African music (Afro-Celt Sound System) without losing its inherent Irishness.[4]

[3] 1992 ('Why Me?', Linda Martin), 1993 ('In your eyes', Niamh Kavanagh), 1994 ('Rock 'n' Roll Kids', Paul Harrington and Charlie McGettigan), and 1996 ('The voice', Eimear Quinn)

[4] Darragh Connolly in interview, Dublin, 1997

According to British music writer May McCann, it is the continuing strength of the tradition in Ireland that formed the base of its appeal to outsiders.[5] Beside Irish music and songwriting, other traditions such as Irish writing, storytelling, and Celtic mythology are alive and strong. Together they have helped to create this multifaceted image of Ireland. The perception of Ireland on a broader level can then be generally regarded as a kind of 'Celticist' depiction. According to Dutch cultural historian Joep Leerssen, this perception, when reflected upon in writing, always becomes a perspective from the outside no matter how sympathetic or propagandistic the intent might be. Regarding the content itself, this Celticist depiction, he continues, contains two major contradictory stereotypes. To regard Ireland as a place of song, poetry, and spirituality is the first. In clear contrast, however, the second stereotype downgrades the island to a place of 'inveterate barbarism and violence'.[6] Especially as far as the North of the island is concerned, this downgrading stereotype still seems to predominate an outsider's perception. The North's seclusion from the rest of the island, caused by political developments, has also led to a transformation of the place and its people. Estyn Evans, first director of the Institute of Irish Studies at Queen's University Belfast, characterized Ulster through distinguishing it from its significant other. According to Evans, the isolation of Ulster has also contributed to its distinctive identity.[7] In addition, 'Evans places identity beyond history, locating a "sense of place" transcending human conquests—the stage upon which Irish history has been played having taken shape through geological time'.[8]

Ever since the Troubles in the North began, right through to the 1994 ceasefire and beyond, artists have continued to reflect on the transformation of Northern Ireland and its people. Like poets, songwriters from the North have over the years made a significant contribution to the documentation of this conflict. Various aspects, such as the North's seclusion, the continuation of sectarian violence, and the beginning of the peace process, are well reflected in Northern Irish song writing. Through songs such as Phil Coulter's 'The Town I Loved So Well' or Tommy Sands'

[5] May McCann, 1995, 51
[6] Aaron Kelly in Belfast Songs, 2003, 13
[7] Evans, 1973 in McCann, 72
[8] ibid.

'There Were Roses', people from outside the island of Ireland have been made aware of the ongoing conflict. Songs such as these have opened a door to the outside world and enabled listeners from abroad to make more sense of the conflict or to even shape their own opinions on the subject. However, not only have these songs opened a door to the outside world, they have also provided people from the North and South of Ireland with an opportunity for reflection and better understanding. The structure of feeling embedded in each of these songs has, over the years, helped to reveal how far people living in Northern Ireland have been affected by the conflict. By doing so, these songs have also brought light to the full impact of the Troubles and their transformation of Northern Irish society. In order to prove this transformation, the following chapter will focus on some theoretical concepts, such as the structure of feeling, signifying practices, and the sense-of-place phenomenon. These concepts have, in recent years, gained major recognition in the British cultural and literary studies debate. Also, these concepts have been taken into consideration in the analysis of song texts about the Troubles in order to understand their significance in the Northern Irish context.

Every work of art, be it poetry, painting, or songwriting, plays its part in documenting and reflecting present developments within society, and it is not farfetched at all to argue that it is through art that a better understanding can be achieved.

> It is only through an understanding of the underlying causes of conflict that society can adequately address it. That understanding can only be achieved by writers prising open a window into the world of terror. One has to get down there into the darkness to find out what it is about. From the first cave paintings about tribalism to the present day, humans have only been successful in dealing with internecine warfare when they have understood its causes. In so doing they have been able to avoid acting in a reflex manner that leaves them vulnerable. Such understanding demands knowledge of the threat and those who represent it.[9]

[9] Dillon in Foreword to Hugh Jordan, 2002, 11

Chapter II will therefore concentrate on the role of the arts in Northern Ireland. The vast amount of documentation material created over the years by Northern Irish artists on the Troubles, and its gradual recognition, clearly justifies the dedication of a full chapter to this subject. With reference to the term *Ulster*, it is important to note that Ulster is made up of nine counties, three that are part of the Republic of Ireland (Cavan, Donegal, and Monaghan), and six that are part of the United Kingdom (Antrim, Armagh, Down, Fermanagh, Londonderry, and Tyrone). Any reference to Ulster made in this book, however, refers to developments in the latter six counties only.

While readers might be familiar with the term 'orange song tradition', this book uses the term 'green tradition' in Chapter III to make a clear contrast between the two song traditions that exist in Northern Ireland. The colour green has long been regarded as a symbol for Irishness and Catholicism in the Northern Irish context. As a cultural marker, this colour has been used to create an opponent to the colour orange, historically very much associated with Protestantism. The two opposing colours, green (Irish, Catholic) and orange (British, Protestant), can also be found on the Irish flag, joined together with the colour white in the middle, symbolising peace between these two rival elements. This symbol or demand, however, has over the years taken its toll. In the Northern Ireland context, green and orange have become stereotypes, like Falls versus Shankill[10] and Derry versus Londonderry.[11] In his study *The English: A Portrait of a People*, Jeremy Paxman argues that 'stereotypes are comforting, they save us the trouble of fresh thought'.[12] A statement like this is very dangerous, and it reflects exactly what happened in Northern Ireland. Both cultural traditions became ghettoized through the use of such stereotypes, and for a long time this process stopped people from thinking. A person was either part of the

[10] West Belfast, a concrete wall and barbed wire divide the Catholic district of the Falls from the Protestant
 Shankill district

[11] Derry—name used by Catholics for this Northern Irish town and county; Londonderry—name still used by Protestants referring to the same place—name historically associated with Protestant resistance at the Siege of Derry in 1689

[12] Paxman, 1998, 183

green or part of the orange tradition, and like black and white, there was nothing in between. By admitting to loyalty to a colour, a person belonged to either one of the two gradually developed stereotypes. The thinking process remained unchanged. To use Paxman's description, there was no need for creating a 'fresh thought'. However, due to new political developments in recent years, it seems that people from both cultural traditions in Northern Ireland have been granted an opportunity to rethink their system of well-established stereotypes and prejudice against each other, and the chances for better understanding, tolerance, and acceptance are now greater than ever before.

In concentrating on Northern Ireland's song tradition, and reflecting on its history and survival, a clear distinction, thus, must be made between the orange and the Irish traditions. While there were many songs to choose from regarding the orange tradition, from nineteenth-century political songs to more modern folk songs, there were also an impressive number of orange songs performed annually by Protestants in preparation for and during the marching season in Northern Ireland. Over the years, both song traditions have been kept alive, and although they have a lot in common as far as their historical background is concerned, they have developed in rather different directions throughout the twentieth century. Their origins, their peculiarities, and their continuation will thus be examined separately in Chapter III.

The first part of Chapter III focuses on the Irish song tradition.[13] It begins with an outline of the history of Irish political song, as this origin can be regarded as a vital element for the survival of the Irish song tradition. This is followed by a reflection on the continuation of Irish traditional music and song throughout the worst period in Northern Irish history. From the 1960s folk club scene, through the 1970s, 1980s, and on towards the end of the twentieth century, a great number of determined Northern Irish singers and songwriters have succeeded in keeping this tradition alive. Despite all the obstacles that confronted them, these artists showed great faith in their cultural heritage. Due to the fact that the number of

[13] referred to as 'Green' tradition

these singers/songwriters coming from the Irish song tradition is quite impressive, as much information as possible will be included here.

A study of the Irish song tradition in the North made it clear that rebel songs,[14] although written on a large scale during the 1960s and 1970s, hardly feature in the Irish repertoire of songs from the North anymore. Instead, Irish folk music and song moved on and also gradually away from being sectarian. Rebel songs were a means of expressing anger and fear during the worst time of the Northern Ireland conflict. As political negotiations began and the peace process slowly but surely was brought underway, rebel songs no longer reflected the thoughts and feelings of the majority of people living in Northern Ireland, and therefore they were soon replaced by songs with different focuses. A variety of themes have formed part of the Irish identity and have since found reflection in the Irish song tradition—attachment to place, pain of exile, the diaspora, cultural diversity, the economy, and even the global village. However, it has to be added that a minority of songwriters still try their utmost to keep this dying tradition of writing rebel songs alive. In general, however, it would be false to argue that rebel songs still feature in the public consciousness to a great extent, or that they form a significant part in the national repertoire of songs in Northern Ireland today. As far as the Irish song tradition in the North is concerned, the days of the rebel songs are over. The title of this book on songwriting from Northern Ireland is *And the Healing Has Begun: A musical Journey towards Peace in Northern Ireland*. Contemporary songwriters who continue to write rebel songs have no interest in peace developments whatsoever. Their songs, even though briefly mentioned in Chapters IV, V, and VI, will therefore not be discussed in great detail.

The orange song tradition, as stated earlier, developed somewhat differently throughout the latter half of the twentieth century. While up until the mid twentieth century the majority of songs from both traditions revealed the same bigotry and violence, the Irish song tradition has since gradually moved away from such images. A major part of the orange song tradition, however, continues to draw inspiration from the

[14] generally regarded as being very sectarian in nature

history of sectarianism in the North. Besides, old songs such as 'The Ould Orange Flute' and 'The Sash my Father Wore' have retained their provocative power, especially when sung during annual celebrations commemorating King William's victory in the seventeenth century or at various events organized by the Orange Order throughout the year. As might be expected, songs from the orange tradition use different sources of inspiration and a different symbolism. Also, they are divided into different categories. The biggest category comprises the vast amount of loyalist songs that continue to be written and that are still used for political purposes today. Loyalist song texts will therefore be examined in greater detail. The different musical sources reflected in the songs of the orange tradition are also of major significance. Adaptations of current or recent popular songs, for instance, frequently occur. In addition, there are also differences concerning the performing context of orange songs. All of these aspects will be discussed in the second part of Chapter III. Combined, these aspects constitute a way of living that the Protestant community in Northern Ireland can easily identify with. Through the shared system of values and experiences reflected in orange songs, Protestants living in the North have also been provided with a sense of security. Finally, the presentation or articulation of such a shared system in song also reveals certain aspects regarding the Protestant and Unionist identity. Reflections on the latter will therefore conclude the examination on the orange song tradition.

Chapter IV is the concluding chapter of the first part of this book. By taking a closer look at concepts such as 'The Past in the Present' and 'Music and Politics', Chapter IV aims at providing a better insight into the coexistence of both traditions in Northern Ireland today. For people living in Northern Ireland, the past has always been considered to be a vital element for making sense of and comprehending present developments. The past in the present as a concept is also well reflected in a large number of rebel and loyalist songs. Most of these songs still dwell upon the past and hence also stand in the way of any new ideas about a peaceful future of Northern Ireland. In general, the concept of the past in the present has certainly had a major impact on the two communities in Northern Ireland and their struggle to overcome the conflict. Chapter IV will therefore analyze this aspect in greater detail. Even though it could be argued that music and politics should under no circumstances be mixed,

the relationship between these two elements is by now well established and recognized in Ireland and Northern Ireland. According to musician, writer, and lecturer in traditional music Fintan Vallely, 'Poetry, recitation, and song and even the slow airs are in many cases so closely linked together as the political expression of the people that they cannot be separated and should possibly all be classified as "political song"'.[15] As another significant aspect in the Northern Ireland context, the concept of music and politics will therefore also be taken into consideration here before the final part of Chapter IV aims at looking into an alternative future for both songwriting traditions in the North.

While the first part of *And the Healing Has Begun: A musical Journey towards Peace in Northern Ireland* (Chapters II–IV) presents a comprehensive analysis of the two song traditions in Northern Ireland, Chapter V focuses on rock and pop artists and their reflections on the Northern Ireland conflict in song. Since the 1970s, various internationally famous artists from outside the North, such as John Lennon, Paul McCartney, Nanci Griffith, Elton John, and bands like the Simple Minds, Bananarama, Spandau Ballet, and U2, have continued to reflect on the Troubles. Their song material will therefore be explored in the first part of Chapter V. In chronological order similar to the structure applied to Irish traditional music in the first part of Chapter III, the second part of Chapter V aims at presenting a comprehensive overview of the great number of popular music artists that Northern Ireland has produced over the years. Despite the fact that some of these artists from the North might not have been recognized on an international level, it is important to note that they continued their creative work throughout the height of the Troubles. As their personal experiences are clearly reflected in many of their songs, this chapter will also look at some of the song material produced by these artists. Even though such a compilation of data will always run the risk of being regarded as incomplete, the reader can be assured that every attempt was made to include as much relevant information as possible. To claim that this examination is either complete or incomplete would counteract its actual purpose. Numerous books, magazines, and journals were consulted. In addition, various

[15] in Vallely, 1999, 366

conversations were held with authorities on the subject. For example, Tony McAuley and Phil Coulter provided valuable information for this chapter. For even more information on the subject, an extensive song list is included in the appendix of this book.

Chapter VI concentrates on the most significant songs written during the Troubles and since the Peace Process began in 1994. By taking the reader from 'The Patriot Game', written in the 1950s, on to and beyond songs of the ceasefire era of 1994, this chapter examines Northern Irish history as experienced and documented by songwriters from the island of Ireland. During the second half of the twentieth century, songwriters from Northern Ireland and the Republic of Ireland were presented with plenty of material arising from the continuation of the Troubles and constant political changes. While most of the songwriters shared the experience of growing up or living in the North at the time, behind all the songs included in this chapter lie a great number of personal stories as well. Fortunately, most of the artists who, during the height of the Troubles in the North, reflected on their own experience in song are still very willing to talk about their personal experiences. A great amount of material resulting from interviews with these artists is therefore included in the first part of Chapter VI.

It is worth noting that numerous conversations with people from communities in Northern Ireland, and interviews with songwriters and authorities on Irish music from the North and South of Ireland were held before a final selection of songs was chosen for this project. Five songs were repeatedly mentioned as the most significant songs about the Troubles: 'There Were Roses,' 'The Island,' 'The Town I Loved So Well,' 'Only Our Rivers Run Free', and finally, 'The Patriot Game'. All of these songs were written during the Northern Ireland conflict. Through the eyes of those who wrote these songs, the Troubles were documented. By examining these songs in chronological order, the reader is thus also presented with a very good insight into how the Troubles gradually affected and shaped Northern Irish society.

Singer and songwriter Van Morrison, some will successfully argue, has never reflected on the Troubles in song although he was born and brought up in East Belfast in the 1950s and 1960s. Yet the sense of

place that his childhood upbringing gave him constitutes the entire basis for much of the imagery and symbolism he used in his songwriting. A brief reflection on this artist's creative work will therefore attempt to shed some light on his continuing search for inspiration through his Northern Irish roots. While Van Morrison has never written a song that has direct bearing on the Northern Ireland conflict, the material revealed in Chapter VI will show that some of his songs do nonetheless reflect the typical experience of a person who was brought up in the North when the Troubles broke out. Morrison found an alternative way of dealing with this experience in song. An analysis of some of his song material can therefore be found in the second part of Chapter VI.

In 1994, both the Irish Republican Army (IRA) and loyalist paramilitary groups announced a ceasefire, which had decisive effects on the future of Northern Ireland. What followed was the beginning of what was then regarded as a very successful decade for the Northern Irish peace process. After many ups and downs, and even though many believe that the Troubles are over, the last decade has shown that there is no quick solution for this conflict. Songs that were written during the first decade after the 1994 ceasefire revealed feelings of renewed fear that the peace process might collapse again. These were mainly triggered by the denouncing of the ceasefire in 1996, new sectarian attacks, and the 1998 Omagh bombing. However, feelings of hope have been equally expressed, especially after the start of all-party talks, the Good Friday Agreement, and the Referendum held in 1998. Songs written during the first decade after the 1994 ceasefire have thus reflected the uncertainty felt by the majority of people living in Northern Ireland. This uncertainty, however, has over the last few years gradually moved away from feelings of anxiety and helplessness and is now shifting more and more towards optimism regarding the success of the peace process. By looking at the songs that were written by Northern Irish artists since 1994, the third part of Chapter VI thus aims at proving that the peace process is gradually entering a new era and is taking shape at last.

Almost twenty years after the first ceasefire was announced, songwriters from the North do not reflect on the Troubles as such anymore. Instead, various themes and images seem to reoccur in the creative work of these artists. Contemporary Northern Irish songwriters such as Juliet Turner

and Brian Kennedy seem to draw inspiration from a very similar set of images. Some of those images will therefore be explored in the final part of Chapter VI. Songwriters from the Republic of Ireland, on the other hand, have continued to reflect on the North in song. While their personal experience has often been described as 'second hand', their song material about new developments in Northern Ireland should not be ignored. Chapter VI will therefore conclude by introducing three songs that were written by songwriters from South Ireland after the peace process in Northern Ireland had begun.

When research for this project began, it soon became obvious that the songs that were to be discussed here had to be divided into different groups. First of all, there were numerous songs that were written by Northern Irish artists. A vast amount of song material, however, also existed from Irish and international songwriters. Then there was the orange versus Irish tradition of songwriting that had to be taken into consideration. Finally, all of the songs also had to be divided into two other major categories. On the one hand, there were songs clearly reflecting an individual's or group's quest for peace. On the other, there were songs that reflected a group's intention or willingness to keep the conflict alive. The aim of this book is to examine the peace-driven songs rather than the conflict-driven songs. However, in order to fully understand the songs that expressed the willingness to end this conflict, it was also necessary to look at songs that reflected the opposite. Although in some chapters[16] it was necessary to explore song material from the second category, the main body of song material discussed in this book does, in fact, consist of songs that reflect the quest for healing and peace in Northern Ireland.

By using a chronological approach and examining a vast amount of song material from the nineteenth, twentieth, and early twenty-first centuries, this analysis first of all aims at revealing how the songwriting tradition in the Republic of Ireland and later in Northern Ireland has been kept alive, and how it had to adapt itself and change because of political and social developments. This book further aims to illustrate that the content of the songs has changed over the years as a result of this political and social

[16] see Chapters III and IV.

changing. Just as society has changed since the nineteenth century, the songs from the Northern Ireland of the late twentieth and early twenty-first centuries deliver a new and different message. Underlying all songs is the structure of feeling, a theoretical concept which will be explained in greater detail in the second part of this introductory chapter. This structure of feeling can help to reveal how far Northern Irish society has changed. By analyzing the song material and revealing how the song content has changed over the centuries and up to the present, it will be possible to find answers to the following questions: How have people from the North and South of Ireland been affected by political developments from the nineteenth century onwards? What impact did the Northern Irish conflict have on changing Northern Irish society? Are the chances for peace, healing, and reconciliation in Northern Ireland now higher than in the past?

The methods of data collection included library research, particularly in the political section of the Linnenhall Library, Queen's University Belfast, as well as the Irish Traditional Music Archive in Dublin. In addition, numerous interviews provided valuable information that would not have been available elsewhere. For Chapters V and VI, it was necessary to remain up to date regarding new song material from Northern Ireland and to engage as many people as possible in this research. Only by doing this was it possible to collect the information required for those two chapters. Also, regular visits to live performances of artists who are included in this examination provided a better insight into their creative work.

Nonetheless, the size of this book imposed its own limitations. A vast amount of information material was available for some of the aspects discussed in this book. For other aspects, however, little material was available, which made research more difficult. For instance, there is an abundance of material on Irish political song and the continuation on Irish traditional music and song. On the other hand, abundant information is not available regarding subjects such as, for example, the orange song tradition and, in particular, its continuation as reflected in the vast amount of loyalist songs. Bill Rolston's and Katie Radford's examinations on this specific subject constituted the main literary sources available. In the first part of Chapter VI, the selection of songs was mainly confined to those that have either entered the

national repertory of songs already or are widely known by the Irish and Northern Irish community. It would be false, however, to assume that the majority of people in these two communities are well aware of the vast amount of song material that, in fact, exists reflecting directly or indirectly on the Northern Irish crisis. For this reason, some of these perhaps-less-known songs will also be discussed in Chapters V and VI.

In 1979, Northern Irish singer-songwriter Van Morrison released the song 'And the Healing Has Begun'.[17] Many years of personal study and reflection on this artist's song material inspired the choice of title for this book on songwriting from Northern Ireland. Due to the fact that the Northern Irish situation has changed over the years, the songs have undergone a process of change as well. The title, *And the Healing Has Begun: A Musical Journey towards Peace in Northern Ireland*, clearly reflects that a process has taken place. Ever since the 1994 ceasefire, it could be argued that the healing process has, in fact, begun, and this has since also found reflection in a great number of songs about the North. As the title suggests, however, this process although it has begun, is still far from reaching its goal. Looking at the ongoing struggle to make this peace process work, and recognizing its reflection in song, it becomes clear that respect, mutual understanding, and forgiveness are still the key elements that can bring closure to struggle, and ensure lasting peace to Northern Ireland.

From early songs of the orange song tradition and Irish political songs to recent song material, songwriters from both traditions have come a long way. This book is structured like a journey, revisiting the origins of older song material before travelling through the history of the Northern Ireland of the 1950s to the 1990s as reflected in song. The wheels of political change have certainly been set into motion ever since the first ceasefire was announced in 1994. More than ever, all endeavours regarding the Northern Irish peace process have had a chance to make progress throughout the last two decades. To what extent progress has been made can also be traced from the creative work of songwriters from Northern Ireland, and it is high time that their voices of concern and comprehension find the acknowledgement they deserve.

[17] on Van Morrison, Into the Music, Polydor, 1979

2

Theoretical Aspects

> Political songs by their very nature, by the fact that they are
> expressing modes of thought which are shared by a group of
> people, by a community, will certainly popularly survive . . .
> Ok, some of them may eventually become traditional; they
> may be kept in a popular repertoire or they may disappear like
> snow in a ditch, but at least they can tell us what people were
> thinking, how they were acting, at a certain time.[18]

In his *Preface to Film* (1954), British theorist in cultural studies, Raymond
Williams, first referred to the concept 'structure of feeling' and described
it as 'the culture of a period . . . the particular living result of all the
elements in the general organization.'[19] Through this concept a group's
general consciousness within society at a certain moment in time becomes
articulated and reflected in texts. Moving on in time, another generation's
consciousness will always represent a different 'structure of feeling', because
conditions will have changed. In other words, and according to Williams,
it is therefore the concrete expression of a group's consciousness in society
in one particular epoch that can be defined as the 'structures of feeling'.
In this concept, the objective element of a society's structure and the
subjective element of feeling are combined in such a way that personal
feelings and experiences are turned into a consciousness. This is then again
turned into a social form that is reflected in a text. The significance of such
a concept is best described in the following way:

> Once the carriers of such a culture die, the nearest we
> can get to this vital element is in the documentary culture,

18 Munnelly in McNamee, 1992, 19
19 in Storey, 1998, 61

17

from poems to buildings and dress-fashions, and it is this relation that gives significance to the definition of culture in documentary terms.[20]

In Ireland, poetry and song have always been closely linked together. Like poems, songs have continued to reflect Irish culture in documentary terms over the years. In his book *Songs of Irish Rebellion*, George-Denis Zimmermann supports Williams' theory of the structure of feeling: 'The ballads [political street ballads] are therefore one of the few means at our disposal to know the popular mind in a period during which the body of the nation was profoundly transformed'.[21] The same author underlines his idea with an interesting quotation from the Irish newspaper *The Nation*, published in 1843. For a better understanding of the importance of songs in Ireland in the nineteenth century this note is worth quoting here:

> We receive at least twenty songs every week, full of bitter complaints of the fallen condition of our country, or hopes of her speedy resurrection. Every one of these we reckon of more value, as an evidence of the condition of the popular mind, than a dozen speeches or a score of petitions.[22]

It is therefore of major significance to understand that song texts must be regarded as historical or even sociological documents. Both Munelly and Zimmermann refer to political songs only while talking about their impact on the documentation of culture. In Chapters V and VI it will be revealed, however, that the term *political song* has to be altered to a great extent, especially in the Northern Ireland context. Throughout the Troubles in Northern Ireland a great variety of songs, both on the traditional as well as the popular music level, do exactly express what Williams described as 'structure of feeling'.

It is not farfetched at all to argue that the majority of songs written by Northern Irish artists should be regarded as significant cultural documents. No matter how unsophisticated or primitive some

[20] ibid.
[21] Zimmermann, 1966, 10
[22] ibid.

contemporary lyrics might sound, they do nonetheless reflect a person's willingness and attempt to put experience and feeling into the words of a song. This is what makes these songs so original and eloquent. This is where the consciousness of a social group in society at a particular moment in time becomes reflected and documented.

As far as Northern Irish writing is concerned, there is little doubt that intractable problems of identity feature dominantly and are well reflected. While cultural nationalism in the South mostly emphasises Gaelic or Catholic values, a significant section of the population in the North is excluded. Northern Irish writing mostly reflects cultural uncertainties and ensuing confusions of identity. While Irish literary critic and cultural commentator Edna Longley suggests the term 'spiritual desolation',[23] Hewitt describes this phenomenon in the following way: 'People of Planter stock often suffer from some crisis of identity, of not knowing where they belong [. . .] some call themselves British, some Irish, some Ulstermen, usually with a degree of hesitation or mental fumbling.'[24] Another cultural contrast between North and South is that there is a greater degree of urbanisation in the North. Most Northern Irish writers feel more comfortable articulating the world of the city, especially suburban Belfast while showing some lack of understanding of rural Ireland.

At the same time, the latent violence in ethnic urban territoriality has been reflected until recently in marches and symbols like graffiti and flags. Because of historical events, the image of an Irish person as a stranger in his own land is often used in both Irish and Northern Irish songwriting. Finally, the love for landscape, feelings of loneliness, underlying melancholia, the force of memory, and a longing to 'come back' are further aspects that are well reflected.

> Writers and artists are both witnesses to our world but also
> products of it, possessing qualities of insight which can be
> mustered in helping to understand the diversity of place and
> the contested meanings that can be attributed to it. Because

[23] Patrick J. Duffy in Brian Graham 1997, 77
[24] ibid

they can express sublime emotions like love, hate or fear and are similarly capable of articulating manifestations of place, society rewards and honours its artists, who are seen as interpreters of national culture. The role of the artist as witness and interpreter of place, landscape and identity, can be broadened beyond mere reflection or revelation.[25]

Seamus Heaney, who, without doubt, must be regarded as an important articulator of Irish consciousness, explained his relationship to Ireland as follows: 'One half of one's sensibility is in a cast of mind that comes from belonging to a place, an ancestry, a history, a culture'.[26] In order to fulfil the ever-changing requirements of society, Irish writing has always interpreted Irish place and landscape variously. Duffy suggests, therefore, that literary texts can thus also be regarded as signifying practices 'which interact with social, economic and political institutions so that they 'are read, not passively, but as it were, rewritten as they are read'.[27] These signifying practices then communicate and produce meaning again, and that sort of meaning, it goes without saying, will change through time but can also change within cultures. According to Stuart Hall, to belong to a culture is to see the world from within the same conceptual map.[28] In his introduction to *Representation: Cultural Representations and Signifying Practices*, Hall explains that we hold mental representations to help us classify and organize the world. Representation is described by the author as 'the production of meaning through language'.[29] In other words, the two systems of representation we work with, according to Hall, are the conceptual map of meaning and language itself.[30] People create their own conceptual map; they think individually but are also able to communicate. To do this, however, people must be able to interpret the world in a similar manner. In other words, they must share meaning or a conceptual cultural map. These shared meanings constitute a culture, and they are learnt unconsciously as a person becomes a

[25] ibid, 64/65
[26] Heaney in Brian Graham 1997, 65
[27] Duffy in Brian Graham 1997, 65
[28] Hall 1997, 22, 61
[29] ibid., 28
[30] ibid., 29

member of that culture. To share this conceptual map, communication is required, and this is done through language. Every word, sound, and image carries meaning and is regarded as a sign. Signs are organized into a language, which is used to express meaning and to communicate thoughts to other people. The conceptual map of meaning and language thus work together to enable meaning in our cultures.

Another aspect which has proven to be of major significance in Irish writing is a phenomenon referred to as the 'sense of place'. First researched in the 1960s and applied to literature from Great Britain and Ireland in general, this issue gained more serious recognition in the 1980s. Since then individuals have started to experience a tension because of ever-faster developments in scientific, technical, and social arenas as well as new rules introduced by society. Adolf Portmann argues that we have since left the 'mediokosmos' behind, a world which was rather easy to understand, and now find ourselves in unfamiliar territory in which we look upon the world and even upon ourselves as strangers.[31] Individuals are torn between their past (imbued with harmony) and their present situation (full of confusion), and it is here that the sense of place phenomenon comes in. Speaking more specifically about the sense of place in the Northern Ireland context, Gerald Dawe explains in *The Rest is History* that this term, 'has been grotesquely theatricalised as a result of "The Troubles" and the physical institutionalisation of sectarian divisions during the 1970s and '80s'.[32] The same author argues that while he was growing up in Belfast in the late 1940s and '50s there was no escape from this inbred sense people had of where they were born, lived, and literally walked. Over the next generations, he continues, people were born with second sight as to where they belonged in the city. Individuals who ignored or lacked such instincts could soon find themselves in a rather dangerous and threatening position.

> From a very early age, Belfast children learned their place in this scheme of things based largely upon their physical surroundings; assimilating architectural and civic barriers of class as much as absorbing, and sometimes, rejecting,

[31] Portmann in E. Schenkel, IX
[32] Dawe, 1998, 13

or transcending as best they could, the discreet signs of religious—and hence, political identity.[33]

Poets and songwriters alike reflected on this sense of place in their creative work. As districts continue to play a key role in defining the identity of this town, the sense of belonging to a particular area can still be recognized in a variety of works by Belfast artists. According to Chris Magee, it is also necessary to note that there are times when a place remains no longer a geographical reality. Instead it can turn into a representation of a specific time or event (for example, the Omagh bombing) or into 'a manifestation of sheer chaos' as often reflected in the case of Belfast. The same author argues that, long after these events have passed or such manifestations have been erased, the same reflections continue to leave their mark on public perception.[34] Sometimes, places and landscapes as constructions of a writer's narrative can become more real than reality itself.[35] Cyprus Avenue, Orangefield, Coney Island— how significant would these places be if Van Morrison had not chosen to reflect upon them in his songs? In poetry, what would Irish bogs be without Seamus Heaney' poem 'Bogland'? These artists, among many others, often set out to construct a deliberate, symbolic landscape as an allegory of identity.

As far as songwriting is concerned, sense of place finds its expression in a variety of ways. Firstly there is the 'home place', closely associated with childhood and often portrayed as perfect paradise. This place, symbolizing happiness and peace, is forever lost. Increasing transience in the late twentieth century and frequent changes on a more global scale have more or less contributed to an experience of 'placelessness'. This can also be described as a negation of the sense of place, and it is often reflected in the quest for a place that symbolizes that loss. In today's society it therefore seems to be quite common to reflect upon one's childhood again. In many cases childhood memories are evaluated differently and are even overvalued sometimes. For many artists, including a great number from the North of Ireland such as Phil

[33] ibid, 20
[34] Magee in Hackett (ed.) 2002, 27
[35] Sheerin in Graham 1997, 66

Coulter, Mickey MacConnell, and Van Morrison, the past is suddenly becoming more important than the actual now. To regard the past as the ideal place is thus a major element in their work, expressing the sense of place phenomenon. The past that is now lost can be compared to a lost phase of living. A loss of identity is also closely associated with this experience. Religious, cultural, and even political awareness only serve to give evidence of how much easier life was in the past. A longing for the past has, therefore, become a major issue in songwriting.

> Memories
> Of summer days so long ago
> People in the places that we used to know
> Oh those memories.
> . . .
> Oh those memories
> Of happy times, those memories
> All I have now is memories[36]

Finally, family name and place, burial places of ancestors, and historic places are other expressions of the sense of place which have occurred in songwriting. There is little doubt that songwriters continue to draw great inspiration from places of historic significance. Especially in the Northern Ireland context, the spectrum is very wide. It includes places associated with scenic beauty as well as with mythic and heroic figures, but also places which have, through dramatic events in the past, become part of a collective memory.

> The Sperrins surround it, the Faughan flows by,
> At each end of Main Street the hills and the sky,
> The small town of Claudy at ease in the sun
> Last July in the morning, a new day begun.[37]

Like every form of art, especially poetry, songwriting can reflect on present developments in society. Traditional and popular songs reflecting

[36] Van Morrison, 'Memories', on Enlightenment, 1990

[37] from James Simmons, 'Claudy', in Ormsby, 1992, 95—for more information on the song, see Chapter III., 3

on the conflict in Northern Ireland therefore serve as an ideal medium for the following examination. Although there is quite an abundance of existing song material on this issue, there has not been a thorough examination so far. In the age of electronic media, however, songs are now accessible through a variety of channels, and traditional and popular songs have become an extremely powerful medium. Indeed, they are perceived as such by the majority of people. It might be worth noting in this context that in comparison to a poem, a song's advantage is that the vivid images described in the lyrics can become enhanced by a charming melody. Besides, there is still a difference between listening to a song on vinyl, tape, CD, MP3 player, or radio and experiencing a performance in a setting in which a song has even greater potential to speak out to an audience. In the right atmosphere and performed live by a genuine singer, a song can go far beyond the bare definition of simply a text enhanced by a melody.

> A song is more than a text and a melody which can be recorded or printed, examined and criticized. It is the result of a communal state of mind and it depends on the conjunction of an inspired singer, a receptive audience, and various circumstances creating a favourable mood. [38]

To turn any song into a good song, it is therefore of major significance that it must be performed by an inspired singer whose voice and performance fit in well with the melody and the lyrics themselves. Listening to a song at a live concert, it should be added, will doubtless always be a different experience from listening to the same song on the radio or any other sort of player. One could also argue that it is rather a minority of people who attentively listen to the words expressed in a song. However, a song would never actually become popular in the first place if the two constituents—melody and words—did not work well together. Therefore, the words of a song have as much impact on making a song popular as the melody itself. Nonetheless, what finally makes a song a good song is predominantly the fact that it stays with us. We continue to remember it, either the words or the melody or both. It is in

[38] Zimmermann, 1966, 12

this respect also that a song continues to be performed even many years after it was written. Such a song is able to stir the audience and often continues to do so whenever it is sung. It can thus be argued that the audience is able to relate to the song.

Although song lyrics are always rooted in the rather individualistic perception of the songwriter, it also constitutes a present awareness of the 'here and now' as experienced by the artist. This awareness of the 'here and now' also describes the present state and development of a society. After a songwriter has described his perception on whatever issue he or she has chosen to deal with in a song, it is up to the listener to relate to the songwriter's creative work. According to Roland Barthes' understanding, the 'death of the author' enables the listener to now attach his or her own meaning to the song: 'We know to give writing its future, it is necessary to overthrow the myth: the birth of the reader must be at the cost of the death of the Author'.[39] It could thus be argued that the author's intentions are meaningless to the interpretation of a text. Every text is intertextual, because it is affected by previous writing and an archive of cultural meanings. Every textual analysis therefore involves opportunities for creative revision and interplay. By demonstrating that every single thought, word, or phrase is part of a cultural product that developed over a period of time and will continue to do so far into the future, Barthes deconstructs the concept of the author.

In a similar way, Michel Foucault's concept of 'discourse' has to be taken into consideration while dealing with song texts. Discourse has a number of complex meanings and was first defined by Foucault in the following way:

> Instead of gradually reducing the rather fluctuating meaning of the word 'discourse' I believe I have in fact added to its meanings: treating it as sometimes the general domain of all statements, sometimes as an individualisable group of statements, and sometimes as a regulated practice that accounts for a number of statements.[40]

[39] Barthes, 1977, 148
[40] Foucault, 1972, 80

Literary and cultural theory is mostly drawn on Foucault's third definition of discourse, described by the author as 'a regulated practice which accounts for a number of statements.'[41] According to Foucault, it is only through discourse that a text is constructed. However, rather than thinking about discourses as sets of texts, the same author argues that they should be regarded as 'practices that systematically form the objects of which they speak.'[42] A discourse is thus not something that exists in itself and can be analyzed in isolation; rather, it is something that produces something else. The process of commentary, for instance, has a significant impact on the construction of discourses. A person who comments on a text constitutes it as a text that can be commented upon. The text is thus important and will soon be circulated and made available for other people to comment upon. It is through this process of commentary that certain ideas about a text are kept current, others are excluded, and new ones are created. For Foucault, these are the mechanisms that regulate the discursive production. The people who are involved in the process of commentary can thus be regarded as the vehicles for the transmission of the discourse.

In dealing with song material, the two theoretical concepts—Barthes' 'death of the author' and Foucault's 'discourse'—can thus be applied but also have to be somewhat extended. A song consists of melody and lyrics. People who listen to a song can therefore either focus on the melody only, on both melody and lyrics together, or simply on the lyrics alone. In any case, it means the 'death of the songwriter' and the continuation of a discursive process as soon as a song is presented to an audience.

> Each time the song is sung, our notions of it change, and we are changed by it. The words are old. They have been worn into shape by many ears and mouths, and have been contemplated often. But every time is new because the time is new, and there is no time like now.[43]

[41] ibid.

[42] ibid., 49

[43] from Ciaran Carson, Last night's Fun, 1996, 116

The following step for the listener is thus to comment on the song and attach his or her own meaning to it. While the song is further circulated, new commentary and new meaning is added. In addition, a song becomes popular only if a group of listeners can relate to the song. By doing so, recipients relate to the words in a similar way to the way they each, the author included, share the same conceptual cultural map.[44] Williams' concept of a structure of feeling can also be applied and turns the song into a historical document in its own right. Although it could be argued that no song can ever fully reveal what exactly happened and what the author intended to mean, each song always reflects on what people thought happened and thus reveals a group's conscious observation. A song, therefore, does indeed give an insight into the present state of a society as observed by a group living in that society and reflecting upon at that particular moment in time.

The following chapters will explore and explain why the arts do indeed have a significant impact in the Northern Ireland context. Focusing on developments in music, and the tradition of songwriting in particular, a lot of evidence will be presented to prove that this form of art has, over the years, not only had the potential to reflect on the Troubles but also to became a major contributor to the reconciliation process. The biggest obstacle within the diversity of culture experienced in Northern Ireland has always been the widespread hesitancy to step across into what is seen as the territory of the 'other side'. An awareness of this false approach would definitely enable people in Northern Ireland to actually learn about, to understand, and to eventually accept the cultural diversity which exists in their surroundings. The following chapters will reveal how far the consciousness of people living in Northern Ireland has changed throughout the last century. Is it possible that a process of peace and reconciliation is gradually manifesting itself in the consciousness of people who have lived through the turmoil of political developments in Northern Ireland? If time really does heal, do contemporary songs already reflect that the healing has, in fact, begun, and that peace in Northern Ireland is about to become real?

[44] see Hall, 1997, 22ff

At the Meteor Awards held in Dublin in March 2004, Sister Stanislaus Kennedy received the Humanitarian Award for her life-long dedication to the poor and homeless. In her acceptance speech, she made an interesting statement about Irish music. Taking Bono Vox's and Bob Geldof's social and political achievements as an example, Sister Stanislaus Kennedy argued that the Irish music industry has, in fact, shown that it possesses the means to encourage people. She described Irish music as 'a creative force that has its finger on the pulse of Irish society.'[45] This creative force has had plenty of time to manifest itself in present Irish and Northern Irish society. It is about time that its impact and achievements be revealed in full detail.

[45] in http://archives.tcm.ie/thekingdom/2004/03/11/story12744.asp, 11/3/2004

II
THE ARTS IN ULSTER

My song for you this evening, it's not to make you sad
Nor for adding to the sorrows of this troubled northern land,
But lately I've been thinking and it just won't leave my mind
To tell you of two friends one time who were both good friends of mine
(Tom Sands "There were Roses", Elm Grove, 1985)

And down in the valley the children are playing
She watches them laugh in the sun
A little girl's teaching her brother to walk
And already he's trying to run.
(Colum Sands "Ceasefire", Spring Records, 1996)

Red brick in the suburb, white horse on the wall

Italian marble in the City Hall.

Oh stranger from England why stand so aghast,

May the Lord in his mercy be kind to Belfast. [46]

[46] excerpt from poem/song 'May the Lord in his Mercy be kind to Belfast', Maurice Craig, 1936 ('ballad to traditional refrain'– song was never released), in Ormsby, 1992

1

The Sociopolitical Context

David Trimble once described the sum of all political changes in Northern Ireland since its foundation as 'a litany of retreat, surrender and concessions.'[47] In fact, there is little doubt that the first fifty years of Northern Ireland's history were marked by gerrymandering, electoral manipulation, and economic discrimination. (Gerrymandering is doing something that attempts to establish a political advantage for a particular party.) Then there was the outbreak of violence in 1969 which had complex political causes.

When dealing with social and political policies in Northern Ireland one could no longer ignore the fact that there were two traditions with different but equally legitimate aspirations. Therefore, it soon became the long-term aim to establish a plural society in which both traditions would be encouraged to express their cultural differences without embarrassment. A policy was to evolve which accommodated and respected differences. Soon the British government could be seen supporting this shift in policy. There was, for example, one hundred per cent financial support for Catholic schools, and grants were made available for the support of Irish-language schools. Glór na nGael—The Voice of the Gael—an organization dedicated to expanding and fostering people's ability to use the Irish language in all spheres of public life, was established in 1982. It was instrumental in the installation of the first Irish street signs. Additionally, the new role for the arts and museums was supported by financial grants from the British government. Regarding segregated schools, there was a strong concern that the further separation within these institutions would only encourage and lead

[47] Trimble in Crozier, 1998, 8

to more mutual ignorance and entrench hostilities. A higher contact between Protestants and Catholics, however, soon contributed to an improvement of the situation. Lagan College in Belfast opened in 1981 and became the first integrated school in Northern Ireland. Eight years later, in 1989, the Education Reform Order finally decided to accept integrated schools as an integral sector within the public education system of Northern Ireland. According to the Northern Ireland Council for Integrated Education, there are currently fifty-eight integrated schools in Northern Ireland, and in September 2005, 500 applicants even had to be turned away due to the enormous increase in popularity and the present lack of places.[48]

During the last two decades, there have also been major changes in the fields of employment, equal opportunity, and electoral procedures. All of these changes have been achieved gradually and almost imperceptibly. Northern Irish society nowadays reflects more equality and fairness than ever before. Nonetheless, a serious number of problems still remain unsolved; for example, higher unemployment rates for Catholics and the ongoing nightmare of the annual marching season. According to John Darby there is still enough evidence to indicate that Catholics and Protestants in Northern Ireland perceive themselves as belonging to distinctive groups. However, people in Northern Ireland do not experience the same high level of segregation in comparison to people living in Israel or in South Africa.[49] Historian A. T. Q. Stewart describes the situation in Northern Ireland in comparison to other conflicts around the world in the following way: 'The essence of the Ulster question is not that the two communities cannot live together, but that they do live together and have done for centuries.'[50] The result of this living together and yet being separated at the same time is a mixture of complicated feelings about identity and constant uneasiness:

> Northern Catholics often aspire to Irish unity, yet sometimes feel alien and are regarded as alien in the south. Northern Protestants almost unanimously want closer union with

[48] from http://www.nicie.org/aboutus/ , 8/1/2007
[49] Darby in Crozier, 1998, 7
[50] A.T.Q. Stewart ibid., 7

Britain—hence are unionists—but almost unanimously distrust Britain.[51]

Another obstacle to all reform has been the sustained violence that has affected people's lives since the 1960s. With a population of almost 1.7 million in Northern Ireland, and a death toll of 3,500 by the mid 1990s, almost every family in the region has been touched by the violence.[52] Darby argued in 1998 that, in comparing the culture of violence and the culture of peace, it is peace that has so far been weak in the Northern Irish context: 'If peace processes may best be understood as the state of tension between a culture of violence and a culture of peace, the culture of violence is vastly more powerful in Northern Ireland. It will take time to change that.'[53] Many people in Northern Ireland have reacted to this culture of violence either by seeking to deny it or to escape it. This was also reflected in a general but measurable decline in the willingness of Northern Irish people to watch the local television and radio news during the height of the Troubles. For a long time, and even after the 1994 ceasefire, this attitude continued and was also reflected in the following excerpt from Robert McLiam Wilson's novel *Eureka Street*:

> A part-time UDR soldier was killed last night in an explosion in the Beechmount area of West Belfast. Two other soldiers were injured . . . A coffee-jar bomb was thrown at the soldiers' Land-Rover. A security force spokesman said that . . . 'I switched off the radio. In Belfast the news was an accompaniment like music but I didn't want to hear this stuff. Suddenly I longed to leave Belfast. Because of an inadvertently heard news story, the city felt like a necropolis. When the bad things happened, I always wanted to leave and let Belfast rot. That was what living in this place was all about. I got this feeling twice a week every week of the year.

[51] Darby ibid., 7
[52] in http://www.cain.ulst.ac.uk/ni/popul.htm, 10/12/2004
for more detailed information and statistics see Marie-Therese Fay, 1999
[53] Darby in Crozier, 1998, 8

> Like everyone here, I lived in Belfast from day to day. It was
> never firm. I always stayed but I never really wanted to.[54]

In the 1980s the conflict acquired a new intensity; never before had Northern Irish society seemed more bitterly divided. Never had the political future of Northern Ireland looked darker than when republican prisoners went on hunger strikes and ten of them starved themselves to death. A number of academics, artists, and writers then felt the urgent need to change attitudes. After the Cultural Traditions Group was founded in 1988, many artists in Ulster soon took on the challenge of dealing with the situation at hand. It became literally impossible for Northern Irish artists not to reflect on the bitterly fought war outside their front door. Somebody had to find a way to express the anger, the fear, and the pain that was felt by every citizen living in Northern Ireland at that time. And yet, there was also a great sense of hope that, through the work of art, the political future of Northern Ireland could somehow be altered.

> The arts generally can make an enormous contribution to
> our society at this time of hope and change. They can play
> a vigorous part in the process of reconciliation, in providing
> employment and improving the quality of life for both our
> own people and those coming to the province for business
> and pleasure.[55]

[54] Robert McLiam Wilson, 1996, 60/61
[55] D.Deeney in Crozier, 1998, 92

2

The Function of the Arts in Ulster

Within the last four decades, Northern Irish poets, painters, and songwriters had the time to reflect on the Troubles and to filter their experiences in their work. According to Edna Longley, however, these artists have nowadays also become the 'victims of improper expectations.'[56] In a similar way, Northern Irish poet Michael Longley warns that in a society at war with itself, each artist will reflect on any given experience in his or her own time:

> Too many critics seem to expect a harvest of paintings, poems, plays and novels to drop from the twisted branches of civil discord. They fail to realise that the artist needs time in which to allow the raw material of experience settle to an imaginative depth where he can transform it . . . he is not some sort of super-journalist commenting with unfaltering spontaneity on events immediately after they have happened.[57]

While many artists have chosen to deal with the Ulster question in their work during the last forty years, others chose not to tackle this subject. According to Carruthers and Douds, however, it is more important that the audience is always reminded of the human voice and experience. Thus, the greatest achievement of Northern Irish artists within the last four decades has been to chronicle a vast number of individual stories. No matter how severely the impact of destruction was felt, through the work of these artists, people in Northern Ireland have always been reminded of the individuals whose stories lie behind the headlines. As far

56 Longley in Poetry in the Wars, 1986, 185
57 Longley in Carruthers, 2001, x

as the role of artists in Northern Ireland is concerned, Donnell Deeney suggests that their contributions have counteracted any false images of Northern Ireland that might have otherwise been created abroad.

> Our painters, our dramatists, our novelists, our musicians, our actors and, of course, our poets have raised a creative consciousness of Northern Ireland abroad which will prove resistant to the explosive impact of negative images, in the long term, which is always where the arts come into their own.[58]

Northern Irish songwriting certainly illustrates the extent to which the arts in Northern Ireland have been able to deal with the political crisis and the war situation. So much has been written about the poetry in the North. In many respects, however, Northern Irish songwriters found themselves in an equally dangerous, yet very challenging, position. Even though songwriters use music as an additional medium, similarities between poems and songs are not at all farfetched. On the level of text production, poets and songwriters do indeed follow a very similar approach. Edna Longley once stated that in poetry language can be used 'with greater concentration or greater intensity or greater memorability.'[59] The same can be said about the lyrics of a song. Poets and songwriters are both conscious of this fact and hence apply it to their work with remarkable effect. Although the majority of poets and songwriters do always in some way reflect on the situation surrounding them, it is important to note that they do not necessarily have to act as spokespersons. In fact, Northern Irish poet Gerald Dawe believes that this idea would be nonsense:

> But to insist that artists act as spokespersons is nonsense. Does every poet from a Catholic background in the North represent a coherent, monolithic experience? Must every Jewish writer speak on behalf of Israel? Before we know it, we will be marching in step to the same tune. We have to be careful not to turn the fierce, steady imaginative journey

[58] Donnell Deeney in Crozier, 1998, 92
[59] Edna Longley in Matthews, 1997, 19

of the artist into a scenic route with awesome views, sites of not so old battles and a compliment of renovated cultural treasures.[60]

However, looking at the situation in Northern Ireland, poets and songwriters were both faced with the task of reflecting on the Troubles and did so in very similar ways. Although the following remarks mainly focus on the poetry of Northern Ireland, they do also reflect how Northern Irish songwriting was shaped by historical events throughout the latter half of the twentieth century.

[60] Gerald Dawe in Fortnight Magazine, Nov. 1994, 33

3

The Role of Poetry and the Future of the Arts in Ulster

We are suspended between two cultures: one, British, made us citizens of the modern hard-nosed urban world of trade and commerce; the other, a gentler Gaelic heritage, made us spiritual and rural. We live in a society that is at once traditional and modern, and the tension between these forces serves to animate our thought and artistic expression.[61]

According to Richard Kearney, Ireland underwent a 'crisis of culture' in the twentieth century. Kearney argues that the experience of a conflict between the claims of tradition and modernity; in other words, 'residing between two worlds' contributed to a crisis of consciousness. Various factors, such as the prevailing sense of discontinuity, the absence of a coherent identity, and the breakdown of inherited ideologies and beliefs, all constitute a major obstacle if a transition between past and future was to be achieved.[62] According to Northern Irish poet Paul Muldoon, who was awarded the Pulitzer Prize for poetry in 2003, there is a sense of uncertainty that people living in Northern Ireland have been brought up with. This uncertainty, in return, had a vast impact on Northern Irish writing. Muldoon speculates that the great variety of good Northern Irish writing has probably got to do 'with that element of uncertainty, of not being sure who one is—or being only too sure, and not liking it.'[63]

[61] John Bradley in Logue, 2000, 15
[62] Kearney in Matthews, 1997, 6
[63] Muldoon ibid., 189

Steven Matthews suggests that, as a response to the renewed violence, there has been an emergence of a late, local modernism in both Irish and Northern Irish poetry. Poets have adapted their poetics both consciously and unconsciously to the terrible and shocking circumstances in their surroundings. In addition, this modernism is revealed in the break-up of traditional form in poetry. By adapting itself to the altering contexts of its creation, even though history partly determines its progress, poetry has also been able to answer back:

> Writers born into the over-determined, over-defined environment, into a tension between political simplicities and cultural complexity, have felt impelled to redefine: to explore and criticise language, images, categories, stereotypes, myths. Northern writing does not fit into the binary shapes cut out by Nationalism and Unionism. [64]

Historical events or even cultural debates can have an enormous impact on poetic texts and often succeed in altering both their form and their reception: 'Poetry is a place where conscious and unconscious relations towards history interact and are questioned and transformed'[65]. Besides, contemporary Northern Irish poetry is a typical example for poetry arising from ordinary speech, capturing the 'here and now'. German sociologist and philosopher Jürgen Habermas describes the same phenomenon as the 'now-time' in which irrefutable modernity is well conscious of its place in history.[66] In a similar way, Matthews argues that, due to the fact that Northern Irish artists experienced a history of violence until 1994, exploitation of 'ordinary Ulster speech' and of 'what's before your eyes' is well reflected in their works.[67]

Northern Irish poet James Simmons[68] believed that poetry's 'high seriousness' urgently had to become enriched by such themes as clarity, feeling, and humour in order to overcome what he perceived as the

[64] ibid., 20
[65] ibid., 25
[66] Habermas ibid., 189
[67] ibid., 194
[68] died in June 2001

elitism of influential modern poets like T.S. Eliot.[69] Besides, Simmons, himself a singer and songwriter, promoted more popular, accessible forms such as ballads and folk songs in his poetry. Yet his love of music was also revealed when one of his best poems about the Troubles could also be heard as a song. In 'Claudy' (1974) political and sectarian murder were presented in an extremely dark and angry poetical form. In this poem and song, the victims are presented by name and are described as going about their daily lives when all of a sudden a car bomb explodes and extinguishes everything that had been before. There is also a certain similarity between 'Claudy' and W. B. Yeats' poem 'Easter 1916.'[70] While this poem reflects on the outcome of the 1916 Easter Rising, 'Claudy' portrays the changes after the explosion in a similar way:

> And Mrs Mc Laughlin is scrubbing her floor,
> And Artie Hone's crossing the street to a door,
> And Mrs Brown, looking around for her cat,
> Goes off up an entry—what's strange about that?
>
> Not much—but before she comes back to the road
> That strange car parked outside her house will explode,
> And all of the people I've mentioned outside
> Will be waiting to die or already have died.
>
> An explosion too loud for your eardrums to bear,
> And young children squealing like pigs in the square,
> And all faces chalk-white and streaked with bright red,
> And the glass and the dust and the terrible dead.[71]

[69] Ormsby in Carruthers, 2001, 58/59
[70] 'All changed, changed utterly: A terrible beauty is born', from W. B. Yeats, Easter 1916 in Duffy, 1999, 27
[71] from James Simmons, 'Claudy', in Ormsby, 1992, 95

Claudy, Northern Ireland

The bombing of a city and its people, the fragility of art in wartime, and the loss of childhood securities are dominant themes in Ciaran Carson's poetical work. His ability to catch the texture of city life is Carson's greatest gift. His poetry reflects 'the labyrinthine nature' of a city, which seems to change day by day, and in which a 'nightmarish atmosphere of dislocation' is created in a familiar place.[72] His ninth collection of poems, *Breaking News*, published by the Gallery Press, was awarded the 2003 Forward Prize for Best Poetry Collection in 2003.[73]

Finally, and returning to the more general level of an artist's role in a society at war with itself, the following remarks might not serve to give an ultimate answer. They will, however, illustrate that an ultimate answer can yet be achieved through works of art. This artwork can help the human consciousness to evolve, to move forward, and to overcome whatever obstacle a society might find itself faced with.

> As always, we are prisoners of our own times and experiences. This is one of the verities of life that artists understand well. And it is one of the things about art which gives it a universal relevance. As spectators of art it gives us the chance to see ourselves in a broad sociohistorical context.

[72] Ormsby in Carruthers, 2001, 72
[73] http://www.gallerypress.com/Authors/Ccarson , 14.1.2004

But, paradoxically, it is not something amenable to precise definition.[74]

During the last few years, the steady democratisation of the arts has emerged as a major trend in Northern Ireland and elsewhere in the United Kingdom. This has obviously had an enormous impact on the way this sector is viewed by the government and rather sceptical groups in society. Author Mark Carruthers and editor Stephen Douds, of *Stepping Stones: The Arts in Ulster 1971–2001*, explain how this change and the present political situation could shape Northern Ireland art in the near future:

> The experience of devolution could yet be the making of the arts in Northern Ireland. The shift from cultural cringe to cultural confidence is underway and perhaps now, as never before, the sector will receive the attention it deserves from government, attention which has been so demonstrably absent throughout much of the recent past. [75]

Carruthers and Douds further believe that it is high time for Northern Irish artists to act: 'Local politicians need to know why the arts matter and it is up to the arts community to be their persuader.'[76] The arts, however, have so far failed to dominate the public's consciousness in Northern Ireland, and the majority of people still believe that art itself has no real impact on their everyday lives. Chapters IV through VII will reveal more information regarding this subject and will help to explain why the arts do, in fact, have a significant impact on Northern Irish society. Finally, and regarding the future of Northern Ireland, Bill Lazenbatt from the English department at the University of Ulster made the following suggestion back in 1999:

> We have been subjected far too long in Ulster to the self-interested cant of a cacophony of political voices; perhaps

[74] Brian Kennedy in Crozier, 1998, 133
[75] Carruthers; Douds, 2001, xv
[76] ibid.

we should reverse the exclusivity of Plato's Republic, banish the political and listen to the artists instead! [77]

[77] Lazenbatt ibid., x

III
ORANGE VERSUS GREEN: THE TWO SONG TRADITIONS IN NORTHERN IRELAND

1
The Green Tradition

This city that treasures our hopes and our fears

Was dragged up from a swamp in the last hundred years.

But the last shall be first and the first shall be last,

May the Lord in his mercy be kind to Belfast . . . [78]

[78] excerpt from poem/song 'May the Lord in his Mercy be kind to Belfast', Maurice Craig, 1936 in Ormsby 1992

1.1. The Green Tradition in the Past

Humble Beginnings

> To use songs for protest, to voice enduring grievances or propagate temporary slogans, praise leaders, lament the fate of ordinary people unwillingly caught in big upheavals or celebrate those who chose to be martyrs, and to inspire revolt or promote some parliamentary action, was not a practice unique to Ireland; but in a country with a history of enduring tensions and recurrent violence and with a taste for eloquence and music, it was a common occurrence, could reach great intensity, take relatively original forms, and seem at times so pervasive that almost any song might suddenly shade into the political. [79]

An impressive number of rebel songs are still very popular today. These songs originally emerged in the cities in the eighteenth century and later in the countryside as soon as the Irish language was replaced by English. These songs dealt with two main subjects. On the one hand, they reflected the struggle of the peasantry to take possession of the land. On the other, they explored the fact that nationalists were trying to obtain emancipation from the religious pressure imposed on them. These songs could also be regarded as a form of propaganda, as they not only expressed the singers' feelings, but were also accessible to the illiterate community. Another interesting aspect is that these songs related to both folk and popular traditions, the Gaelic Irish and the English. Therefore, they can be described as a 'curious melting pot for different kinds of literature and sub literature.'[80]

These popular political songs show a vast and ever-recurring body of themes and motifs and should, thus, be understood as a whole. In addition, these songs also contain a complex system of symbols. Although hardly any of these ballads contains what could be called political realism, the will to protest is well reflected. Therefore, the

[79] Zimmermann, 1966, 1f.

[80] ibid., 9

predominant themes and motifs include a disposition to anger or derision as well as a great amount of sentimentality and sadness. At the same time, an admiration for good riots and fights is reflected along with strong religious conviction, an obsession with failure, an acceptance of misfortune, and finally, at the same time, a strong believe that one day this nation will rise again to glory.[81]

Two characteristics were inherent in political street ballads: both cause and effect. While strong collective emotions were expressed, opinion could be profoundly affected. At the same time, a common memory of some events was shaped through these songs, which in turn influenced the attitudes and opinions of the people listening to the songs. It is therefore hardly surprising that, before an expected rising, nationalists published violent songs in order to excite and prepare people's minds for what was coming. As a consequence, many of the young Irish soon developed a desire to die for their country and to become martyrs for Ireland. Conforming to this popular idea of a national hero can thus again be traced back to the effects these political ballads achieved. No matter how influential these songs were, there was another negative aspect linked to the singing of these songs. In 1848, there was a complaint in the newspaper *The United Irishman* about the fact that too much energy had been wasted on songs. This is also evident in an observation by Fenian member O'Donovan Rossa, who argued that songs were only a substitute for action.[82] (Fenian was a nineteenth—century revolutionary nationalist organization.)

The songs that were written from the eighteenth century right up to the end of the nineteenth century reflect the situation of the Gaelic Catholic people from the time when they were oppressed and not allowed to play any part in Ireland's political life, right to the time when their successors were soon to gain political independence. The situation of nineteenth-century Ireland and the impact of political street ballads is well reflected in Zimmermann's description:

[81] ibid., 11
[82] ibid., 10

> The poorness of these street ballads is in itself significant; it shows to what the Irish people, kept in misery and deprived of their own culture, were reduced in the greater part of the last century. There is something pathetic in the descriptions given by some travellers of the ragged crowds who swarmed around the street singers and followed them step by step, eagerly listening to their wretched songs.[83]

Political street ballads are often divided into three categories, each addressing a different cultural level in society. The first one deals with songs that have been mainly written by people who had no real political consciousness and rather reflect spontaneous protest. On the second level there are songs that are more closely connected with the national movement and were written by the lower or middle classes. The third level are written by educated writers whose purpose is mainly to influence people.

The Great Famine between 1845 and 1852 obviously left an enduring mark on folk memory. While ballads at that time still tried to express optimism and hope for a better future, songs that were written ten to twenty years later were full of denunciation of the oppression felt: 'There is many a brave heart here, mother, dying of want and cold, / While across the channel, mother, are many that roll in gold . . . '[84] A vast variety of songs and ballads deal with emigration and reflect the theme of reluctant exile from Ireland to roam in foreign lands:

> Farewell dear Erin, fare thee well, that once was call'd the Isle of Saints,
> For here no longer I can dwell, I'm going to cross the stormy sea,
> For to live here I can't endure, there's nothing here but slavery,
> My heart's oppress'd, I can find no rest, I will try the land of liberty.[85]

[83] ibid., 11

[84] excerpt from 'Give me three grains of corn, mother', ibid., 16

[85] excerpt from 'A New Song Called The Emigrant's Farewell To Donegal' (1846), ibid., 237

Very often these laments also took a political turn, and emigrants promised to return in order to free old Ireland from all slavery. Cursing the enemies of Ireland was another predominate theme: 'Till the day of his death may he have a bad breath, That will stick like a rotten old cold.'[86] Another favourite theme which started to emerge in mid nineteenth century was the narration of fights between Catholics and Protestants:

> The Lord he has agreed it that loyal we should be,
> Unto our fellow creatures, or heaven we would never see;
> I hope he will forgive me for the truth I do declare,
> My heart is good whenever I could, but a Billy I can't bear.[87]

According to Zimmermann, these 'faction fights', however, illustrated generally no real political shade and were rather regarded as a 'rude form of sport.' The following excerpt illustrates that Protestants simultaneously reflected on the same events:

> There was a damsel among them all, and one we shall adore,
> For she wore the Orange around her head and cried 'Dolly's Brae no more'.
> And if they ever come back again, we'll give them ten times more,
> And we'll christen this 'King William's Bridge', and cry 'Dolly's Brae no more'.[88]

The Society of United Irishmen, founded in Belfast in 1791, was of major importance in the evolution of Irish Nationalism, and thus, with its reflection in songs. To secure constitutional reforms by uniting Protestants and Catholics was the original aim of the United Irishmen, and soon ideas about an Irish Republic emerged. Republic and patriotic songs that were sung at their meetings were also circulated with the help of broadsheets and booklet series such as *Paddy's Resource* and *The Harp of Erin*.[89] The predominant keywords in these songs include *liberty*,

[86] excerpt from 'Skin The Goats Curse On Carey' (1883), ibid., 282

[87] excerpt from the 'The Noble Ribbon Boys' (Billy synonymous with Orangeman), ibid., 202

[88] excerpt from 'Dolly's Brae', ibid. 312

[89] see ibid., 38

freedom, and *union*. In all of these songs there is a clear message for the Irish; namely to awaken, to unite, and to take up arms against the enemy. Shamrocks, harps, St Patrick, and Granuaile (sixteenth-century female clan chieftain and folk hero) also appear frequently in these songs. The French Revolution and the repression at the end of the eighteenth century remained a great source of inspiration for ballad makers throughout the following century: 'What a feeling of pride and sorrow [fills] the name of ninety-eight . . . '[90] From France and Italy an important song theme reached Ireland and could soon be found in many of the songs from the nineteenth century. As opposing symbols against the English, liberty trees first appeared in America around 1765–1775 and soon became very popular all over Europe. As far as Ireland is concerned, there was yet another ancient reason why this symbol became so popular. Tree worship could here be traced back to the religious life of the ancient Irish. Now, however, it was used in a different context and took on a more political shape: 'Sons of old Erin, support this young tree, 'Gainst British connections a charm let it be.'[91]

In 1796, Lord Edward Fitzgerald was asked by English officers to take off the green silk scarf he was wearing, according to observer Thomas Moore. They were offended by the colour. There are similar stories including press articles of the time which announced that even accidentally worn green ribbons and handkerchiefs could lead to imprisonment or 'expose women to the brutal insults of the common soldiery . . . '[92] The 'wearing of the green' refers to the shamrock, which first became associated with nationality about 1700. According to legend, St Patrick introduced the shamrock to Ireland in order to explain the trinity of Father, Son, and Holy Spirit. Ever since then it has been regarded as a religious emblem for Ireland. Since the late eighteenth century, however, it has also been used as an emblem for Irish independence and can be found in many songs:

> Green are her fields, her waves, and green each grove,
> And green's the badge of Liberty and love.

[90] from 'The Rising of the Moon' (1865), ibid., 260
[91] from 'Shoot of Liberty', ibid., 42
[92] ibid., 43

> The myrtle-green is Venus fav'rite tree
> First planted in a land of Liberty.[93]

Glorification of Irish heroes was obviously another predominant theme. After the failure of his rising and his successive execution in 1803, Irish patriot Robert Emmet became 'the darling of Erin.' A melancholic theme runs through all the songs that were written about him: 'But alas! He is gone, he has fallen a young flower, They have murdered my Emmet—my Emmet's no more.'[94]

A few years later, Daniel O'Connell, was similarly regarded as a hero for his political achievements: 'Brave Emmet, Fitzgerald and Grattan, Have died in defence of the tree, While Sheil and O'Connell predicted, That the plant would see Ireland free.'[95]

Then there was the Fenian movement, or Irish Republican Brotherhood, founded in America in 1858, which contributed to a great variety of new songs. Poems and songs were published in its weekly paper, *The Irish People* until 1865. Some of the greatest ballads in these collections were written by Charles Joseph Kickham[96] and John Keegan Casey,[97] both of whom were soon regarded as talented songwriters.

Zimmermann argues that Irish nationalism always seems to have been exceptionally rich in symbols. Some of the reasons for that include 'that rebellious implications had to be concealed' and that irrational representations have always seemed to be more powerful than their logical opponents. In addition, people taking part in social uprisings as experienced in Ireland have often regarded their involvement as a kind of mythical fight; therefore, their engagement is also expressed in a similar way. The main reason for the richness of symbols and the use of allegorical elements, Zimmermann believes, takes its roots from the 'ancient taste for enigmatic expression' found in Christian tradition and

[93] excerpt form 'Green Top Knot' (1797), ibid., 43

[94] excerpt from 'My Emmet's no more', ibid., 175

[95] excerpt from 'Ireland's Liberty Tree', ibid., 254

[96] e.g. 'Patrick Sheehan', ibid., 245

[97] e.g. 'The Rising of the Moon', ibid, 259

Irish folklore. Oppressed people, then, prefer to make use of what they know and cherish the symbolism which foreigners might not be able to understand.[98]

One of the most frequently used symbols is the presentation of Ireland as a woman. According to Kickham, the romantic Irish rebel regarded Ireland as 'his mother, his queen, his idol, his all the world.'[99] In order to humanize and individualize the image, a proper name was often given to the woman. Names that had already been used by Irish Jacobite poets in the eighteenth century reappeared on the nineteenth-century broadsheets. One name, however, was soon preferred by many of the ballad writers. Courage and victory are just two words that are closely linked with the name Grace O'Malley, legendary chieftain of a district around Clew Bay in the sixteenth century. It is therefore hardly surprising that Irish variants of her name (Gráinne Mhaol, Granuaile, Grana Uaile, and Grania for example) feature in many of the songs: 'I looked all around and could not see but the walls of a lonely jail, And that was the last I've seen of poor old Granuaile.'[100] Another interesting aspect is that animals often symbolize men, and heroes are often referred to as birds. Daniel O'Connell, for example, was represented as an eagle, standing for faith, courage, and supreme power:

> From the green fields of Kerry so merry my Eagle took wing,
> With talent so rare and clear he began for to sing;
> The people admired and delighted in his charming air,
> So soon they elected him a member for the county Clare.[101]

Invaders, in turn, were regarded as dark ravens 'haunting the ruins.'[102] While allegorical elements could still be found in songs of the late nineteenth century, Zimmermann suggests that this interest gradually disappeared. Looking at songs of the twentieth century, it soon becomes

[98] ibid., 53
[99] Kickham ibid., 54
[100] excerpt from 'Poor Old Granuaile' (?1870's), ibid., 272
[101] excerpt from 'The Kerry Eagle' (1847), ibid., 233
[102] ibid., 57

obvious that authors of popular songs were no longer satisfied with this form and only rarely made use of it.

How Did the Songs Travel?

Passing the singing tradition on was mainly realized through word-of-mouth circulation. In other words, as long as the majority of people in Ireland were illiterate, the oral tradition was kept alive. In the mid nineteenth century, however, this was no longer the only means by which a song could travel around Ireland. All over Europe, street singers had already been selling broadsheets for centuries. As more and more Irish were eventually able to read and understand English, the great invention of the broadsheet had an enormous influence in Ireland as well. After the original British broadsheets were first popular in Irish cities, they started to travel around the Irish countryside during the first quarter of the nineteenth century. In good time, the Irish printed their own ballads, and soon songs reflecting the latest crimes, love stories, and even political developments travelled all over the country. Although often the sheets were hardly readable or, in some cases, even indecipherable because of misspellings and incorrect punctuation, they could even be regarded as a modest form of newspaper. People enjoyed hearing about 'A New Song on Michael Davitt' (1881), for example, and purchased the latest news about their fellowmen:

> You true Irish heroes to me lend an ear,
> For soon in a moment the truth you'll hear
> Concerning young Meagher, as you may understand,
> That was forced to flee from his dear native land.[103]

These broadsheets were sometimes also the only 'objects of art' people could afford to buy. Zimmermann argues that, even in the houses of the poorest, these sheets could be found hanging on the walls; for instance,

[103] excerpt from 'The Escape Of Meagher', Thomas Francis Meagher, who had been sentenced to death and later reprieved and transported to Tasmania, had escaped to America in 1852. Irish people at home were delighted when they found out about his triumphal escape., ibid., 242

right underneath 'the coloured effigy of a saint.'[104] Travellers who came to Ireland were often astonished by the popularity these ballad singers achieved. G. D. Zimmermann discovered an interesting report by German J.G. Kohl who visited Kilkenny at the time of the races in 1842:

> In Kilkenny there were literally twice as many ballad-singers as lamp-posts standing in the streets. Their usual stand is in the gutter which separates the footpath on which the foot-passengers walk from the carriage-way; and in this kennel they are perpetually strolling up and down. They are generally provided with a number of printed copies of the ballads which they sing, and their principal employment consists in the sale of these songs . . . [105]

Kohl continues and argues that the reflection of people's own misfortunes in such ballads, as well as the great delight the Irish take in music and song, are the reasons for the singer's great popularity.

An interesting issue which should be explained here, too, is the question of who actually wrote these broadsheets. I would again like to refer to G. D. Zimmermann, who offers the following answer. Broadsheet printers often seem to have employed 'hack poets' who in turn wrote the more topical songs to their employers' order. It is also interesting to learn that even writers as well known as Oliver Goldsmith used to make their contribution in writing broadsheets anonymously for printers. It goes without saying that, despite these professionals, there were also a number of people who simply wrote ballads because it felt like the right thing to do. Sometimes people just felt they had something to say and wanted to express their feelings; this was especially true of teachers in small towns.

Ballad singers were still very active in the 1880s. However, the majority of people were now more literate and began to read newspapers instead of focusing on songs. In addition, political issues soon offered no real exiting news, and so the need for singers rapidly declined too. By the time the First World War was over, 'ballad mongers' could hardly

[104] ibid., 21
[105] J.G. Kohl ibid., 23

be found in the country any longer according to Zimmermann.[106] Looking at the situation a century later, it is now obvious that trade in broadsheets belongs to the past; it no longer exists. Another form of circulation is extinct today as well. Zimmermann called them 'garlands' in order to distinguish them from any other kind of songbooks. A simple sheet folded twice and made into a booklet containing up to six songs was frequently used until the mid nineteenth century. As far as the lower classes were concerned, the broadsheets, however, had the greatest impact on the passing on of songs throughout the nineteenth century.

Political Realism in Songs

The songs written throughout most of the nineteenth century consistently glorified the Irish past and romanticized heroes who had fought and died for their country. Because of new political developments, however, it was soon obvious that this was no longer enough. The first songs that gave political directions appeared at the last quarter of the nineteenth century and were closely linked to the activities of the newly found Land League under Michael Davitt. The major aim of this organization was to give clear orders to the Irish peasantry to defy their landlords by active resistance: 'No more rack-rent or evictions, For the tenants must be free.'[107] A short period later, the Home Rule movement took over and became a decisive force. Under leader Charles Stewart Parnell, this soon became a dominant issue in British politics and saw extreme nationalists and Home Rulers united for a short period of time. Together, they revived old song themes and found in Parnell the legendary hero they had so badly missed since O'Connell's death. 'Go search the world o'er and o'er, there's none has fought so well, To right the cause of Ireland as O'Connell and Parnell.'[108] After Parnell's sudden death in 1891, nationalists were left more divided than ever before, and songs were filled with bitterness and grief.

It is also significant to note that, compared to contemporary revolutionary songs from other European countries, there was almost a

[106] ibid.
[107] excerpt from 'The tenants should be free', ibid., 60
[108] excerpt from 'Release of C.S. Parnell', ibid., 62

total absence of anti-clerical song material in Irish songs of the time. The main reason is that in Ireland the Catholic Church had no real impact on revolutionary developments, and a priest was thus never regarded as an enemy.

At the beginning of the twentieth century, rebel songs became very important. The South African war was compared to the situation in Ireland and inspired songwriters. Through most of the songs runs a strong anti-English theme. "'Revenge! Remember '98, and how our fathers died. We'll pay the English back to-day," cried fearless John McBride.'[109] At the same time and in the west of Ireland, Lady Augusta Gregory collected 'daring ballads' in the market towns, at fairs and races.[110]

Soon angry farmers who had been ballad heroes earlier in the nineteenth century were replaced by another protagonist. The idealistic rebels were more controlled and generous than ever before, and this was reflected in their songs as they documented the progress made by popular political consciousness. Although the new rebel songs were mainly written for emotional appeal, they clearly expressed, in a simplified way, the ideal that the rebels were fighting for. This is illustrated in the following example:

> Cheer up my gallant Fenian men, the day is not far away
> When our Fenian boys the flag will raise and trample tyranny,
> Our gallant sons beyond the seas will join in unity,
> And we will raise the flag of freedom and fight for liberty.[111]

Many of these new protagonists were intellectuals, and their aim can clearly be summarized as 'free the country' or 'break away from the English connection.'

After Arthur Griffith founded Sinn Féin in 1905, songs and poems were immediately published in the organization's newspaper. Zimmermann argues, however, that none of this creative work was outstanding.[112]

[109] excerpt from 'John McBride's Brigade' (1900), ibid., 293
[110] ibid., 66
[111] excerpt from 'O'Donovan Rossa's Farewell to Dublin' (c.1965), ibid., 261
[112] ibid.,67

Nonetheless, Fenianism and the Gaelic League, whose intention was to revive all national traditions, contributed to a new separatist tendency. When in 1912, the House of Commons suddenly approved the third Home Rule Bill, political passion experienced another boost. While the opposition in the North founded the Ulster Volunteer Force to resist Home Rule, the rest of Ireland saw the creation of the Irish Volunteers, which was inspired by the revolutionary spirit and inspired a variety of marching tunes. Furthermore, in Dublin, nationalism and republicanism were also linked to socialism and led to the publication of particularly violent songs in newspapers of the Labour movement.

Then, the First World War put developments on hold in Ireland; however, not completely. The Irish Republican Brotherhood made use of England's difficulties and planned a rebellion against British rule in Ireland. It is clear today that a number of songs, like 'God save Ireland' (1867) and the 'The Memory of the Dead' (1843), were sung during the rising and contributed to creating and sustaining the right spirit for the rebels.[113] The patriotic spirit that lies at the heart of these rebel songs was defined by nationalist and political activist Padraic Pearse as mainly being 'a memory of heroic dead men and a striving to accomplish some task left unfinished by them.'[114] The Easter Rising, with all its ambitions and tragic outcome, revealed once again that the Irish showed an intense power when stirred by the sorrows of the past. As a result, the images of dead heroes and the glorification of martyrs were revived and remained two important themes of rebel balladry. In turn, the same themes helped to encourage patriots in their resistance. After the 1916 rising, the necessity for sacrifice—to die for Ireland—became a kind of revolutionary gospel. Very often, fallen heroes were compared to Christ who on the cross, and the motif of 'blood sacrifice' appeared so that Ireland might become reborn again: 'Let me carry your Cross for Ireland, Lord!'[115]

Between 1915 and 1925, a great number of political broadsheets were issued again. The majority of them reflected events and developments like the Easter Rising and the guerrilla war that followed between

[113] ibid., 68

[114] ibid., 69

[115] excerpt from 'Marching Songs of Ireland No.3, ibid., 71

1919 and 1921. Phrases like 'Who fears to speak of Easter Week' and excerpts from the last speeches of the leaders before their execution dominated lyrics. In addition, intensified anger and the action of the Irish Volunteers after 1919 inspired a great number of songs which in turn reflected on ambush, raids, and reprisal.[116] It might be interesting to note that, among the rather less professional writers, Sean O'Casey contributed to a great number of songs at that time. A small number of songs were also published after 1921 when the Anglo-Irish Treaty contributed to a crucial battle between divided Irish politics. These songs were extremely bitter and revealed the persistent hatred.

In more recent times, new types of songs have taken the place of rebel songs. In fact, while street singing has now wholly disappeared, only the more 'racy' older ballads seem to survive. According to Zimmermann, the abatement of political passions is to blame for this decline.[117]

Songs of the Middle Class

> Music is the first faculty of the Irish, and scarcely anything has such power for good over them. The use of this faculty and this power, publicly and constantly, to keep up their spirits, refine their tastes, warm their courage, increase their union, and renew their zeal, is the duty of every patriot.[118]

The following chapter will briefly examine song material written by the middle class and more educated people, such as professional writers. This will help to illustrate that there was also another variety of songs that were created between the eighteenth century and the beginning of the twentieth century. Compared to the material so far examined, which was created from a rather spontaneous point of view, the poetry and songs written by these representatives were more of the literary kind. The main difference in these songs was that their writers recognized the songs' potential to be used as a form of propaganda. Broadsheets easily reached a popular audience.

[116] ibid., 72
[117] ibid., 73
[118] Thomas Davis ibid., 75

Therefore, writers consciously made use of popular themes and forms to shape public opinion or to simply renew their inspiration.

Studying at Trinity College Dublin, Thomas Moore became friends with Robert Emmet and other United Irishmen. Soon he sympathized with their ideas and was to become the first acknowledged man of letters who wrote songs on Irish patriotism. Between 1807 and 1834, ten collections of his famous *Irish Melodies* were issued. According to Zimmermann, patriotism is present in about one third of the collection's songs and is generally expressed in frustration, death, and despair.[119] However, Moore believed in peaceful reform and was convinced that the days of revolt were over. There has always been much criticism about Thomas Moore, and that criticism has varied in intensity. Some offered strong reproof, especially the Fenians regarding his creative work as simply a 'whining lamentation over our eternal fall, and miserable appeals to our masters to regard us with pity.'[120] Others believed 'Moore has done more for the revival of our national spirit than all the political writers whom Ireland has seen for a century.'[121] According to Zimmermann, there is little doubt, however, that Thomas Moore opened the path for nationalist writers of the mid nineteenth century.

As one of the leaders of the Young Ireland movement, founded in the mid nineteenth century, journalist Thomas Davis wrote a number of songs and ballads. Together with Young Ireland leader Gavan Duffy, he recognized the idea of using songs as an instrument to educate people about nationality. It is interesting to note that Davis came from a Munster protestant background, while Duffy was an Ulster Catholic. Duffy also issued an anthology of ballads, which was soon commented on by Davis as 'propaganda worth a thousand harangues.'[122]

A collection of songs which was to become even more important than Duffy's was the Young Irelander's booklet, *The Spirit of the Nation*, by writers of *The Nation* newspaper. The first publication appeared in 1843,

[119] ibid., 77
[120] from The Nation (1843), ibid., 77
[121] from L.A.G.Strong, The Minstrel Boy, ibid., 77
[122] Thomas Davis (1845), ibid., 79

and a new series of songs was issued at the end of 1844. The purpose of this new collection was mainly to reach the poorer classes, who so far had remained faithful only to their own broadsheet ballads. The 'nonsense' of these street ballads was to be replaced by the literary songs of the Young Irelanders. Despite the fact that a great number of these new songs were printed and passed around on broadsheets, the influence of the ordinary broadsheet ballads of the 1840s was hardly affected by this more sophisticated material. The influence of these songs, thus, was not immediately apparent and was yet to emerge.

At the turn of the century, W. B. Yeats made the following observation: 'When our modern movement began, it attempted not only dramatic literature but new popular songs.'[123] Popular street ballads now became a thing of the past, and the new songs aimed at maintaining traditional patterns and simplicity while exploring new forms. It is worth noting that there was one symbol appearing frequently in Yeats' poetry at the time.

The 'rose' motif became very popular throughout Europe, representing perfection, love, and religion. In Ireland, there was a significantly different meaning associated with this symbolic motif. Here it represented a woman with dark hair—Róisín Dubh or Dark Rosaleen—who personified Ireland. The rose was also regarded as a flower that stood for Ireland, or for freedom. Sometimes it also was interpreted as a Marian symbol, and thus stood for Catholicism. Then again, it could also be associated with quite the opposite, as a symbol for hatred, because the rose was also the emblem of England. This association predominated in the nineteenth-century street ballads: 'Viva la, the rose shall fade, And the shamrock shine for ever new!'[124] However, it would be false to assume that this symbol had a huge impact on the popular political song poetry of the nineteenth century. While it was first used as an essential motif in Anglo-Irish patriotic literature, it is only today that this symbol is generally accepted in poetry and songs. As an allegory of faith, another flower was used as a symbol for Ireland at the end of the eighteenth century. The lily was referred to in a song by Mary Tighe.

[123] W. B. Yeats ibid., 83
[124] excerpt from 'Clare Dragoons', ibid., 85

After withering in wintry storms, according to the author, it would blossom again when tears would bedew it.[125]

According to Zimmermann, Yeats believed that the collecting and writing of songs could 're-awaken the old imaginative culture distributed among the people.'[126] In addition, he was rather convinced that some of his songs in the old rebel style, like 'Come Gather Round Me Parnellites' or his self-proclaimed 'ferocious ballad' called 'The Forged Diaries of Roger Casement', would be adopted by the younger generation and enter the national repertoire of folk songs after his death. Yeats' ballads, however, were still not comparable to ordinary ones distributed on broadsheets. Although he revived simplicity and made frequent use of borrowing phrases and tunes, the popularity of his ballads soon declined.

As far as the evolution of Irish patriotic literature is concerned, there is little doubt that the two trends, popular and literary, remained rather separated until the second half of the nineteenth century. It was only when the lower classes became more conscious politically that they looked for appropriate material in the canon of patriotic poetry of learned origin. By the end of the nineteenth century, songs by patriot writers became more prominent and, thus, some of the themes were gradually accepted as truly popular.[127]

Returning to the subject of political ballads from the late eighteenth and early nineteenth centuries and their survival, Zimmermann argues that some of these political songs have rather been out of favour for some time. They belonged to a 'sensitive area', and according to the same author, a number of people hoped that they would soon be forgotten.[128] McCann, on the other hand, is convinced that the political ballad, because it is part of a written tradition by acknowledged authors, is still of major relevance today. Through continuing connections between music collectors, popular music, politics, and political balladry into the

[125] ibid.
[126] ibid., 83
[127] ibid., 86
[128] ibid., 2

next century, the political ballad was able to establish itself as the 'prime element of national popular culture.'[129]

> The ballads performed an indispensable function for the freedom-fighters of Ireland and their supporters, giving them courage to continue, warming their hearts in bitter times, and, above all, keeping their hopes alive. Without the ballads, there might not have been the same continuity of aspiration the same steady stream of young idealists the same unending attrition. [130]

Going hand in hand with the developments of the Gaelic revival at the end of the nineteenth century, Douglas Hyde, first president of Ireland, believed that a new Irish nation had to be built 'by reforging the cultural continuity of our past history . . . The matrix of the Irish people is the Gaelic tradition and in this mould they must be cast.'[131]

[129] McCann 1995, 57
[130] Whitfield in Rolston 1999, 33
[131] in McCann, 1995, 62

The following section will examine the present situation of Irish traditional music and song. Is the musical heritage of the Catholic community still recognized and supported by the public in the North? Do old traditional songs still feature in the repertory of Ulster musicians today? To what extent is the Irish songwriting tradition still alive? Finally, in what way did the outbreak of the Troubles in the late 1960s affect Irish traditional music in the North?

1.2. The Green Tradition Continues

Introduction

> The Irish are very proud of our cultural heritage and I wish
> and hope for further recognition for our music, songs, poetry,
> film, and all forms of Irish art in the twenty-first century.[132]

As far as Ireland's traditional music and song are concerned, one could
argue that there is, in fact, a greater richness and variety in Ulster than
in the rest of the country. One major reason for this is that, over the
years or even centuries, it has absorbed the richness in melody and lyric
from the Scottish tradition. While until the 1950s the cultural elite
in Northern Ireland more or less ignored this musical heritage, public
awareness and support for traditional music and song grew in the late
1950s and 1960s. After being diminished in the 1970s and 1980s,
mainly because of political instability and the impact of violence, it is
now becoming more popular again.

In his article 'Traditional Music and Song', songwriter and BBC
broadcaster Tony McAuley points out that some quarters in Northern
Ireland still perceive traditional music and folk song as 'cultural
appendages of nationalist and republican politics.'[133] In fact, with regard
to traditional songs, there has been a general tendency by the audience
to start disliking older ballads. Although traditional music survives
in some homes as a normal social outlet, Irish folk song collector Tom
Munnelly believes that old songs, and in particular old ballads, are being
discriminated against. Irish traditional singers used not to care about
the origins of a song: 'A good song was a good song: beginning, middle
and end of story.'[134] Today, a form of sectarianism seems to have crept
into the choosing and performing of songs: 'Nowadays if you are singing
traditional songs you are perceived by a lot of people to be making a

[132] Paddy Moloney in Logue, 2000, 183
[133] Tony McAuley in Carruthers, 2001, 171
[134] Munelly in McNamee, 1992, 18

political statement . . . people no longer feel confident with these older songs.'[135]

The term 'Fenian music' has often been used by the Protestant community, especially since the Troubles worsened and Protestants became alienated after the 1960s. Before that, it was rather common that people from both communities supported traditional music and song and went to the clubs or attended the various county *fléadhs*. Soon, however, it became obvious that the music was regarded as an extension of Catholic's cultural and political identity, and musicians of the protestant community who wanted to play traditional music were soon faced with a dilemma. Various musicians from the North who performed regularly in traditional clubs and pubs in Northern Ireland throughout the 1980s and even early 1990s described and confirmed the following scenario repeatedly. Every time members of the Irish Republican Army (IRA) entered such musical venues, the performing artists were requested to play the Irish National Anthem and other Irish rebel songs such as 'Sean South' instantly. Musicians were under severe pressure to know and to be able to play the requested numbers. Especially those from the Protestant community who wanted to continue playing in such venues had to adapt very quickly and learn these songs, as they were obviously not part of the musical tradition they had been brought up with. Any failure to perform this music easily revealed their Protestant identity to the IRA, with consequences that need not to be elaborated upon any further here.

As a protest against the introduction of internment in Northern Ireland, the governing body in traditional Irish music, Comhaltas Ceolteórí Éireann, decided to cancel the All Ireland Fléadh Cheoil (Festival of Music) in 1971. Thus, the situation was made much worse, and the inevitable result was that traditional music was soon dragged right into the political turmoil of the Troubles. The worst, however, was yet to happen. The loyalist terror group, the Red Hand Commando, threatened to blow up any hotel or pub in the Newtownards area[136] that allowed musicians to play traditional music. Although after an immediate outcry this threat was soon withdrawn, the message was

[135] ibid.

[136] northern part of County Down

nonetheless clear to all musicians who played traditional music, and it left no doubt of how they were perceived by some. This event clearly revealed how this unique and important cultural resource had been manipulated and misunderstood.

In the 1990s, local television stations were still reluctant to broadcast programmes featuring traditional music. According to Tony McAuley, there was far too little on the local stations that did justice to the vast amount of talent within the world of traditional and folk music in Ulster.[137] The situation was different in the 1970s and 1980s when, especially the BBC, broadcast a great variety of series featuring traditional and contemporary folk music, such as *Folk Weave, One Night Stand*, and *As I Roved Out*. The latter, produced annually from 1976 to 1988, was probably the most important as it provided the sorely needed platform for many of the emerging talents. Many artists who are now part of the iconography of Irish music featured in the series or even made their television debuts: Planxty, the Bothy Band, De Dánann, Mary Black, Maura O'Connell, Arty McGlynn, Paul Brady, Andy Irvine, Davy Spillane, Kieran Goss, Frances Black, and Enya. It was also the programme's achievement to present the Chieftains and Van Morrison in concert shortly before its final broadcast in 1988.

Irish music has come a long way since. In 1993 all of the BBC programmes on traditional music had come to an end. At the same time, however, Irish and Northern Irish traditional musicians and singers were touring the world. Riverdance contributed to the already increasing international popularity and placed Irish music on the world stage. Although in the Republic of Ireland the music is now regarded as a key cultural resource and rather well promoted, the musical situation in the whole of Ireland up until the late 1950s was rather different. The music was then perceived by the younger generation as rather old fashioned; therefore, the playing of jigs, reels and hornpipes was seldom heard. The *céilí* dancing with its rather rural image was in decline and was never able to fully recover. (A céilí is a traditional Irish gathering for the sharing of music.) The Irish song tradition suffered and went into

[137] McAuley in Carruthers, 2001, 172

decline too. From time to time one could hear patriotic songs, but the real tradition of balladry was rarely heard any longer.

Despite these developments in Ireland and Northern Ireland in the 1950s, the American folk revival soon enabled Irish traditional songs to become popular again. At the forefront of the then newly emerging Irish ballad boom were the Clancy Brothers and Tony Makem.

> In Belfast traditional music was a growing phenomenon amongst young and old alike; in addition to small informal sessions, occasional céilís were organised in places like the International Hotel. The Ulster Hall became a regular venue for the Clancy Brothers and the Dubliners. When Luke Kelly of the Dubliners was in Belfast, he always turned up after his gig at whatever social event was on, and he was happy to play benefits for Belfast republicans. Billy McBurney ran a pioneering record company in Smithfield Market, recording the McPeakes, Eugene McIldowney, Sean Maguire and others, as well as some Orange bands and some interesting little collectors' pieces of traditional songs.[138]

It was, however, mainly the achievement of Seán Ó Riada to enable the revival of the ballad boom and to transform the status of Irish traditional music in the 1960s. In 1967, Ó Riada was nominated Composer of the Year at the Belfast Festival.[139] Like no other composer, he immersed himself in the oral tradition of Ireland, and he responded to the great challenge that was presented to Irish music in the twentieth century. There is a far reaching aspect about Seán Ó Riada's work; contemporary, folk, classical, and rock musicians of recent years who are interested in working with Irish idioms regard him as a very creative source. Among Irish people in general, Seán Ó Riada is often regarded as the person to whom they owe the restoration of their nation's music. In the 1950s, the status of traditional music in Ireland was rather low, and it was mainly confined to the rural areas. Ó Riada set himself the task of reviving Ireland's musical tradition and reintroducing Irish people to it in a more meaningful way.

[138] Gerry Adams, 1996, 80
[139] in Tomás O Canainn, 1996, 16

He achieved his goal of reintroduction by putting the music in the same sort of atmosphere as classical music; namely, in concert or on stage even though that sort of presentation hardly suited the music itself.[140]

In 1960, Ó Riada wrote the music for the film *Mise Eire*, a documented history of Ireland's progress from British colony to nation state. The film and the music were overwhelmingly successful, and even raised the status of Irish music amongst a section of society that had not had any interest in Irish music before. Along with his success with traditional music, Seán Ó Riada also had a major impact in the church music of Ireland. After 1964, he composed three masses in Irish based on the *Seán Nós* singing tradition, a highly-ornamented form of singing in Irish or English, often without accompaniment: 'By providing liturgical music of this kind, he ensured that the cadences and idioms of traditional singing remain familiar to Irish ears.'[141]

Ó Riada's achievements were many, though there might be one which outshines all other aspects—he raised the status that traditional music enjoys nowadays again. He was able to demonstrate to the younger generation that there is an energy and spirit in Irish music that equals what popular contemporary music has to offer, and in that way, he secured the survival of the old traditions.

A vital factor in reviving the ballad boom was also the introduction of television to many Irish homes around that time. The Clancy Brothers and Tommy Makem had created a huge audience for Irish ballads in the United States and London. By the time they made their sensational return to Ireland, people at home had already been made aware of their international success by the established national television. According to social anthropologist and traditional musician Gearóid Ò hAllmhuráin, after only a few days, the legendary street rhyme, 'I'll Tell My Ma', was sung by every schoolchild in Ireland.[142]

[140] see Nuala O'Conor, 1991, 93
[141] ibid., 98
[142] in G. Ò Hallmhuráin, 1998, 129

Throughout the 1960s, the ballad boom was nurtured and intensified through emerging and now legendary groups such as the Dubliners, the Wolf Tones, the Johnstons, and the Fureys who frequently could be heard in the so-called singing pubs of Ireland.

> This was a time of a great revival of interest in traditional music, which was well represented in impromptu sessions in the lounge. Ballads provided the staple fare here, and amongst those who played in the place on occasion were Ted Furey, father of the Fureys, and members of the Dubliners. Some people sang quiet republican songs, like 'Henry Joy', but in general the ballad-singers avoided party songs as such, favouring instead good northern songs like 'Slieve Gullion Brae'. Some, like Pronsias MacAirt, sang in Irish, commanding complete silence and rapt attention from their audience.[143]

Inspired by Raidió Teilifís Éireann (RTE), the public service broadcaster of Ireland, broadcaster Sam Hanna Bell devised a series for BBC Northern Ireland called, *Listen Here Awhile.* This programme was broadcast monthly until 1968 and included singers and players from every county in Ulster. The recording industry, which had begun in the late 1950s with the Gael Linn 78-rpm recordings, was prospering in the 1960s too. Back in 1960, the first LP of Irish traditional music, *All Ireland Champions*, was recorded.[144] Folk clubs soon sprang up, such as The Old House in West Belfast, which was always crowded for the regular evening sessions.

Toward the end of the 1960s, however, it was not possible for the music scene to continue and to flourish as it had previously done. Due to new political developments and sectarian murder attacks, folk clubs stopped promoting Irish music. Belfast's city centre became a kind of no man's land, and The Old House, formerly the centre of traditional music in the North, was demolished. By the 1970s traditional music and song were confined within a cultural ghetto:

[143] Gerry Adams, 1996, 63
[144] in G. Ò Hallmhuraín, 1998, 129

Irish music, dance and song were involved in maintaining boundaries as well as in a battle of legitimacy, seeking at most full Irish independence, at least, parity of esteem. These battles were of course fought on grounds other than cultural. Over time, as a consequence of coercive legislation, reprisal policies against the entire Catholic community, sectarian practice in relation to the franchise, jobs and housing, and workplace expulsions, resistance was worn down and Irish Catholic culture in Belfast became ghettoised.[145]

Although it had been ghettoized, Irish traditional music, dance, and song survived. Ever since the 1994 ceasefire the traditional Irish music scene in the North has gradually recovered and headed with full steam into the new millennium, bringing along a new generation of very talented musicians. If recognized as a significant way to attract visitors to Northern Ireland, these developments could, in fact, have been very beneficial. Unfortunately, however, Northern Irish local councils have so far failed to promote this art properly. In comparison to the situation in the Republic, the support is very weak in Northern Ireland. Traditional music is more or less limited to just three institutions: the Belfast Folk Festival, the Belfast Festival at Queen's where folk club concerts are held every year during the festival period, and finally the Arts Council. Two members of the Arts Council, Michael Longley and Ciaran Carson, should be commended. Their efforts to promote traditional arts were very effective, especially at the time when obstacles were almost insurmountable,.

In the following part of Chapter III the continuation and development of traditional music and song from the 1960s up to the present will be examined. To a great extent, social interaction in the North has involved the ability to read the signs. With the help of this practice, once described by Burton as 'telling',[146] it is possible to either identify targets for sectarian attack or to initiate the much more acceptable strategy of avoidance: 'When used beneficently these practices allow people to interact amicably

145 May McCann, 1995, 65
146 Burton 1976, ibid.

but superficially, avoiding the fundamentals of religion and politics.'[147] According to McCann, it was through the beneficent use of this avoidance strategy that peaceful cross-community interaction was made possible in the North. The emergence of the folk revival movement in Belfast in the 1960s clearly reflected this mode of social interaction.

The 1960s Ulster Folk Club Scene

> It is suggested that the folk revival of the 1960s in Belfast provided a social context in which young Catholics and Protestants could interact within a shared cultural framework.[148]

Between the late 1950s and early 1960s, a number of significant sociopolitical developments took place in the Republic of Ireland and Northern Ireland. In the south these have to include the armed IRA Border Campaign (1957–1962) and Seán Lemass' succession as *Taoiseach* (prime minister of the Republic of Ireland) in 1959. According to his new economic policy, protecting native industry was no longer effective. Attracting foreign investment was, therefore, to be favoured. The trade agreement, signed in London in 1960, paved the way for subsequent cross-border economic talks. In the North, talks were held between the leaders of the Ancient Order of Hibernians and the Orange Order. Additionally, an organization for reform was set up by a group of Catholics, which, 'while maintaining aspiration for a united Ireland, accepted the Northern Ireland constitution and condemned violence.'[149] The British 1947 Education legislation had a major impact on social and cultural developments at that time. While the course was set for a permissive society, nationalist and republican political culture continued even if only at a minimal level and enabled traditional nationalist and Catholic musical culture to continue.

[147] ibid.

[148] ibid., 52

[149] ibid., 66

At the same time, youth subcultures emerged inventing their own new musical expression. Influenced by mass media and American and English popular culture, the younger generation were no longer inspired by their parents' cultural and political pursuits. Young Irish Catholics in particular regarded the Irish world as something that had to be rejected, as it was too much associated with parental as well as clerical control and archaic politics. International culture, anti-nuclear movements, and other progressive political movements offered a new platform for inspiration.

The strategy of avoiding sensitive political issues, which had enabled a peaceful sectarian practice until 1969, was also well reflected in songwriting during that time. It was through the apparently apolitical nature of folk songs that an oasis of non-sectarian music-making could be created in Belfast. The emergence of the British and North American folksong canon had a major impact on the extension of the repertoire and the creation of a new sound. McCann describes the new repertoire of songs as follows:

> There were songs from different countries and in different languages. Political songs also made up a significant proportion of the local repertoire. They included Woody Guthrie ballads and McColl's political songs. There were workers songs of protest and resistance and contemporary protest songs against nuclear weapons and war. Nationalist songs from Wales and Scotland were also sung. [150]

Belfast, with its linen mills and shipyards, was, at the time, the most industrial part of Ireland. Nonetheless, sectarian politics constituted an obstacle which kept the labour tradition from developing appropriately. McCann argues that, as a result, the songs that were written in this tradition were more likely to be political or sectarian.

Increased unemployment in the Belfast shipyards was reflected in the song 'The Islandmen'. Another song, 'Fishers of Lough Neagh', was about a contemporary campaign for the rights of local fishermen,

[150] ibid., 67

supported by the Communist Party and the new Left Irish Republican Army at that time.[151] Except for musician and broadcaster David Hammond's 'Sir Edward Carson's Cat',[152] sectarian street songs were hardly sung. The same can be said about songs of the Irish rebellion, the only exception here being the occasional rendering of writer and songwriter Domnic Behan songs.

It was fundamental to the whole concept of the folk revival to acknowledge the value of the culture of the common people. In other words, the culture of industrial workers, as well as that of the rural folk, was equally important. Specific venues, such as nationalist or republican clubs and venues used by the Communist Party, emerged. Young socialists also ran a number of folk clubs.

In this way, political groups and individuals were able to express their political views in song in a safe environment. In addition, the emergence of such venues contributed to the expansion of the song repertoire. According to McCann, politics and folk songs coexisted amicably at the time, and to mutual benefit. The political nature of these venues was only revealed as such when announcements about forthcoming meetings were made.

Non-aligned folk clubs, on the other hand, put a clear emphasis on the music instead of politics. The songs included political undertones, but because of the mixed political and religious nature of their participants, their significance was rather constrained.

In general, all of these folk clubs were primarily singing events that focused on the performances themselves rather than supporting the concept of playing in a session. The democratic structure of such events also enabled the singers to expose their true beliefs.

> The songs, for the most part, did not accord with academic definitions of folksong, and their accompaniment and manner of performance were not traditional. The preference

[151] see ibid., 69

[152] '...who sat upon a fender, and every time he saw a rat he shouted; 'No Surrender', ibid.

in folk clubs was for unaccompanied singing of ballads, 'the big ballads,' 'the lyrical songs and later ballads' and sea shanties. Young Irish men and some women sang in accents which imitated the great names of the revival in England and the united States: Ewan McColl, A.L. Lloyd, Peggy Seeger. [153]

Epitomized in the Ulster Folk Music Society, the folk club movement in Belfast modelled itself on the folk revival clubs in England. The Singers Club in London, in particular, ranked as one of the most famous, and soon Belfast and London benefited from a relationship of exchange. It is equally important to note that the religiously mixed youth culture, which was rather internationally oriented, and the older world of Irish Catholic traditional culture co-existed amicably back then. Finally, as far as both the nationalist and Protestant identity are concerned, the folk revival offered an alternative escape route:

> In some ways the folk revival's apparently apolitical stance in relation to Irish politics provided an escape from an identity based on nationality and religion for both Catholic and Protestant youth. For Protestants, there was also a new opportunity to tap into a cultural heritage, British, and ultimately Ulster—an Ulster cultural heritage significantly different from that provided by the Orange Order, which, at this time, was just beginning to lose the support of more liberal unionists. [154]

McCann suggests that it could also be understood as, 'a short-lived opportunity for a progressive, educated middle-class minority of Northern Ireland Protestants to claim/construct a British and ultimatively [sic] Ulster folk heritage/culture distinct from the triumphalist street band culture of Orangeism.'[155] Progressive young Catholics on the other hand, McCann continues, were offered 'a transitory alternative to a nationalist-imbued traditional culture.'

[153] ibid.
[154] ibid., 68
[155] ibid., 52

Developments in the 1970s and 1980s

During the 1970s and 1980s, there was a major shift in the way Irish music was perceived all around Ireland. Irish traditional music had then migrated beyond its former communal settings. Suddenly Irish music became a product that could be sold on a commercial basis. Traditional musicians soon became marketing icons for the Irish tourist industry. Although some musicians continued to perform in kitchens or small halls, the majority now took to the stage in theatres, halls, community centres, and television and radio studios. McAuley argues that some soon earned more money in a short period of time 'than their predecessors would have earned in a lifetime.'[156] The seventies produced some outstanding bands and solo artists,[157] both north and south, and saw the creative interaction between diverse musical forms—traditional, blues, folk, country, and rock. It was also a time of folk and traditional music festivals.

The singing group known as the Chieftains, founded in the seventies, retained the most traditional profile and were the first stars of traditional music. They were the first Irish folk ensemble to be named 'group of the year' in the *Melody Maker*, a weekly music newspaper published in the United Kingdom. They were the first band to play in the Capitol Building in Washington DC, and they were the first Western musicians in history to perform on the Great Wall of China. They were also the first Irish group to win an Oscar. Talking about the continuity of their success, Chieftain founder and leader Paddy Maloney explains: 'We let the music speak for itself.'[158] Besides playing reels and jigs, the band also played slides, mazurkas, and slow airs. The difference now was that the audience had paid and was willing to sit down and listen to Seán Ó Riada, who always told them something about the song they were about to hear. The group's instrumentation included two fiddle players, a flute player, a harper, a *bodhrán* (Irish drum) player, and a piper. Paddy Maloney's great reputation is reflected in Seán Ó Riada's words. He believes that Paddy Maloney is, 'one of the most gifted pipers in

[156] McAuley in Carruthers, 2001, 177
[157] highlighted when first mentioned in the following chapter
[158] in Bill Meek, 1987, 9

Ireland.'[159] A unique aspect of the Chieftains' achievement has always been the emphasis on instrumental music:

> Their mission was to spread the sound of the instrumental tradition. In doing so, they opened up new geographic territory which benefited other Irish musicians following many different musical trends.[160]

In 1998, the Chieftains celebrated their thirty-fifth anniversary. Unfortunately, the group was short one member for their fortieth anniversary; Derek Bell, outstanding musician and very talented harpist, who had been with the Chieftains for many years, passed away in October 2002.

A great number of young groups followed the Chieftains and demonstrated to people at home and abroad that Irish music and song was indeed excellent and varied. Musicianship and skill soon reached unprecedented levels and led to the development of new sounds, new methods of presentation, new line-ups, and even fresh interpretations of old material. At last traditional music became a part of culture again, and a quickly growing number of young musicians were extremely motivated to learn how to play.

In 1970, a young group emerged from Donegal. They were all related and played regularly in Leo's Bar near Gweedore. Their name, Clannad, was derived from Clann as Dobhair—the family from Gweedore.[161] A characteristic feature of Clannad's music was their mixture of Irish traditional songs with jazz, classical, and folk styles. In addition, their unique vocal arrangements and adaptations of Donegal songs were remarkable, as was their unmistakable sound from the instrumentation they used—double bass, silver flute, harp, bongo, and synthesizer. In 1970, Clannad won first prize at the Letterkenny International Folk Festival[162]. It was also their great achievement to bring Irish songs to

159 S.Ó Ríada in Nuala O'Conor, 1991, 142
160 Bill Meek, 1987, 11
161 see McAuley in Carruthers, 2001, 178
162 see ibid.

international attention. In 1982, Clannad composed and performed the signature tune for the television series, *Harry's Game*, which took them to the top of the British recording charts. Two years later, the group's youngest member, Enya, left the band to start her own solo career. In 1986, Enya achieved celebrity status with her debut solo release *Enya* (later remastered as *The Celts*), the soundtrack album for a television documentary series, *The Celts*. She was the first solo artist who used Irish as the first language with great success. Like no other Irish artist, Enya also succeeded in 'merging the mystique of Ireland with the mysticism of the new age style.'[163]

Soon other musicians followed the success of Clannad and Enya. Skara Brae from northwest Donegal released a very influential album of native songs in 1972. Singing in a rather contemporary style, they were also 'among the first to put guitars and Beatles-style harmonies to old songs from the Gaeltacht'[164] (Irish-speaking region). Then there were Four Men and a Dog whose music remained fairly traditional. Founder, fiddle, and banjo player Cathal Hayden (from County Tyrone) contributed to the high energy and driving style of the band's music. Arty McGlynn (from Omagh , County Tyrone) featured on their first album, *Barking Mad*. After several changes in the line-up, the band members dispersed to go their individual ways. Arty McLynn, however, remains one of the best and most-influential musicians ever to emerge from the North of Ireland. Making his first public appearance in a television programme alongside singer-songwriter Paul Brady, who was then pursuing a solo career, McGlynn soon gained the reputation for being 'the world's best interpreter of traditional Irish music on guitar.'[165] His first solo album, *McGlynn's Fancy*, was released in 1980, and according to McAuley, 'must rank as one of the defining recordings of the last thirty years.'[166]

Paul Brady, originally from Strabane and a guitar player and singer with the Johnstons, soon started his successful solo career. The Johnstons

[163] see Watermark in Rolston, 2001, 52
[164] McAuley in Carruthers, 2001, 179
[165] ibid.
[166] ibid., 181

had been very successful with their repertoire of traditional ballads and contemporary folk songs. They broke up in 1974, but are still well remembered: 'I think that the Johnstons were really the first group . . . to bring Irish singing to the population of Ireland since the Clancy Brothers.'[167] Paul Brady subsequently teamed up with singer-songwriter Andy Irvine, and their joint album, *Paul Brady and Andy Irvine* (1976), became a 'milestone in the maturing of the folk tradition.'[168] The album included some songs that had so far been unknown to the general public. Among these were some taken from Irish folk song collector Sam Henry's comprehensive collection of Ulster songs, which the artists arranged in a radically different style. Brady's following solo album, *Welcome Here Kind Stranger*, further demonstrated his ability to bring new life into old song material and thus inspire other singers into trying a similar approach as well. Brady can be regarded as both an innovator and a preservationist. His creativity and sheer energy are well reflected in songs like 'Arthur Mc Bride', 'The Lakes of Pontchartrain', and 'The Homes of Donegal' to give just a few examples. Chapter VI will examine his mesmeric song 'The Island' in detail, as it clearly reveals the singer's interest in reflecting on the Northern Irish Troubles in his own words.

In 1974, Paul Brady became a founding member of Planxty and played with them until their first break-up in 1975. Doubtless, Planxty was one of the most important and innovative bands at this time. Their instrumentation consisted of bouzouki, mandolin, guitar, and pipes. Songs of other singers, especially traditional singers, and songs from old song collections were their sources. They became known for segueing from a vocal number into a traditional dance tune, which was a very new idea at the time. Another innovation was the introduction of the bouzouki to Irish music. The Irish bouzouki was adapted from the Greek bouzouki in the late '60s. Unique in its talent and its choice of material—Irish, English, American, and Balkan—Planxty was, in fact, the most influential group to appear in Ireland since the Chieftains. It was also one of the few groups who were willing to tour the North at that time.[169] The identifiable sound of this mainly song-based band

[167] Paul Brady in Nuala O'Conor, 1991, 143
[168] McAuley in Carruthers, 2001, 181
[169] see ibid., 182

derived from Christy Moore's unique vocal style. Moore is regarded by many as Ireland's most popular folk singer of the last three to four decades. Without a doubt, he has, more than any other Irish folk singer, tackled the most controversial subjects in the fields of politics. In regards to Northern Ireland, he has reflected on the prisoners' protest in the Royal Air Force station at Long Kesh, the strip-searching of women in Armagh jail, and the 1981 hunger strikers. In addition, he has recorded two songs, 'I wish I was back home in Derry' and 'McIlhatton', both written by hunger striker Bobby Sands.

The early seventies also saw the formation of The Dubliners, with their typical balance between traditional music, which had a rural root, and the songs that rather belonged to urban folk. The raw hard quality of the voices of Ronny Drew and Luke Kelly gave the band its characteristic sound. Two different but complementary faces of Irish folk music were presented through Planxty and the Dubliners:

> Planxty experimented with song arrangements, instrumentation and accompaniment. They looked for new ways to present old material . . . The Dubliners' traditional arrangements did not stray from standard presentation, but their singing style was unique as were their collective and individual personalities.[170]

As far as instrumental music is concerned, The Bothy Band has to be mentioned here. Established around 1975, it became the most popular traditional band in Ireland within a short period of time. Their arrangements of instrumental music were very successful. Donal Lunny, musician and arranger with connections to the counties of Donegal and Fermanagh, was their musical guide and continues to have an enormous influence on musicians today. The Bothy Band had strong Northern connections with players such as Tommy People, Tríona, and Mícheál Ní Dhomhnaill and was a powerful force for change. There was a gradual drift later in the 1970s away from the old Clancy Brothers and Dubliners style of ballad performance. Thus, bands like The Bothy Band as well as a group called

[170] Nuala O'Conor, 1991, 137

81

Dé Danann started to become very selective, more cautious and more self-critical in their approach to Irish traditional music.

Dé Danann, which was Galway-based also founded in the 1970s, became famous for their driving, energetic style. Besides including the bouzouki as Planxty had previously done, they were also admired for their brilliant melodic arrangements of dance tunes. Mary Black, Dolores Keane, and Maura O'Connell, who later went on to have successful solo careers, all began as singers with Dé Danann. Elanor Shanley, with her fine singing of traditional and popular ballads, continued with Dé Danann over the last few years.

Moving Hearts, set up in 1981 by Christy Moore, was another milestone in the recent development of Irish music. The band leaned heavily towards the instrumental, although it is impossible to ignore Christy Moore on vocals. 'A Moving Hearts' gig was a heady mix of old music with a beat that had the audience on its feet for most of the gig.'[171] They created an identifiable Irish modern sound with their combination of jazz, traditional, and folk music styles.

Following in the footsteps of Clannad in winning international acclaim was Altan, formed by Frankie Kennedy and Mairéad Ní Mhaonaigh in the late 1980s. Most of their songs are in Irish, while the tunes are of both Irish and Scottish origin. Promoting the musical culture of Donegal, Altan is still one of the best-known Irish groups playing traditional music at present.

> Altan and Clannad are unique—no other groups with Ulster connections have come close to achieving similar success at an international level, and no other groups have displayed their individuality and originality in combining the 'sean-nos' or old style and the new age.[172]

[171] ibid., 146
[172] McAuley in Carruthers, 2001, 179

The Survival of the Ulster Song Tradition

The Ulster song tradition, although it is still healthy, is nowadays often described as having taken a back seat as a result of the ever-growing popularity of the playing tradition. McAuley argues that there no longer seems to be the same enthusiasm for the folk song as there was perhaps thirty years ago.[173] There are various reasons for this development. First of all, folk clubs in Northern Ireland, once such a dominant scene for great traditional music and song, no longer exist to any significant extent. Secondly, traditional songs require an attentive audience, and it is more and more difficult to find the right atmosphere for performing, especially in pubs where the noise level challenges singers to make themselves heard. Referring to the Irish language song tradition, radio and television producer Cathal Goan argues that there is often an extensive story associated with each song. The telling of that story, even if it is done through a song, requires a social interaction, which is generally lost on the concert stage or in the pub venue.[174] Although singers seem to get better attention once they start singing, this attention regularly vanishes after a while. Traditional players, however, seem to be part of the whole atmosphere, and they are more immune when it comes to audience response. Thus, one could even give a third reason for the decline of enthusiasm for singing folk songs. Because of the attention-related situation, there seems to be an ongoing, though scarcely acknowledged, rivalry between instrumentalists and singers. Singers often find that, once instrumentalists start to play, they are hard to stop. And sometimes instrumentalists feel exactly the same way about singers. Tony McAuley explains this new situation traditional folk singers find themselves in as follows:

> This does not mean that the song tradition is in any way under threat. It is alive and it has been well served and supported by the people who cherish it, but the conditions that fostered the traditional folk songs and moved people to write them, belong to another era. The singer's art is severely

[173] McAuley in interview, Belfast, 2002
[174] Goan in McNamee, 1992, 56

challenged by the pub atmosphere in which traditional music apparently thrives.[175]

Ulster Folk Singers

It is worth noting that the 1970s saw the maturing of several fine singers in the North. A closer look at selected singers[176] from different Northern counties will prove how much alive this tradition has always been, and in fact continues to flourish even today.

Starting with County Derry, there was the exceptional singer and songwriter Gemma Hasson who recorded two albums. Having an unusually strong voice and a natural empathy with the audience, she was 'among the best in the country' according to McAuley.[177] Kevin Mitchell and Brian Mullen, both excellent unaccompanied singers and originally from Derry, now perform some unique songs from different areas of Ulster.

In County Tyrone, the Hanna family from near Coalisland was well known for their singing style. Special attention deserves Geordie Hanna, who had a remarkable store of traditional songs and chose to sing in the old unaccompanied style, rather uncommon at the time for Northern singers. Tyrone is also home of great singer Sean Donnelly who seems to make every song his own with his unique voice.

County Antrim saw Joe Holmes and Len Graham, who helped preserve the song tradition with an extensive song list resulting from the songs they collected from Northern Ireland over the years. Graham has performed with many well-known groups such as Skylark and continues to sing. He also performs regularly with John Campbell, a great County Armagh storyteller. Other outstanding singers and songwriters from County Antrim include John Kennedy, David Hammond, Jeannie McGrath, and Archie McKeegan.

[175] McAuley in Carruthers, 2001, 185
[176] highlighted when first mentioned
[177] ibid., 186

Finally, another person of major importance for the Ulster song tradition has to conclude the list from County Antrim. John Moulden is regarded as one of the most respected collectors of traditional song and has been researching material for nearly forty years. Moulden, now living in Portrush, has written and published extensively about the Ulster song tradition.

A great richness in music and song can doubtless be found in County Armagh as well. While the town of Keady is proud of its connection with Sarah and Tommy Makem, there are also many singers and musicians in the south of the country. Forkhill has produced a very fine singer and writer of contemporary songs in Briege Murphy. Briege has been steeped in the musical traditions of her home county since her childhood. Her songs are strongly influenced by the traditional folk style, but also by the country and western music that has long been very popular in the South Armagh region. She combines traditional material with her own lyrical and very observant songs. While this singer-songwriter has never released a song about the Troubles, she has always been very concerned about political developments in her surroundings. This was clearly reflected when she participated at the Citizen's Assembly held in Belfast in August 1996.[178] In 1995, the artist released her first album The Longest Road.[179] Her third collection of songs, *The Elm Wood*, was released in 2002, and once again gives evidence that Briege Murphy is a very sensitive, sublime singer and guitarist. The song 'The Hills of South Armagh' included on *The Longest Road* deals with emigration, which has remained a predominant theme in Northern Irish songwriting throughout the Northern Ireland conflict and the beginning of the peace process. The final part of Chapter VI, which deals with the songs that have been written by Northern Irish artists since the ceasefire in 1994, will therefore return to this artist and take a closer look at this song.

Len Graham, earlier mentioned, lives in Mullaughbawn with his wife Padraigin Ní hUllachain, a talented singer and songwriter herself. Mick

178 for more information on the Citizen's Assembly see Chapter IV (3. Music and Politics) and Chapter VI

179 Spring Records, 1995

Quinn, another great performer of traditional music, lives nearby, and thus sessions of music and song can be enjoyed regularly around this area. Mullaughbawn is also home to the great storyteller John Campbell, previously mentioned. Furthermore, Sean O'Boyle, who wrote various chapters on traditional music and song, lives in the town of Armagh.

Well represented in traditional song is also County Fermanagh, the county with the smallest population in Northern Ireland. Singers like Paddy Tunney, Rosie Stewart, Gabriel McArdle, and Cathal McConnell are widely known around Ulster as well.

Finally moving back to County Down, music and song continue to thrive in only some smaller areas like Killyleagh and the Ards Peninsula where there is a strong Ulster-Scot tradition. Dedication and consistency, however, have been shown by the Downpatrick Folk Society and especially by founding member Pat Connolly. Portaferry near Strangford Lough is the home of talented singer and songwriter Rosemary Woods, 'one of the best writers of song in Ireland and, a performer with a compelling presence.'[180] While the richness of tradition seems not to be so extremely evident in this county, there is, however, one major exception. One particular group—in fact, one particular family—deserves special attention, and will therefore conclude this chapter on Ulster folk singers.

The Sands Family from Mayobridge started their career when they won the All Ireland Ballad Group Competition in the late '60s, which offered them a three-week tour of New York.[181] The Sands Family are essentially a singing group. At the same time, however, they are accomplished instrumentalists who play with sheer professionalism. Over the last thirty years, Tom, Ben, and Colum have each extensively toured through Europe, either as a group or as solo artists, and have by now each written many fine contemporary folk songs. Their blend of Irish music and contemporary songs is unique and appeals to a very wide audience. The playing of traditional tunes and songwriting, especially about problems concerning the conflict surrounding them, has always been their major concern. 'Colum is one of the few people who can write about the Troubles without his compassion or anger being

[180] McAuley in Carruthers, 2001, 188
[181] ibid.

sentimental.'[182] Songs like 'Ceasefire', 'The Last House in Our Street', (both Colum Sands) and 'Sailing through the Sky' (Tommy Sands) express how much they deal with the situation of living in Northern Ireland. Some of Tommy Sands' songs, like 'There were Roses' or 'Daughters and Sons' have become quite popular and have already entered the Irish traditional repertoire. In addition, this singer and songwriter has always been very interested in the traditional music scene of his native country. Since 1976 he has broadcast a weekly programme on folk music on the Downtown Radio station, Northern Ireland. At the same time, however, political developments at home and abroad have always had an enormous impact on his songwriting and have encouraged him to make his voice heard.[183] In the early 1980s at one of the many festivals abroad, the Sands Family met Pete Seeger. Since then, Pete Seeger has been a great inspiration for Tommy Sands' songwriting. Sands' album *The Heart's a Wonder*[184] also features the song 'The Music of Healing', which deals with the peace process in Northern Ireland and was written by Seeger and Sands together.

The Sands Family are as well known in Germany and the continent as they are in their native County Down. In October 2002, they opened the fortieth *Belfast Festival at Queen's* in the legendary Belfast Folk Club. Their songs reflect a mixture of wry Irish humour and a genuine concern for the well-being of all people: 'This planet needs more people like the Sands Family, and long may their music continue.'[185] As both Tom and Colum Sands have over the years continued to regard peace developments in the North as their major concern, Chapter VI will concentrate on their creative work and examine their song material in greater detail.

[182] James Simmons in Fortnight, 1990, 31

[183] On 13 September 2001, two days after the 11 September tragedy in New York, Tommy Sands wrote a new song. A week later, he recorded the song 'Time for Asking Why' and sent it as an e-mail attachment to numerous friends, fans, and colleagues in the music business. This is a direct reflection of the broadsheet tradition of songwriting in Ireland, only now modernized in the form of an e-mail attachment, are still written and passed around. This is exactly what being a songwriter is all about. Whenever historical, political, and social events cry out to be understood and explained, there are still people who do sit down straight away and express their feelings in song.

[184] Green Linnet, 1995

[185] Phonsie Travers in interview, Ballyshannon, 1997

Keeping the Tradition Alive

Until rather recently, Northern musicians were faced with huge difficulty performing locally. Either there were not enough venues, or the venues that existed were neither large nor popular enough to host performing artists on a regular basis. In addition, most agencies that specialize in promoting traditional music are still mainly based in Dublin. Thus, many talented musicians missed out on financial and artistic rewards. During the darkest hours of the Troubles, McAuley argues, it was the amateur musicians who kept the musical tradition alive in the North.[186] They were determined to continue playing despite existing political and social developments. So was the sparse audience determined to persevere, and in places like Belfast's Rotterdam's Bar or the Sunflower Club musicians met regularly to demonstrate but also to develop their musical skills. It made, incidentally, little difference to either performers or audience, that the Sunflower Club was in Corporation Street at the very heart of the Troubles, and according to Tony McAuley sometimes resembled post-war Berlin.[187]

However, it was through a small number of people who kept on promoting and supporting folk music in the North that this tradition was actually able to survive. The list of contributors must include Brian and Eithne Vallely, who founded the Armagh Pipers Club in the 1960s; Francis McPeake, who ran popular whistle-playing classes in Belfast; Sam Murray from Belfast, maker of the wooden flute; and Geoff Harden, who ever since moving from England in the 1970s supported the folk music in the North. The Armagh Pipers Club alone enabled about 3,000 musicians to learn their music and contributed to the great success of Northern Uilleann pipers. According to McAuley, this instrument has since been saved from near obscurity, and its survival demonstrated to everyone in Ireland 'that the North could hold its own on an instrument not traditionally associated with music in Ulster.'[188]

[186] McAuley in Carruthers, 2001, 183
[187] ibid.
[188] ibid., 184

This chapter illustrates the richness and variety of Irish traditional music and song in Northern Ireland; however, it is beyond the scope of this chapter to examine how much of this song material actually had a direct bearing on the troubled situation in the North. According to Tony McAuley, there is little worth noting in this context. Except for the enthusiastic willingness by Tom and Colum Sands to write about the Troubles directly, the same author argues that no songs of lasting merit have appeared. McAuley believes that, while the conflict has engaged poets, writers, and dramatists, remarkably few songwriters have produced anything of worth. The exceptions he gives include Mickey McConnell's 'Only Our Rivers Run Free', Phil Coulter's 'The Town I Love So Well', Paul Brady's 'The Island', Tommy Sands' 'There Were Roses', and also James Simmons' poem and song 'Claudy'. Tony McAuley has a point when arguing that recurring images like body bags, bombed streets, flags, graffiti, and funerals can no longer be recognized in most of the existing song material. According to McAuley, these images, 'have exposed the grim realities of conflict and have effectively silenced the triumphalism of songs glorifying tribal loyalty and marching men.'[189] Therefore, with peace developments making progress in the North, most of these songs have somehow lost their importance.

However, ignoring songs like these would be an error in judgement. These songs, like many others in the area of Irish traditional music, but also in rock and pop music, have succeeded in reflecting on political and social developments in the North. In addition, many of the songs that were written by Northern Irish songwriters over the years reveal the same or similar themes and images, which clearly relate to the Northern Irish conflict. From the outbreak of violence in the 1950s and 60s to the 1994 ceasefire and the beginning of the peace process, Northern Irish songwriters have continued to reflect on their surroundings in song. Chapters V and VI will therefore explore various issues related to this subject and focus on the song material with regard to the North in greater detail.

[189] ibid., 189

2
The Orange Tradition

We swore by King William there would never be seen

An all-Irish Parliament at College Green.

So at Stormont they are nailing the flag to the mast,

May the Lord in his mercy be kind to Belfast . . . [190]

[190] excerpt from poem/song 'May the Lord in his Mercy be kind to Belfast', Maurice Craig, 1936, in Ormsby, 1992

2. 1. The Orange Tradition—An Introduction

Although songs written in the orange tradition are less numerous and might lack the romantic appeal of Irish political songs, their historical importance cannot be ignored. In comparison, these songs have been less seriously collected, and according to Zimmermann, 'express the sentiments of a stern-faced minority who tries to defend its privileges.'[191]

Orangeism began in the late eighteenth century at a time of frequent conflicts between Catholic and Protestant peasants. Soon oath-bound societies aimed at defending Protestant lives, preserving peace while maintaining Protestant ascendancy and the connection with the United Kingdom. They supported the government in 1798 against the rising and were opposed to Roman Catholicism throughout the nineteenth century. Reflecting their anger about papist tyranny, they defined 'Home Rule' as 'Rome Rule' later in the century. Throughout the twentieth century and up to the present, the Orange Order has continued to be a powerful force in Northern Irish politics. It is important to note that at present one quarter of all Protestant male adults belong to the Order, among them a large number of working people. According to Zimmermann, this is significant because it clearly illustrates the Order's fundamental opposition to class war.[192]

Music and song material by the Orange Order has always had an important impact on the conflict between Protestants and Catholics. The Catholic community soon perceived it as extremely provocative. As a result of two decades of religious wars and persecutions, sectarian feeling was extremely strong in Ireland at the beginning of the nineteenth century. While in the middle of the nineteenth century Irish nationalism was still very much associated with Catholicism, religion remained a major stimulus for Ulster Unionism as well. Orange songbooks of that time revealed the same bigotry and violence that was evident on the other side. While a number of these songs were also orally transmitted or appeared on broadsheets, the first orange songbooks were published in 1798, and especially seemed to appear in greater numbers in moments of crisis such as during the Fenian and Home Rule movements. Catholic anger was

[191] Zimmermann, 1966, 295

[192] ibid., 296

deliberately roused when the Order began to march in processions playing their songs: 'We'll fight for our country, our king, and his crown, And make all the traitors and croppies lie down.'[193]

An orange song printed in the early twentieth century reveals how provocatively intolerance was still expressed: 'Dark deeds of devilry trouble our land, Satan and Popery walk hand in hand . . . '[194]

The annual marching season in Northern Ireland commemorating King William's victory at the Battle of the Boyne is still a period of high tension in the North today. To reduce provocation and to avoid violent attacks, processions have sometimes been banned. This also had an impact on the repertoire of songs chosen for the marches. Therefore, extremely provocative songs like 'Croppies Lie Down' have now been replaced during the marches by less disturbing songs such as 'The Ould Orange Flute' and 'The Sash My Father Wore'. However, the older, more provocative songs are still part of the orange tradition's repertoire, and whenever they are sung, they retain their inciting power.

As orange songs obviously illustrate a particular symbolism, it might be helpful to categorize the themes that predominate the song material. According to Zimmermann, the five categories are ballads commemorating past victories, convivial songs, sentimental texts, descriptions of party fights, and finally songs which deal with the rituals and mysteries of the Orange tradition.[195]

Regarding ballads commemorating past victories, a great number of songs written in the nineteenth century reflect on either the Siege of Derry or the Battle of the Boyne. In 1854, for example, the Battle of the Boyne found reflection and was published in full detail in the form of the ballad 'The Boyne Water,' consisting of nineteen stanzas.[196]

[193] excerpt from 'Croppies Lie Down' (c.1798), croppies synonymous with Catholics, ibid., 307
[194] ibid., 298
[195] ibid., 300
[196] ibid., 301

While most of the convivial songs centre on the annual celebration of the twelfth of July—Orangemen's Day—sentimental songs either reflect on lamentations over deaths or on the farewells of emigrants, and both of these categories are well represented in orange balladry. These numerous songs often refer to a hero, reveal sarcasm on Catholicism, or express epic enthusiasm and delight in merciless bloodshed:

> And when we came to Dolly's Brae they were lined on every side,
> Praying for the Virgin Mary to be their holy guide;
> We loosened our guns upon them and we gave them no time to pray,
> And the tune we played was 'The Protestant Boys' right over Dolly's Brae.[197]

Songs dealing with the rituals of the orange tradition are especially worth noting here. Their often resolutely cryptic character and inspiration from the Bible are also evidenced in the following excerpt:

> But when we came up to a door and found that it was locked,
> My conductor he was standing by and gave a gentle knock,
> He knocked once, he knocked twice, the third time I did hear
> A voice that came from the inside which filled my heart with fear,
>
> Saying, What unworthy now comes here our pleasure to annoy?
> He is a true and worthy brother, for him I surely tried,
> He has been in the darkness and crossed Jordan's stream,
> And he is willing now to travel for our secret again.[198]

[197] excerpt from 'Dolly's Brae' (1849), ibid., 301
The song remembers the tragic event in County Down on 12 July 1849, when Protestants wanted to march
through Dolly's Brae Pass and were hindered by Catholics. Protected by the military, Orangemen killed thirty
Catholics in the riot that followed. (see Mulcahy, 1982, 82)

[198] from 'The Grand Mystic Order', in Zimmermann, 1966, 314

Nationalist ballads can also be regarded as some form of inspiration for an orange writer in so far as he aimed at presenting an antidote to the nationalist song material. In many cases, themes and symbols of the other party were adopted and transposed to suit the orange idea. Thomas Moore's *Irish Melodies* were for some time preferably chosen for such proceedings too. Similar to the shamrock standing for nationalism, the orange lily stood as the Order's great emblem and was celebrated in the songs.[199] Furthermore, the image of the tree was regarded as a symbol used by both traditions. Here, the orange tree or, tree of liberty, was brought over to Ireland by King William and is still waiting to bloom again:

> The winter blew severely, and the soil did not agree,
> And it blew the branches fairly off our darling Orange tree.
> Now winter it is past and gone, and summer fair and clear,
> Our Orange tree is budding in the springtime of the year.[200]

After this brief introduction, the following pages will reveal in how far this tradition is still relevant to the Protestant community in the North today. The outbreak of the Troubles in the late 1960s effected the orange songwriting tradition to a great extent. A more detailed insight will therefore be given regarding the different categories, music and song material that now characterize orange songs.

2. 2. The Survival of the Orange Tradition

Loyalist Songs

Unlike the Irish national repertoire of songs, the orange repertoire is experiencing a decline. While the archaic language of the material can be regarded as one reason for the demise, it is also obvious that a lot of situations that formerly gave rise to the songs are gradually fading out of folk memory. The third reason, according to Radford,

[199] It might be worth noting that the orange lily still stands as a symbol for loyalism today. It only blossoms once a year, usually around the 11 July, thus exactly at the same time as the annual celebration of King William's victory at the Battle of the Boyne.

[200] excerpt from 'The Old Orange Tree', ibid., 304

is a reflection of the present impact of the Orange Hall. Playing a less cohesive role within the social life of loyalists, this institution has by now also contributed to a clear change of cultural practices.[201] Poverty of knowledge and lack of familiarity is also widespread. However, some older songs like 'The Sash', 'Dolly's Brae', and 'The Orange Lily O' are still very popular. Irrespective of the age of the audience, such songs are repeated constantly, and their popularity does not seem to decrease. A techno mix of these orange songs is presented on dj F.T.P.'s *Ultimate 12th Party Mix*,[202] so that younger audiences can also become familiar with the much-loved older repertoire.[203]

Concerning the repetition of the more familiar tunes from the collective social memory, Radford suggests that a cohesion is created whenever audiences and participants are united in their 'memorialisation' and humour at the expense of the Catholic 'other'. Nonetheless, the same author argues that the interest to explore older songs does not appear to be sufficient. As far as the performance context is concerned, and in comparison to participation in music in nationalist pubs in Belfast, there is no real culture of 'collectively or individually singing Party tunes in paramilitary clubs or pubs on the Shankill.'[204] Instead, the performance venue of paramilitary songs varies. Sometimes they are played at home or at private parties; sometimes they are spontaneously sung by loyalists on buses heading towards orange events. It is important to note that in all these contexts individuals of all age groups are participating. According to Radford, even children can be heard singing paramilitary songs on outings organized by some local community groups.[205] In addition, many of the songs are also available on jukeboxes in loyalist paramilitary clubs. The loyalist folk band The Platoon is doubtless the most popular Ulster Volunteer Force (UVF) clubsound. A performance of the now-legendary Platoon at fund-raising events organized by the UVF is a guarantee for great financial support. In general, the main reason for the success of performing loyalist songs is that the music's communicative effect

[201] Radford, 2001, 85

[202] FTP = Fuck The Pope (typical feature in Northern Ireland graffiti)

[203] ibid.

[204] ibid.

[205] ibid.

provides a sense of security. Through the songs, loyalists can identify with the various identities that are symbolized in the lyrics and with the shared experiences of the loyalist community.

Loyalist songs continue to be used for political purposes and can therefore still be regarded as political weapons. It is important to understand that at any kind of performance of these songs attempts are being made 'to legitimate paramilitary activity by harnessing that ideology to Orangeism and British militarism.'[206] Radford argues that the present discourse around cultural relativism constitutes a clear danger in Northern Ireland as it is at risk of 'swamping the perniciousness of the sentiment behind the lyrics.'[207] According to the same author, recent songs continue to reveal attempts to ridicule the Catholic 'other' and even seem to have become more vitriolic in their expression. This is reflected in 'Bobby's Anthem', a song about hunger striker Bobby Sands: 'Listen, every time a screw opened the door, this is what he said to him: Would you like to try a cheeseburger, Bobby Sands?' The hunger striker is further provoked in the song with phrases such as 'Well I'm going for my dinner now, Bobby Sands. Will I bring you back a doggy bag?' and 'Would you like a wee cool can of Coke? Well you're not fucking getting one and I hope you choke.'[208]

Choosing G. Zimmermann's approach to categorizing the songs of the orange tradition according to the themes that predominate the song material, it is necessary to transform this categorization in a way that is more appropriate in terms of developments throughout the second half of the twentieth century and the continuation of that tradition today. Sectarian viciousness, tales of past battles, fear of attack, and references to the Bible that support the Protestant faith and criticize the Catholic Church continue to be the most common themes in this song tradition.

[206] ibid., 98
[207] ibid.
[208] on The Platoon, Murphy's Party CD, Track 13, 'Bobby's Anthem', Belfast 2002. Murphy's Party CD was put together by a local resident of the Shankill Road and recorded at the studios of Switch FM, involving no official record label. It was created to raise money for a young man who needed a life-saving operation, and was copied and sold in local shops in the area.

At the same time, it seems that these songs still aim at presenting an antidote to the nationalist opponent. They are less political and extremely sectarian and racist. Suggesting that these songs have thus not really developed any further throughout the twentieth century would, however, lead to false assumptions. Speaking about the continuation of the Orange tradition, George Newell, from the Ballymacarrett Arts & Cultural Society, argues that 'loyalist songs' can be regarded as an umbrella term for the four categories of songs that are nowadays part of this tradition. [209]

The most obvious category includes the vast amount of paramilitary song material that exists today. Organizations like the Ulster Defence Association (UDA) and the Ulster Volunteer Force (UVF), the two principal loyalist paramilitary organizations, or even the Red Hand Commando, have all made a great contribution to enhance the already-existing material. Themes of acts of bravery, fighting the enemy, or dying for one's country are well reflected in these songs. Past victories are commemorated in many of the songs (for example, 'Siege of Derry' and 'Battle of the Boyne'). In addition, a vast amount of this material must be regarded as extremely racist and sectarian. Images of guns and petrol bombs also predominate the song material. While the following three categories seem to have overcome this theme, merciless bloodshed, as reflected in a great variety of songs from the orange tradition throughout the nineteenth century, continues to run through paramilitary songs. As far as both melody and lyrics are concerned, it has to be said that, particularly in this category of loyalist songs, the compositional outcome is rather poor, and in many cases even lacks any form of sophistication. In her introduction to *Sounds Sectarian* on loyalist songs, Radford described most recent paramilitary compositions as 'sectarian rants full of vitriolic profanities overriding any intended humour or wit.'[210]

> I would like to be up the Falls Road now
> With a 9mm and a couple of hand grenades.
> I would walk into the first Sinn Fein office

[209] George Newell in interview, Belfast 2003.
[210] Radford, 2001, 76

Shoot the fuckers dead, blow out all their brains
Who shall separate us? Tell me who?
Who shall separate us? [211]

Oh I'll always be a Womble till the day I drop and die
As I'd hate to be a Fenian, cos they're bastards and they're sly
Oh They're all dirty wee fat fucks and they're
Two faced slimy cunts
They should be burnt out and sent to Dublin
To spend their fucking punts [212]

The first paramilitary recordings appeared in the 1970s. Since then, new material has been added each year, particularly at the time approaching the annual 'marching season' in July. While the musical quality of some of these recordings can be regarded as highly professional, a great amount of the recorded material on vinyl, tape, or CD must also be referred to as rather poor and extremely unsophisticated. By now there is a grand collection of CDs and LPs that contain paramilitary song material. The small but very profitable record industry in Northern Ireland and Scotland has contributed to making these songs more accessible and available for consumption.

The second category of songs consists of the song material that has over the years been collected and contributed by the Orange Order. Historical and biblical events feature most prominently here and help to remind the community of their rich heritage. It is through these reminders that cultural identity can be revived and re-established. Therefore, the majority of songs deal either with rituals of the Orange Order, are inspired by biblical events, or simply continue to centre around the annual celebration of the twelfth of July. One of the most recognisable songs in this respect is 'The Sash', written back in the first half of the twentieth century. Up to now, the significance of this song within as well as outside loyalist communities is unquestionable as is its potency as a 'rabble rouser' for loyalists.[213]

[211] ibid., 91
[212] from 'Join the UDA', ibid., 94f
[213] ibid., 80

For those brave men, who crossed the Boyne have not fought
or died in vain,
Our Unity, Religion, Laws and Freedom to maintain,
If the call should come we'll follow the drum, and cross that
river once more,
That tomorrow's Ulsterman may wear the sash my father wore! [214]

Arising from a rural background originally, some orange songs also reflect on this origin and express people's experience of being part of country life. The substantial number of songs from the first two categories mentioned can also be combined in the more general term *party tunes*. According to Radford, songs from both categories do also overlap and are connected in the public consciousness. According to Loyalist claims, the term *party tunes* derives its meaning from the fact that they are perceived as 'convivial songs principally composed for consumption by and within the loyalist community.'[215] As loyalist memorabilia is rather confined to limited outlets, its restricted availability seemingly justifies such claims. Regarding the content of party tunes, there are four categories that occur in the repertoire:

1. Songs commemorating battles or skirmishes
2. Songs of loyalist comradeship and brotherhood
3. Songs composed with the intention of being humorous/light hearted
4. Sectarian songs in which anti-Catholic sentiments dominate [216]

While the term *party tunes* refers to the shared material of orange and paramilitary songs, it would, however, be false to assume that there is in fact a 'trajectory that implicitly links the two genres.'[217] Despite the combined classification, it is important to clarify that some paramilitary songs are sung without being authorized and approved by the Orange Order.

[214] from 'The Orange Lark', 1987, 14
[215] Radford, 2001, 95f.
[216] ibid., 76
[217] ibid.

A variety of gospel songs form the third category. Protestant belief and biblical images are the major sources for inspiration here. While the singers of these songs are often simply described as the 'happy clappies', it is probably more accurate to sum up the expressed themes as faith, rejoicing, and freedom delivered through Protestantism.

Songs from the Ulster-Scots tradition make up the forth and final category of songs. The image of country life and people's own experience of growing up and living in these surroundings is even more predominant here than in the previously mentioned category.

> I will build my love a tower near yon pure crystal fountain,
> And on it I will pile all the flowers of the mountain,
> Will ye go, lassie, go?
> And we'll all go together to pluck wild mountain thyme,
> All around the blooming heather,
> Will ye go, lassie go? [218]

This category also includes a greater variety of rather sentimental lyrics that deal with laments concerning emigration and death. Some other songs reflect on the celebration of friendship and the remembering of good times as is evident in the popular song 'Auld Lang Syne'. Most of the song material in this particular category, it should be added, is enhanced by the great variety of instrumentation the Ulster-Scots tradition has to offer. The Lambeg drum, the fife, the guitar, and the fiddle often serve to highlight the words of these songs. In 2000, the Ulster-Scots Folk Orchestra was formed in recognition of the rich Ulster-Scots cultural traditions. On the album cover of their 2002 album, the following observations regarding the present situation of the Ulster-Scots tradition were made:

The title track ['Endangered Species'] is a reference to the belief that Ulster-Scots cultural traditions and the individuals who represent this distinct identity, are indeed endangered due to a lack of recognition and respect from the appropriate

[218] from 'Will ye go lassie go', on a clatter o fowk - A Collection of poetry, music and song from the Ulster-Scots
Tradition, album produced by FowkGates, Belfast

authorities. It seems that in today's world of globalisation/commercialisation, there is need for homogenisation of cultures and control of culture . . . The lack of interest and respect for our distinct cultural heritages, is surely a factor in today's growing indifference to family and community values, and indeed to the lack of necessary concern for the sustainability of our local environment. In this context we are all part of an endangered species. [219]

The Music

According to John Moulden, student of Anglophone traditional song in Ireland, all loyalist songs derive melodies from five sources: Irish traditional melodies, Scottish tunes, hymn tunes, British military tunes, and country western tunes.[220] The Irish traditional melodies reflect the intention to present an antidote to the vast amount of nationalist songs that exist. In many cases, both the song title and the words of such songs have been entirely transformed to support the loyalist cause. In others, however, the nationalist title remains while only the song text was changed (for example, 'Men behind the Wire'). Scottish tunes can be explained through the strong Ulster-Scots connection that exists and has deepened over the last centuries.[221] Hymn tunes like 'The Lord's My Shepherd' or 'Old Rugged Cross' reveal how melodies have also been borrowed from the Presbyterian tradition.[222]

Legendary gospel hymns like 'Amazing Grace' or 'When the Saints Go Marching In' have equally been used and set to new song texts (for example, 'East Belfast' and 'Ulster Today'). Melodies derived from British military tunes contain strong military or even battle sounds. According to George Newell, the songs in this category are often referred to as 'bloodthunder' songs.[223] The last group reflects the

[219] introduction to album Endangered Species by the Ulster-Scots Folk Orchestra, CB Productions, Belfast, 2002

[220] John Moulden in interview, Belfast, 2002.

[221] In fact, a great variety of protestant songs can actually be found on Scottish websites, for further information see: http://www.scottishloyalists.com;http://www.battlehill395. freeserve.co.uk;http://www.ulsterloyal.freeservers.com;http://www.ulsterloyalist.co.uk, 15/1/2003

[222] John Moulden in interview, Belfast 2002

[223] George Newell in interview, Belfast, 2003.

musical influence of Ulster-Scots who emigrated to particularly the Appalachian region of America. Since this emigration began in the eighteenth century, a rich cultural expression has worked both ways. While contemporary American country and folk music still reveals its historical roots (Ulster-Scots and Scots-Irish traditions), the American musical style has, over the last few centuries, also been transported back to Ireland and is thus also consciously used in contemporary songs and tunes composed in Ulster.

In listing the vast amount of paramilitary songs that have appeared throughout the last three to four decades, it is necessary to add yet a sixth musical source. While Tina Turner's 'Simply the Best' is doubtless the most commonly known, many other popular songs have since been used by paramilitary organizations as well. While in some cases (for example, Turner's 'Simply the Best') only a few lines of the original song text were altered ('fuck the pope and the IRA'), the song material of other songs was completely transformed (for example, Dylan's 'The Times They Are a-Changin'):

> Come on you young brethren and listen to me
> And pledge that your country stays loyal and free
> And step proudly forth each 12th of July
> And let Dublin know now that Ulster won't die
> (chorus)
> And if you love your country you'll stand up and cry
> That the Times they are a-changing.
> . . .
> For the red hand of Ulster, the red, white and blue are the symbols of freedom for me and for you let your watchword be courage, let the union jack fly for we won't surrender and Ulster won't die.[224]

One could argue that the different musical sources that are used in loyalist songs reflect the multiculturalism ideals of loyalism. To regard this as a healthy sign, however, would be a consideration hard to sustain.

[224] from: http://www.geocities.com/Capitol Hill/5567/ooooo3.html, 15/1/2003

Rolston argues that this range of styles rather reveals a general problem with loyalism; namely, that of defining identity.[225] Therefore, some of the songs also reveal a great incongruity. This is mainly evidenced in the common practice of borrowing existing tunes from other musical sources. Common to the folk tradition and the belief that a good tune is a good tune and should not be wasted on only one song, loyalists might have a different approach. While in the folk tradition it would not be regarded as stealing, loyalists tend to 'raid' everywhere for tunes, with a particular preference for contemporary ballads, pop songs, and songs from the republican tradition.[226] Probably one of the best examples is John Denver's 'Take me Home, Country Roads', which has been used for at least two loyalist songs. In 'Chase Them Home' the litany of suffering experienced by Unionists is expressed, while in another song, young people of the unionist community praise their home in West Belfast: 'Shankill Road, take me home / To the place I belong / West Belfast, Northern Ireland / Take me home, Shankill Road.'[227]

In the case of Loyalist songs, one could argue that this transferability of tunes is purposely applied. The effect of a song, Rolston argues, derives from more than simply the song text alone. From a theoretical point of view, Roland Barthes offers the following explanation on the subject: If a tune is regarded as a sign known to the audience (e.g., an original love ballad like 'Sometimes When We Touch') it immediately conjures up emotions and feelings whenever the audience is again confronted with that tune or sign. According to Barthes, the tune as a sign works on both

[225] Rolston, 1999, 38f

[226] for more examples and information, see ibid.

[227] 'Shankill Road', Murphy's Party CD (2002)

 'It was written and performed by a young peoples group from the Woodvale area of the Shankill although the music is from the popular song Country Roads, the words and way the song was performed has made this song a favourite around the Greater Shankill and further afield. It describes a journey from Belfast city Centre up the Shankill Road and mentions some of the landmarks of this great thoroughfare. The young people had no vocal coaching and did the whole recording in a local community radio station back room 'no fancy recording studio's required', it was with the assistance and encouragement of the SWITCH FM staff and Volunteers that the song made it to CD. The young people like so many of their forefathers before them adapted it and changed it and made it their own.' introduction on Murphy's Party CD (2002)

a denotational as well as connotational level. Thus, the aura of a song has the potential to precede new lyrics.[228] In this respect similar feelings are already created before the new song text is understood. This effect has often successfully been used in Loyalist songs. The following excerpt is taken from the song titled 'The Ulster Girl', which was recorded in 1989 by The Platoon on their CD *UVF Songs*. The song soon became very popular among Loyalists. The melody was borrowed from the popular love ballad at the time 'Sometimes When We Touch".

> Through many a bloody time of woe old Ulster's heart has bled,
> But still she makes her enemy know her spirit has not fled.
> God bless the men who for her sake their love and freedom gave,
> God bless the mothers of these sons who nursed no cowardly slave.
>
> Chorus:
> The Ulster girl is me, I'll tell it honestly
> That I'd die to keep this land of ours still free.
> And if we lost our freedom, my heart would break in two,
> And if I couldn't stay here, I don't know what I'd do.[229]

Adaptations of current or recent popular songs feature most prominently in the chosen repertoire of melodies. According to Radford this practise indicates 'the temporary and dynamic fashion in which more recent party tunes feed into and reinforce the collective social memory.'[230] The list of adaptations includes a variety of popular songs, like Tina Turner's, 'Simply the Best', Baha Boys' 'Who let the Dogs Out', and Bette Midler's 'Wind beneath My Wings' to give just a few examples.[231] In many cases, popular songs have been picked either for their suitability and transferability as marching songs or because their words could easily be modified. In addition, another suggestion as to why popular songs are favoured as adaptations is offered by Frith. He argues that, through pop songs,

[228] Barthes in Rolston, 1999, 40
[229] ibid., 29
[230] Radford, 2001, 86
[231] for more examples, see ibid., 86f. and Rolston, 1999, 39

people are supplied with 'the romantic terms in which to articulate and so experience their emotions.'[232]

Finally, as far as republican tunes are concerned, transferability is rather limited. The tune of a romantic ballad can easily transfer because of its connotations. Rolston argues, however, that a republican tune is more difficult to tackle, because it is 'carrying the stigma of its origins.' According to Cooper, the problem here lies in the fact that the melody itself functions 'as a cultural and social signifier, independent of the literary text.'[233] Before the tune can be absorbed into a loyalist song, the stigma must therefore be overcome.[234]

'I Was Born under the Union Jack'—A Closer Look at Loyalist Song Texts

> One important way in which many ordinary unionists manage
> to articulate their ideology eloquently is through song. [235]

In addressing the distinctiveness of political Protestantism, Bennett argues that orange marches, flute bands, lodge banners, and sectarian songs are 'the sum of all cultural life in that community.'[236] The sense of siege lies at the heart of loyalist ideology and is thus also well reflected in songs. Many of the songs present the 'litany of suffering' experienced by the unionist community since the 1960s: 'Burned our homes, blocked our roads in the place where I belong. / Trouble-torn, cities roaring; chase them home, country roads.'[237]

Loyalist songs clearly reflect that the siege is historic, but at the same time current too. In other words, there is nothing new about the sense of siege unionism has experienced:

> They fought and they won the battle of the Somme

[232] Frith in Radford, 2001, 87
[233] Cooper 2001 in Radford, 80
[234] see Rolston 1999, 40/41
[235] ibid., 45
[236] Bennett, ibid., 43
[237] from 'Chase them Home' sung to melody of John Denver's 'Country Roads', ibid., 46

But for Major and Dublin the fight will still go on
For God and for Ulster is cast on every breath
Of the suicide battalion of the UVF.[238]

Words like *again* and *another* feature most predominantly in the song material and clearly stress that this battle is, in fact, timeless:

Well I am a Loyal Ulster man
They say this day that I must hang
I fought those evil men
And I'd do it all again[239]

According to Rolston, loyalism regards itself as being an upholder of liberty. This liberty, he continues, rests on the two inseparable elements of Protestantism and Britishness.[240] As Unionists are under siege, and despite all differences of class, loyalism also clings to an 'ideal of unity'[241]:

Yes, we know that place they call Ulster
Where the people are loyal and true
And they fight to defend their freedom
And keep Ulster red, white and blue.

Now loyalists must be united
And fight for our protestant cause
For our fathers before thought to gain us
Our freedom, religion and laws.[242]

Rolston also suggests that the 'ultimate consequence of the siege mentality' can also be understood as what Brown described as 'the historical myth'

[238] from 'Come All Ye Young Protestants', sung to the tune of Dominic Behan's 'The Patriot Game', ibid., 46

[239] from 'Build My Gallows', on http://www.uksprite.co/search/search/Regional/Europe/United Kingdom/Northern Ireland/Society and Culture/Religious and Sectarian Conflict/Loyalism/ , 20/1/2003

[240] Rolston, 1999, 47

[241] ibid.

[242] from 'Our Ulster', track 13 on album Loyalist Prisoners Aid—1976

of 'the whole Protestant community.'[243] In a similar way, Memmi argues that loyalists claim to be the true protectors keeping the 'core values' of the British civilization—'freedom, the Protestant religion and laws'—in Ireland alive. In songs like 'Billy McFadzean' or 'Orange Wings', the sacrifice made by loyalists in order to stay British is commemorated:

> Let me tell you a story of honour and glory
> Of a young Belfast soldier
> Billy McFadzean by name
> For King and for Country young Billy died bravely
> And won the VC on the fields of the Somme[244]

> These fighting men from far and wide
> Hell towards they fought and died
> Now their sons let their fathers rest
> To guard the badge of the U.V.F.[245]

This sacrifice doubtless led to loyalist belief that Britain can be trusted and relied on in Ulster's hour of need, as is revealed in the following song:

> Just across the Irish Sea / Stirs a heart of loyalty /
> Raised in honour and in dignity / Drives a will to keep us British free /
> Not alone are we on this journey / For in a land across the sea /
> Is a hand that reaches out in friendship / And bond that lasted centuries.

> And its hands across the water / Reaching out for you and me /
> For Queen, for Ulster and for Scotland / Helps to keep our loyal people free /
> And let the cry be 'No Surrender' / Let no one doubt this loyalty/

[243] Rolston, 1999, 47

[244] from 'Billy McFadzean', in Songs of Honour and Glory, 1998

[245] from 'Orange Wings', in http://www.uksprite.co/search/search/Regional/Europe/United Kingdom/Northern Ireland/Society and Culture/Religious and Sectarian Conflict/Loyalism/ , 20/1/2003

Reaching out to the brave Red Hand of Ulster / Is the hand
across the Sea.[246]

Having continuously experienced the lack of British assistance since the
1960s, this reliance on behalf of loyalists, however, gradually declined.
Loyalists argued that political events such as the Sunningdale Agreement
(1973) or the Anglo-Irish Agreement (1985) were evidence of Britain's
refrained support. In songs such as 'Proud to be a Prod' or 'We Don't
Want the Deal' their anger about these new developments was clearly
expressed:

We don't want the deal, we don't want the deal
Don't you ever think how we really feel
Listen, Maggy Thatcher to this last appeal
We are simply telling you, we don't want the deal.[247]

The strong feeling of isolation commonly experienced by settlers also
reveals itself in loyalist ideology. The feeling of being alone and having
no one to depend on but themselves soon encouraged an emphasis on
self-reliance. Going hand in hand with this emphasis, extreme vigilance
is expressed in many songs too: 'One cannot trust one's enemy, one does
not know one's friend.'[248] For each settler it is, according to Clayton,
'the most important task to keep the enemy at bay.'[249] As reliance on
the British has clearly failed, loyalists feel isolated and scared. Violence,
therefore, remains the only means by which loyalists feel they can
defend their position. Clayton argues that this violence is, in fact, rather
legitimate for settlers:

Violence in settler societies, on the part of both settlers and
'natives', is normal. Colonies were won and maintained
by violence and the threat of violence. 'Native rebellion',
however, is painted as arising out of the primitive nature of
the people rather than out of legitimate complaints. Settler

[246] from 'Hands across the water', in Songs of Honour and Glory, 1998
[247] from: Quis Separabit—Ulster has awakened. Black Mountain Music. MC, Track 4
[248] from 'The Ballad of Tommy Herron', in Rolston, 1999, 47
[249] Clayton 1996, ibid., 50

violence, on the other hand, is often part of the structure of coercive domination, carried out by legally-constituted authorities, and is characterised merely as the upholding of 'law and order' which is necessary in any civilised society.[250]

In looking at songs such as, 'An Orangeman's Testament', it soon becomes obvious that whenever the loyalist way of life is threatened by Irish rebels, violence is legitimate. In other words, violence is and has always been the loyalists' way of self-defence:

> And they still haven't changed they're at it today
> They've planned a rising next month, the bold I.R.A.
> They'll sneak over the border at ten past midnight,
> If you're wearing your sash they'll shoot you on sight.
>
> And that is the reason they must be kept down
> If they get half a chance they'll abolish the Crown.
> Yes, they'd turn Ulster over to Lynch and his gang,
> Surround all the Orangemen, and blow 'em up. Bang![251]

In terms of religion, loyalists regard Catholicism and popery as the antithesis of liberty. Freedom is for Protestants, and according to loyalists, there is no doubt that God is on their side. God is, therefore, frequently called upon to back their cause. Hardly understandable, however, is the juxtaposition of religion and calls to violence as in: 'So, Lord, show me the message / And I'll show the republicans.'[252]

Although members of the IRA can be regarded as the real enemies in this armed struggle, Rolston convincingly explains, that by now any *'taig'* (a derogatory term for an Irish Catholic), Fenian, Catholic, or nationalist is regarded as the enemy by the loyalist community: 'We have bombs, we have guns, we have Fenians on the run, / And the ones that we killed

[250] ibid., 51

[251] from 'An Orangeman's Testament'(Alan Harper), in John Moulden Collection, 1991

[252] from 'Sons of Ulster', in Rolston, 1999, 49

were all bastards, every one.'[253] These enemies are not even human and are rather regarded by loyalists as animals: 'These monsters are not human, they're not even men.'[254] Finally, the song 'I Was Born under the Union Jack' states what sadly seems to be obvious to loyalists: 'Taigs are made to kill.'[255]

In Search of a New Orientation

As far as the articulation of loyalism is concerned, Rolston sums it up as being 'remarkably inarticulate about its fears and aspirations.'[256] Nationalism, on the other hand, is regarded as being highly articulate. Aughey is convinced that there is a clear connection between the way unionism has presented itself—or failed to do so in the past—and the 'sense of isolation and ineffectiveness' felt by Unionists today.[257] According to the same author, 'Unionist politics has been reduced to its most paranoid and emotional elements.'[258]

Concerning the construction of identity, McCann argues that the folk revival of the 1960s had the potential to contribute towards the emergence of a Protestant and Ulster identity. While associating itself with the English folk revival and distancing itself from the pre-existing folk music of the Irish Catholic nationalist tradition, the folk revival in the North supplied Protestants with an opportunity for a new orientation. Nonetheless, the same author suggested in 1995 that Protestants should still, in a way, rethink their identity: 'Ultimately the coloniser still must seek a non-essentialist, place-oriented version of Irishness, and indeed Ulsterness.'[259] It has often been argued that the failure to develop a nationalist identity lies at the heart of the unionist

[253] from 'Goodbye My Loyal Friend', melody taken from popular ballad 'Seasons in the Sun', ibid., 52
[254] from 'Enemies of Ulster', ibid., 52
[255] ibid.
[256] ibid., 43
[257] Aughey, ibid.
[258] Aughey, ibid., 45
[259] McCann, 1995, 73

problem.[260] It might be this failure that still has a profound effect on unionistic cultural life at present. Many educated young people from unionist backgrounds in Northern Ireland still seek to leave Ireland to become British in a 'proper' way: 'Better be fully British in Edinburgh or London, than half British and half nothing in Belfast.'[261] In an interesting article published in the *Ulster Patriot* in the late 1980s, a teacher made the following remarks on the identity crisis experienced by the majority of people in Ulster:

> The Ulster people must see that it is not in their interests to cling on to Great Britain, until Britain shakes them off. If the Protestant ethos in Ireland is to survive, the Ulster people must assert themselves, and take their destiny into their own hands. They must promote, not a British identity, which is moribund, but an Ulster identity . . .

> Ulster people are often accused of living in the past. To continue to promote a British identity is living in the past. To promote an Ulster identity is learning from the past, and facing the future. Only when Ulster people sort out who they are, and where their loyalty lies, can they really hope to effect a change of attitude . . . [262]

According to Ruane and Todd, it was already difficult to distinguish a distinct Ulster identity when the state of Northern Ireland was formed. They argue that a specific Ulster identity was mainly formed by unionistic politicians by means of distancing themselves from the Irish tradition. Like every ideology, unionistic ideology invented its own tradition. In *The Invention of Tradition* (1983), Eric Hobsbawm defines 'invented tradition' as follows:

> . . . a set of practices normally governed by overtly or tacitly accepted rules and of a ritual or symbolic nature, which seek to inculcate certain values and norms of behaviour by

[260] see O'Dowd in Rolston, 44
[261] T. Brown in Longley, 1991, 78
[262] in Ulster Patriot, 1980s

repetition, which automatically implies continuity with the past. In fact, where possible, they normally attempt to establish continuity with a suitable historic past. [263]

In comparison to the Irish tradition, however, the tradition created by unionism was much more simplistic. Even so, the ideological simplicity of unionism must be understood in its own right. Rolston believes that the representation of loyalist ideology by politicians on the one hand and popular expressions of ideology in loyalist songs on the other are, in fact, interrelated.[264] According to O'Dowd there was a clear contrast between the 'one-dimensional nature of unionist political thought' and the 'complex differentiation of the unionist community along class and religious lines.' For this reason, popular loyalist ideology had to be kept simple. As a result of its democratic approach, both political experts and ordinary unionists alike have therefore equally been able to formulate this ideology effectively and eloquently.[265]

Despite this, many political observers have argued convincingly that what unionism would really need is an alternative vision. In his book *Rethinking unionism: An alternative vision of Northern Ireland* (1996), Norman Porter argues that this alternative vision can only arise from an entirely new form of unionism, which he calls 'civic unionism'. Do loyalist songs that have been written during the last decade reflect whether this new vision has, in fact, already been created? It would be a challenging task to explore this issue in greater detail. As was stated in the Introduction chapter, more research and a thorough examination of contemporary orange song material has yet to be undertaken. Do the majority of Protestants living in the North still see their identity clearly reflected in the vast amount of overly sectarian loyalist songs? If the answer to this is no, have new songs articulating a different, more tolerant and peaceful vision possibly been written already? In 2002, East Belfast's Ballymacarrett Arts and Cultural Society (BACS) launched

[263] Hobsbawm in McCann, 1995, 23
[264] Rolston, 1999, 45
[265] O'Dowd, ibid.

an album called *Belfast City Sunset.*[266] This album was the result of workshops held by the BACS in East Belfast, which, according to this organization, was aimed at making a contribution to cultural awareness. Songs like the title track suggest that the process of rethinking unionism has, in fact, slowly but surely begun. When research for this book ended, *Belfast City Sunset* remained the only album of that kind released by the Protestant community in Northern Ireland. In another album, called *A Clatter of Fowk*, released by FowkGates, The Ulster-Scots Collective of Performing Artists focused on the recognition of the diverse range of Ulster-Scots material and included some contemporary pieces. Apart from attempts by these two organizations, the majority of song material available for this research consisted of the loyalist songs that were thoroughly examined in this chapter. It is hoped, however, that a further research on the subject will soon be undertaken in order to find out whether any additional alternative song material has been written since. This, in return, would reveal how far a new alternative vision of Northern Ireland has become reality.

In Chapter IV, various aspects concerning the co-existence of both traditions in contemporary Northern Ireland will be discussed. 'Music and Politics' on the one hand and 'The Past in the Present' on the other are doubtless two significant topics that need to be examined in the Northern Irish context. Another important topic is how the song material from each tradition is presently perceived by both parties. The chapter will also include a brief excursion into the future of these two traditions and their possible impact on cultural and political developments in Northern Ireland. While there are obviously many differences between the two song traditions, there are various elements that both traditions share. While focusing on rebel songs and old orange ballads that were written up until the beginning of the twentieth century, Zimmermann arrived at an interesting conclusion. According to this author, orange ballad makers were better storytellers, and nationalist ballad makers were more individualistic. While the songs on both sides could express old grievances or extreme violence, nationalist songs turned to lyricism and sentimentality more often than their orange equivalents. Both traditions,

[266] Belfast City Sunset, Songs composed and sung by Brian Ervine, Ballymacarrett Arts and Cultural Society, Belfast, 2002

however, shared the same characteristic in often confounding religion with politics. Furthermore, they often explored religious differences to trace and maintain political advantages.[267] Finally, it should be noted that both traditions have, for a long time, paradoxically developed in parallel directions and have doubtless more in common than their expressed hatred against each other.

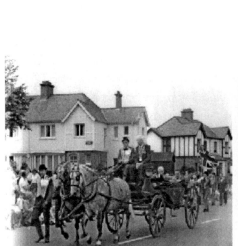 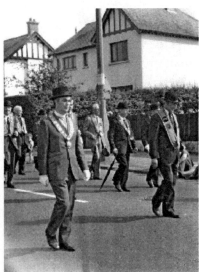

[267] Zimmermann, 1966, 304f.

IV
THE CO-EXISTENCE
OF BOTH TRADITIONS
IN CONTEMPORARY
NORTHERN IRISH
SOCIETY

The rain it will fall and the wind it will weep

And the black Lagan fog lulls the city to sleep.

It's to hell with the future for we live in the past,

May the Lord in his mercy be kind to Belfast. [268]

[268] excerpt from poem/song 'May the Lord in his Mercy be kind to Belfast', Maurice Craig, 1936, in Ormsby, 1992

1

Introduction

After the partition of Ireland, a Protestant unionist culture was established in the North, receiving full endorsement from the state. The anti-Catholic Orange Order with its significant role helped to manifest unionistic musical culture with their marching bands and triumphalist annual parades. According to McCann, their triumphalism was expressed in the songs, the manner of playing the music, as well as in the location of the parade route. In addition, the Lambeg drum—very large and carried on the player's chest—was regarded as a major musical symbol of identity. Even if the tunes played were Irish, McCann argues that whatever was played by the marching bands tended to be categorised as orange music.[269]

In contrast, the Ancient Order of Hibernians supported the political and musical culture of the Catholic nationalist population in the North. However, this organization never succeeded in gaining parallel status and suffered frequent bans. Annual parades were always limited to places where loyalists would not be offended, and Hibernian bands and banners were hardly tolerated. McCann argues that, at this point, Irish culture and identity were in fact no longer contested; instead, 'Irish identity was equated with Catholic and within the context of northern politics, subversive.'[270] In other words, the Catholic population in the North found the expression of their political and musical culture dramatically confined and had to contest over political and cultural legitimacy.

[269] McCann, 1995, 63
[270] ibid.

As a tragic result of the political Troubles that began in the 1960s, traditional music was soon regarded as a product of republicanism. Traditional music became Catholic music, and unfortunately even forty years later, people in some parts of the Northern Irish society still perceive it as such. One has to bear in mind, however, that the younger generation of Protestants has also included many traditional singers over the years. In addition, to associate Orange ballads and Lambeg drumming still with every Protestant living in Northern Ireland could lead to false assumptions about the present and the past.

From the late 1960s onwards, a great variety of songs dealing with present developments, such as internment, have been written on both sides. Republicans and loyalists have, over the years, both produced songs voicing their aspirations, celebrating their victories, and justifying their struggle by means of violence and armed force. One of the first songs of major importance that appeared was Dominic Behan's 'The Patriot Game',[271] which was soon performed as a key song in nationalist clubs. Since then a great variety of songbooks have been produced and have been circulated widely among each political persuasion. Singing groups soon performed these songs in clubs in front of participative audiences successfully. Not only were key songs thus soon made popular, they also provided the listeners with an alternative hit parade to the one of ordinary popular songs on the radio. Before long the first recordings appeared. Up to now a great variety of recordings has been produced on both the nationalist and loyalist side.

[271] see chapter VI.

2

'It's to hell with the future for we live in the past'[272]—The Past in the Present

> Ulster was not just another region of Britain. Physically it was
> part of the island of Ireland and historically it was part of the
> political entity of pre-partition Ireland. Ulster [. . .] was one
> of the five historic provinces of Ireland and the founder of the
> fourth-century Kingdom of Dal Riada, based on the colonisation
> of Western Scotland. All of these pasts were available as cultural
> capital for a variety of potentially competing interests. [273]

The majority of people in Northern Ireland are living in the past
or at least dwell too much on the past, according to McCann.[274]
It is an emotional tie to the Irish past that lies at the heart of a rebel
song. Perhaps the very same tie lies at the heart of the Irish question
itself. In the preface to his book, *Blood on the Harp*, Turlough Faolain
explains that this glorification of the past through rebel songs still has
a dangerous impact today: 'The rebel songs live on gloriously in our
history, and tragically, in our present.'[275] According to the same author
this emotional tie also has to be regarded as an obstacle in overcoming
the Northern Irish conflict: 'Those who dwell in that history can lose
touch with the present . . . thus never giving the future a chance.'[276]

[272] excerpt from poem/song 'May the Lord in his Mercy be kind to Belfast', Maurice
 Craig, 1936
[273] McCann, 1995, 70
[274] ibid.,13
[275] T. Faolain, 1983, xii
[276] ibid.

An explanation for this strong sense of historical imagination in the republican tradition is given by Terence Brown. He argues that nationalists needed history for inspiration and sustenance because they were the losers in this process of colonization: 'In the Irish context, colonialism led to the dominance of unionism, the suppression of nationalism, and an inequality of power at the economic, political and cultural levels that exist in the North to this day.'[277] While history always operates on the basis of selecting from the past, it seems that the selection chosen by unionism is more restricted. In comparison to nationalism, history had to serve fewer functions and is simpler on the unionist side. Brown describes their historical imagination not only as simple but also as, 'depressingly lacking in emotional range and complexity.'[278] Both cases, however, reveal that it is extremely significant to understand the importance of the past in the present in the Northern Ireland context. Talking about the interrelation of history and collective identity, Peel suggests:

> What gives history its continuing power is not falsehood, nor for that matter truth, but the sense of continuing identity, expressed in re-enactments by ritual and riot. The enemy of such myths is not truth but individualism, the dissolving of the sense of collective identities and temporal continuities. [279]

According to Hobsbawm it is generally accepted to use the past in the development of a nation state. Even misconceptions regarding the past must therefore be tolerated: 'Getting its history wrong is part of being a nation.'[280] On the other hand, McCann argues that societies reflecting a strong concern with the past and with tradition have always been characterized by scientists as 'backward' and 'non-progressive': 'In contemporary western societies it is desirable to be "with the times", or "ahead of the times", never "behind the times" or "living in the past".'[281]

[277] Rolston, 1999, 36
[278] Brown ibid.,44
[279] Peel in May McCann, 1995, 24
[280] Hobsbawm, 1999, 12
[281] McCann, 1995, 15

The past in the present, as well as long manifested symbols like parades, the waving of flags, and the wearing of orange sashes can also be explained with Ardrey's concept of 'territoriality'. He argues that the sense of community generated through such manifestations is the only means of providing some sort of security in Northern Ireland.[282] This security, however, has so far not managed to weaken the genuine sense of fear that still exists on both sides in Northern Ireland today: 'Fear . . . , although often based on incorrect assumptions is at the root of tribalism and explains the absence of rational thought and action in Northern Ireland.'[283] The following remarks by Jackson made on the genuine fear in Northern Ireland in 1979 are to a great extent still true today:

> It is fatally easy for the detached observer to ask loftily why the two sides don't just do this or that to resolve their differences. There is always the calm assumption that reasonable men sitting round a table can come to terms with any problems. But it is vital to grasp that this sort of 'reason' is still far off in Ulster because of the enormous build-up in pressure created by the quite genuine fears on each side. [284]

[282] Ardrey ibid., 5
[283] ibid.
[284] Jackson ibid., 5

3

Music and Politics

Virtually since we have knowledge of music in Ireland, its relationship to politics has been evident in terms of song content, music, and cultural meanings. Irish music, per se, not just the sub-section 'political song', has been within the domain of cultural politics throughout Ireland's colonial relationship with England.[285]

The relationship between music and politics in Ireland is well established. Numerous ballads were written on the nationalist side in the past dealing with the politics of the time such as the United Irishmen Rebellion of 1798 (for example, 'The Rising of the Moon') or the Young Irelanders Movement of the 1840s (for example, 'A Nation Once Again'). Many of these songs are still popular and sung today although some of them contain rather archaic language. Nationalist songs, according to Tony McAuley, 'concern themselves with endurance, defeat and with the possibility of one day winning. The big songs always have to do with losing [. . .] But constantly throughout the song is the idea that the loser will one day become the winner.'[286] As far as political propaganda is concerned, McCann argues that the United Irishmen recognized that a song, compared to prose, had greater appeal to the audience: 'Song and satire were major tools in their campaign to capture the hearts and minds of the Irish people. Both formally and informally, music and song animated the United Irish Society.'[287]

[285] ibid., 54
[286] McAuley in Rolston, 1999, 31
[287] McCann, 1995, 56

Political music as an old tradition can also be found on the Unionist side. The theme that predominates the song material is either about siege, or centres on winning battles. This siege mentality is described by Bobby Hanvey, musician and broadcaster, in the following way: 'Keep to your own clan, don't mix [. . .] The Protestant songs are bordering on paranoia at times because this is the way they have seen themselves down the years, because they have been under siege.'[288] According to Rolston, however, the repertoire of unionist songs has been drastically narrowed. Apart from a few exceptions such as 'Dolly's Brae', 'Lilliburlero', and 'The Aghalee Heroes', many traditional orange songs have been forgotten or are no longer popular.

Speaking about the extent in which popular music has been able to relate to the violent conflict in Northern Ireland over the past fifty years, Rolston also agrees that there has always been a close relationship between music and politics in Irish history. While over the last three centuries nationalists and Unionists each had their repertoires of songs, both sides continue to draw from this musical heritage today and continue to write new songs relating to more contemporary events. Although both varieties of political song, nationalist and loyalist, are very much alive and popular, official broadcasting outlets, for reasons rather plain, are hardly willing to play them. These songs, however, continue to be performed in republican and loyalist clubs and are also available on CD.[289]

From a cultural point of view, songs are often seen as major contributors to the continuation of violence. Rolston argues that republican songs have the potential to stir up archaic sentiments and to perpetuate tired old myths. The same author even goes as far as to explain that in the past, 'young men have gone out to kill and to die simply so that they will be remembered in a ballad.'[290] The assumption that songs have therefore the potential to lead to conflict is nonetheless rejected by Kiberd. Speaking about the activities of the IRA he argues: 'What created the modern IRA was not any cultural force, but the bleak sectarian realities

[288] Hanvey in Rolston, 1999, 31
[289] see Rolston, 1999, 29-56
[290] ibid., 33

123

of life in the corrupt statelet of Northern Ireland.'[291] In *Poetry in Wars*, Edna Longley speaks about the relationship between poetry and politics. Although she refers to poetry rather than songs, Longley's reflections are in clear contrast to Kiberd's rejection concerning songs and politics:

> Poetry and politics, like church and state, should be separated. And for the same reason: Mysteries distort the rational processes which ideally prevail in social relations; while ideologies confiscate the poet's special passport to terra incognita. Its literary streak, indeed, helps to make Irish Nationalism more a theology than an ideology. Conor Cruise O' Brien calls 'the area where literature and politics overlap' an 'unhealthy intersection'; because, 'suffused with romanticism', it breeds bad politics—Fascism and Nationalism.[292]

In 1971 hard-line Loyalist John McKeague was prosecuted for publishing the *Loyalist Song Book*. The recently introduced incitement to hatred legislation in Northern Ireland strongly condemned the book, and in particular the words of one song, called 'I Was Born Under The Union Jack':

> I was born under the Union Jack.
> I was born under the Union Jack.
> If guns were made for shooting, then skulls are made to crack.
> You've never seen a better taig than with a bullet in his back.[293]

The case of McKeague was unsuccessful; he remained the only person to be prosecuted under this legislation, and no other songbooks have been banned since.

According to Rolston, the relationship between music and political conflict in the North of Ireland is under researched.[294] The conference

[291] Kiberd, ibid.
[292] Edna Longley, 1986, 185
[293] excerpt from 'I Was Born Under The Union Jack', in Rolston 1999, 35
[294] ibid., 32

Traditional Music: Whose Music, sponsored by Cooperation North in 1991, can, however, be regarded as a modest approach to tackle this issue.

> . . . we are talking about something that is intimate and at the same time vast, and we have in Northern Ireland . . . the uniquely rich confluence of English and Irish and Scottish songs and tunes, and it is that very richness which produces political problems, social complexities. [295]

As musician, writer, and lecturer in traditional music Fintan Vallely pointed out at the conference, there is not necessarily a need to regard Irish music as being able to solve political problems. He believes that politics and Irish music do, in fact, exist parallel to each other.[296] However, Tony McAuley argued that Irish music has, over the years, got itself into a mess. He explained that Irish music has somehow become marginalized, even politicized. It is often understood by people as mainly music of one side of the community in Northern Ireland. As a result, it can, in fact, often be heard in areas visited by one section of the community alone.[297] Present developments within the orange tradition, especially regarding loyalist song material, have shown that there is, in fact, a danger in playing down any relationship between music and politics in Northern Ireland today.[298]

On the other hand, it is worth noting that some musicians have tried their utmost in the past to be of some kind of assistance to politicians. Some even succeeded in becoming engaged in the peace process in Northern Ireland itself. In 1996, the well-known Northern Irish singer/songwriter Tommy Sands became the brainchild of the project Citizens' Assembly. The two-day event was held in Belfast in August 1996 with the aim of offering new proposals to politicians for tackling the peace process. The people taking part in this assembly were volunteers representing all shades of political opinion in Northern Ireland. The public was invited to enjoy

[295] Michael Longley in his speech summing up the results of the North Conference, in McNamee, 1992, viii

[296] Vallely in McNamee, 1992, 22

[297] McAuley ibid., 171

[298] for further information see chapter III.

a weekend of great music, song, and humanity; according to its initiator, this event guaranteed 'an opportunity to create hope for the future of Northern Ireland.'[299] The singer clearly stated that it would be too easy to blame politicians for the failure of the peace talks. However, he also offered a good description about the interaction between politics and individuals in Northern Ireland:

> Politicians need to divide people to get elected, keep them divided to stay elected and divide them again to get re-elected. It's like sitting in never-ending traffic jams, watching bus drivers shake their fists at each other while we in the bus wait and wonder what is going on. [300]

During the event, questions about identity were discussed, and methods for finding consensus and compromise were sought. Some of the North's best-known artists and playwrights backed this assembly with the aim of replacing 'divisive adversarial politics with a consensus agreement.'[301] In a moving article in the *Belfast Telegraph* in July 1996, journalist Lindy McDowell expressed her concern about living in Northern Ireland at a time when the peace process was once again about to collapse. According to her, there have always been, and will always be, factions in the North who see murder and mayhem as a viable career option. Feeling tremendously let down by politicians, she is convinced that this lack of discernible leadership lies at the heart of the Northern Irish problem. For Lindy McDowell, however, as well as for many other individuals concerned about the future in the North, a sense of hope was once again created when a singer/songwriter took on the initiative himself: 'it provides reassurance that out there we still have leaders, if only in the musical sense, who believe that the beat of different drums can be incorporated in a peace anthem. Instead of a war song.'[302]

[299] Tommy Sands in interview, Limerick, 2004
[300] Tommy Sands in Irish News, Dublin: August 1, 1996
[301] Phelim McAleer ibid.
[302] Linda McDowall in Belfast Telegraph, July 20, 1996

4

Conclusion

But what really stirs my blood is our own music: Ulster Orange music. I think that is the difference. It is the music of the people. It's what stirs your heart; and that's what seems to be left out a bit today. It's what moves you! Now, I was listening to very nice music there, but it did almost nothing for me. It didn't make me alive, and I feel that this is what binds people together and is the heart of traditional music, whether they be Orange, Green, whatever; it relates one person of the same group to another. I think that is the big part of traditional music, if not the major part of it.[303]

Although there are, in fact, two song traditions in Ulster, huge controversy has, over the last few decades, arisen regarding this issue. Musically speaking, Sean Corcoran believes there is only one such tradition in the whole island of Ireland. He argues that once people start talking about different musical traditions in Ireland, they would identify thousands. Just like regional dialects and accents, each area also has its own distinct style of music. Unfortunately, since the Troubles started, some people in Northern Ireland have come to the conclusion that traditional music is 'Catholic' music.

It is rather obvious that the two major distinctive song traditions—'green and orange'—made their own contribution in delaying a peace settlement in Northern Ireland. The revival and continuance of rebel songs on the one hand and songs from the orange tradition on the other still have enough power to stir up anger on both sides today. It

[303] David Bush, Ulster Society, in McNamee, 1992, 16

would, therefore, also be a major step towards a conflict settlement if both sides eventually realized that these songs, even if sung today, belong to the turmoiled past. Speaking about politics, Peter Rooney made the following observation in 1995:

> Sinn Fein has changed; the RUC has changed; the British approach to the Irish problem has changed; working-class Protestant reaction to the Republican campaign has changed. Is the Orange Order determined to perpetuate the mistakes of the past and confine Protestantism to a tribal culture that will not move forward into a more peaceful future? [304]

There is a clear warning in the statement above—a reminder to everyone involved in the Northern Irish peace process, be it politicians, artists, or individuals. There is no harm in remembering the past, but it has to be left behind. Awakening to the reality of the present holds the key for a brighter-looking future.

> It is like the story of a man who stepped inside a tall tower. While groping inside in the dark he came across a circular staircase. Eager to know where it led to, he decided to climb. Soon an uneasiness grew in his heart. He turned around only to find that every time he climbed a step, the previous one fell off and disappeared . . . [305]

It is not farfetched at all to mention another ability here, which, if practised more often, would function as a great catalyst to overcome the crisis in Northern Ireland. The ability to forgive is something with which the majority of human beings still have a great problem. Religion is supposed to teach us to forgive our foes. In the whole island of Ireland especially, where religion has always had such an enormous impact, why is it that the practise of forgiveness is still next to impossible?

Despite the ongoing divide in Northern Ireland, most musicians and artists in general have rather overcome the conflict by now. Whenever

[304] Peter Rooney in Fortnight, June 1995, 38
[305] from A. de Mello, The Heart of the Enlightened, Fount, London 1997, 13

musicians get together, talk about music, or play in sessions, music is the only thing they are interested in. Why should they hate each other for coming from different traditions? It is rather challenging to see what can be applied to one's own tradition from the traditions of others. In the case of traditional music from the North, there have been several occasions in which musicians from the 'other side' were asked to join traditional folk groups. One of the musicians of Northern Irish band, the Art (popular in the 1980s), for example, was proud of his origin and influence by the Shankill pipers. To give another example, a Protestant musician from County Antrim is well worth mentioning here. John Kennedy, born in 1928, comes from a strong family tradition of song. He is known for playing Irish traditional tunes that have been transformed and performed in Protestant contexts. Although there have been alterations in timing and pitch range, folk song researcher John Moulden believes that this is a perfect example of how music can adapt itself to the 'use in regional or sub-cultural groupings.'[306]

As far as the future of the diverse musical traditions in Ulster is concerned, there is no such thing as a simplification of the matter. One has to accept that there are, in fact, many traditions coexisting locally, and that even each singer' s experience has been different. A brief reflection on cultural differences in general, and their impact in Northern Ireland in particular, will help to explain this idea. According to David Trimble, Catholic culture often tends to refuse to recognize the existence and validity of the Ulster-British culture. As far as cultural differences are concerned, however, he argues that in many countries with similar diversities in cultural terms, these differences do not necessarily result in conflict. The precondition for avoiding and overcoming such conflicts can thus be described as follows: 'Any form of co-existence must acknowledge the right of each culture to exist and to perpetuate itself.'[307]

In an interview with the author, George Newell, from the Ballymacarrett Arts & Cultural Society (BACS) in East Belfast, described the diversity between the green and the orange traditions

[306] John Moulden in interview, Belfast: 2002
[307] Trimble in Logue, 2000, 290

in Northern Ireland. According to him, the two traditions find themselves in a typical brother-sister relationship. While the sister might be concerned only about the latest fashion and glamorous clothes, the brother has ever only shown interest in fast cars. These interests do in fact never mix.[308] Yet, growing up in the same environment and living together always implies the opportunity to understand, accept, and learn from one another. As there is always a chance for brother and sister to turn their differences into an advantage, to reconcile after a fight and to learn from the past, there has also always been and will always be a challenge for both cultural identities in Northern Ireland to do exactly the same. Despite the broad range of diversity, it is never too late to start anew: 'Belfast is a city where art is being reclaimed by working class communities as an expression of their identity, hopes and fears. Protestant communities are just as interested in this revival as anyone else.'[309] With the aim to promote artistic and cultural development within the Protestant community, the Ballymacarrett Arts & Cultural Society was founded in 1996. Through this organization the community of East Belfast is given an opportunity to express itself in the areas such as music, dance, drama, poetry, and education.

> We seek to educate through social interaction with other communities and facilitate the endeavours to address questions of Division, Diversity, Pluralism, Heritage and Allegiance with the view of enhancing understanding of such issues.[310]

In 'Prods Can't Act, Sing or Dance', a report on the work of the BACS, Newell mentions that the support for BACS projects from local communities has been tremendous since the foundation of the society. Each community's interest in reclaiming cultural identity and taking pride in its heritage has given everyone involved, but especially young people, a sense of pride as well as a stake in the future.[311] In the year 2000, one of the society's initiatives was to bring the unionistic tradition

[308] G. Newell in interview Belfast: 2003
[309] in Foreword to Prods can't act, sing or dance, published by BACS: 2000, 2
[310] G.Newell on album cover, Belfast City Sunset, BACS, 2002
[311] in Prods can't act, sing or dance, BACS, 2000, 2

of music and song to border regions, which, it should be said, were also regarded as a 'haven for IRA terrorism'. 'You always hear people saying that the hair stands on the back of your neck when you go into these places, that there will be IRA men hiding behind bushes with ArmaLites (guns manufactured by US company ArmaLite). We want to dispel that and face up to it.'[312] According to George Newell, there is a great sense of hope that such performances help to heal the differences between the two communities on both sides of the border.

Respect for diversity and for the rights of others were regarded by Mary Robinson, President of Ireland from 1990 to 1997, as the key for uniting all cultural diversities in Ireland. During her tenure she said, 'I would like to see both traditions working towards this goal by coming to accept each other's different inheritances and by recognising the legitimacy of each other's values and beliefs.'[313] In other words, and according to Sister Helena O' Donoghue, the future goal should be a 'creation of unity that embraces diversity in harmony.'[314]

Finally, from around the last decade of the twentieth century up to now we have lived in probably the greatest time of change, uncertainty, and transition. Then again, perhaps we share this experience with so many people who have lived through a turn of a century and especially a millennium shift. In our evolution, however, it seems that we have now moved onto a new level of consciousness, which now makes us aware of the fact that our own decisions and choices change the world of tomorrow. According to Sister Helena O' Donoghue, we are experiencing an age of 'people power' and even media power, which in turn makes all dimensions of life, such as religion, going through a profound metamorphosis.[315] A general awareness has yet to manifest itself in our minds that, in fact, none of us has an ultimate knowledge of the world and everything has to be regarded as being relative. Therefore, no religion and no institution—like a church—can deliver a fullness

[312] from Drama & Arts Across Borders. An evaluation report of the project by Brid Ruddy, BACS, 2000

[313] in Edna Longley, 1991, 5

[314] in Longley, 1991, 151

[315] H.O' Donoghue in Longley, 1991, 149

of understanding. It is in this connection, too, that each individual's search will be ongoing in the human heart and spirit. This awareness, culminating in a responsible respect from all sides, is thus the only way to a future of harmony and peace.

Ballymacarrett Arts & Cultural Society (BACS), East Belfast

Children from East Belfast celebrating the
Queen's Golden Jubilee in 2002

Georg Newell in the BACS
office, East Belfast

Re-enactment of the Battle of the Boyne,
Belfast, July 2000

Willy Drennan, Ulster-Scots
musician playing the Lambeg
Drum

Photographs printed with kind permission of George Newell, BACS, 2005

Parades organized by the Ballymacarrett Arts & Cultural Society

Re-enactment Parade, Belfast, July 2000

Celebrating St Patrick's Day, Scottish
Dancers from East Belfast, March 2000

Celebrating July the 12th, Orange
Parade in East Belfast, July 2000

Photographs printed with kind permission of George Newell, BACS, 2005

Keeping Traditions Alive
Ballymacarrett Arts & Cultural Society, East Belfast, 2000

Photographs printed with kind permission of George Newell, BACS, 2005

Children from the Ballymacarrett Arts & Cultural Society visiting Derry

Waterside, Derry 2001

Photographs printed with kind permission of George Newell,
BACS, 2005

V
ROCK AND POP ARTISTS AND THEIR REFLECTIONS ON THE TROUBLES

1

Introduction

Over the years, a great number of popular music artists have reflected on the Troubles in song. Especially since the 1970s, there have also been many attempts by Irish and international artists to portray the situation in the North in their creative work. Even though songs that were written outside Northern Ireland are capable only of expressing an outsider's perspective, they nonetheless reveal how this conflict engaged and had an impact on people living outside of Northern Ireland as well. In addition, due to the fact that the vast number of popular songs about the Troubles written outside Northern Ireland has so far received very little recognition in writing, it is high time that they are examined properly. After a brief introduction into popular music and its ability to address political issues, the first part of Chapter V will therefore explore this outsider's perspective in greater detail and illustrate how the Northern Ireland conflict has continued to challenge rock and pop artists from the Republic of Ireland and abroad over the years. The final part of Chapter V will then concentrate on the vast number of popular music artists from Northern Ireland and their reflections on the Troubles in song. To emphasize the continuation of popular music in the North and to illustrate how many popular music artists Northern Ireland has in fact produced over the years, all artists and bands with Northern Irish connections will be highlighted when first mentioned in this Chapter.

From the 1950s showband scene, Van Morrison's ongoing success to Brian Kennedy and Juliet Turner's international breakthrough in the 1990s, Northern Ireland's popular music artists have proven that, despite all the obstacles created by the Troubles, their art is still very much alive. The last part of Chapter V will therefore take a closer look at these artists and their creative work. It is finally also important to note that the purpose of Chapter V is not to analyze the song material in greater

detail, but to introduce and bring together the existing body of popular song material about the Troubles for the first time.

In the post-war West, mass culture has become a very important cultural phenomenon. It is described by Alan Finlayson as 'a vibrant, colourful, fun and dangerous thing, the reproducer of dominant ideology and its subversive enemy.'[316] Finlayson also refers to the mass as 'the entertainment junky of late capitalism'[317] and argues that anybody who has an interest in the culture of politics or the politics of culture has to have an interest in the 'popular' too. The same author further explains that 'the arena of the popular is where politically-charged identities can be explored and toyed with in a struggle for cultural and political legitimacy.'[318]

Popular culture is easy to understand but difficult to explain. Triviality and simplicity lie at the very heart of the problem with popular culture, according to Finlayson. This also explains, for example, why the majority of people are satisfied by simply listening to an ordinary pop song. It could be argued that it is the vagueness of many songs that makes them easy to relate to. However, the words of a pop song also carry meanings and arise out of conceptual cultural maps as described by Stuart Hall.[319] In other words, popular songs are easily accessible, because a shared memory is common to people who listen to them.

According to Adorno the ability of a popular song to tackle political issues is rather poor. In a similar way Harker argues that songs are only political if they speak of political issues.[320] What this author is referring to, is in fact, the general emphasis on song texts in popular music. It is, nonetheless, not farfetched at all to believe that songs can also be perceived as political without directly expressing political issues. Song lyrics cannot simply be regarded as a solid matter that, through being created, simply exist. Their power arises from the fact that each listener

[316] in Fortnight, June 1995, 22
[317] ibid.
[318] Finlayson in Fortnight, February 1990, 22
[319] Hall, 1997, 22ff (see Chapter I)
[320] Adorno and Harker in Rolston, 2001, 50

chooses to attach his or her own meaning, and thus is able to identify with the music and the song. In some cases, individually attached meanings can differ to a great extent from the original intentions of the author. Roland Barthes uses the concept of the 'death of the author'[321] to explain the difference between the production and the reception of a text. Similarly, Foucault argues that the meaning of a song is created only through 'discourse.'[322] As soon as a song is presented to an audience it is commented upon. When it is circulated and more people comment upon it, new meanings are added, some are kept current, and others are excluded. This is, according to Foucault, how discursive production works. Both Barthes and Foucault support the idea that the meaning of a text or song text can change significantly once it is completed and made available for reception. In other words, even though it might not have been the author's intention to write a political song, the audience could still interpret song text as political.

As far as the political potential of popular song texts is concerned, it is thus of major significance to look at a popular song's ability to speak for and to a community. According to Rolston, the magic of popular songs lies in their potential to provide 'shared pleasure.'[323] The same author, however, explains that there are major limits to music's ability to create a lasting community, as most of the so created communities are often rather fleeting. A 'fan' group at a rock concert, for example, is in many cases nothing but a temporary community. In other cases, popular songs can, in fact, serve the needs of and speak to a community. According to Rolston, the prerequisites for such a shared perception include shared interests of class, gender, race, and ethnicity. In other words and according to Stuart Hall, people share a conceptual cultural map.[324] It is under these circumstances that popular songs are able to inspire and even mobilize political groups. Rolston summarizes this process as follows: 'When preferred meaning, consumer interpretation and political community come together, pop music has the power to articulate and

[321] Barthes, 1977 (see Chapter I)
[322] Foucault, 1972 (see Chapter I)
[323] Rolston, 2001, 51
[324] Hall, 1997, 22ff (see Chapter I)

celebrate political aspirations and causes.'[325] A song should, therefore, not only be regarded as being political when political issues are directly addressed. It can provide a much deeper understanding and sharing of political aspects whenever Rolston's three patterns interact.

Popular songs are generally divided into two major categories—pop songs and rock songs. Pop songs are often regarded as rather commercial. Some critics also argue that the lyrics of a pop song hardly ever contain a deep 'message'. According to Adorno, the only thing pop songs are capable of is suppressing and smoothing political thought and to produce nothing but silly love songs.[326] Other critics, like Harker, simply regard pop songs as 'pap for the masses' except for a small number of songs that actually refer to political issues.[327] In comparison, rock songs are more likely perceived as having something to say. Rolston argues that rock is supposed to be rooted in rebellion and freedom and imbued with the myth of authenticity. Comparing rock and pop songs, he makes the distinction that pop centres solely around pleasure and is more interested in selling out to the culture industry. Rock singers, on the other hand, are often regarded as truly meaning what they say and as delivering a direct message. Nonetheless, even the message of a rocker can be rather imprecise and very individualistic; and so, both rock and pop songs have their limits in portraying political themes in communal terms, according to Rolston.[328]

However, while Rolston mentions the limitations, it is important to note that some of the rock and even pop songs explored in this book do indeed contain political messages. Popular songs generally reflect the musical taste of a community and also express its thoughts and feelings at a certain period of time. This means that, during the height of the Troubles, popular songs that contained political messages were more likely to reflect the thoughts and feelings of the Northern Irish community. They reflected what Raymond Williams described as the

[325] ibid.
[326] Adorno in Rolston, 2001, 50
[327] ibid., 51
[328] ibid., 54

'structure of feeling.'[329] Even though Rolston argues that most of these songs express only an individual point of view and are rather limited in portraying political themes, many of these songs were once regarded as great songs by the Northern Irish community. They reflected their musical taste and succeeded in expressing their feelings. It goes without saying that, as time went on and once the musical taste changed and new developments happened, most of these songs were soon forgotten. Nonetheless, when the songs were first performed, the majority of listeners found their thoughts and feelings reflected. Many of the rock and pop songs that were written about Northern Ireland during the time of the Troubles can thus, indeed, be regarded as being political.

[329] in Storey, 1998, 61 (for more information on the subject see Chapter I, 2. Theoretical Aspects)

2

International Artists

According to the *All Music Guide*[330] back in 2003, when research for this chapter was completed, there were eighty-six songs with the word *Belfast* in the title alone. Although this number is not at all comprehensive, it nonetheless indicates that over the years popular songwriters have continued to regard Northern Ireland's capital as an ideal setting for their songs. It is worth noting that the majority of these songs were actually not written by people who grew up or lived in Belfast.

> Great Britain you are tremendous and nobody knows like me,
> But really what are you doing in the land across the sea? [331]

Since the 1970s there have been many attempts by artists to tackle the politics of Northern Ireland directly. Events in Northern Ireland during the past thirty to forty years have provided songwriters with a great variety of source material. Most of the songs dealing with Belfast or Northern Ireland focus on the conflict, on emigration, and on love across the barricades. Some artists refer to daily experiences, historical events, or choose to mention certain areas of the city as will be shown in a variety of examples here. Stephen Hackett argues that, especially as far as songwriters outside Northern Ireland are concerned, the motives to produce such works should be questioned. The mentioning of Belfast in a popular song by these artists hardly ever goes beyond the awareness that there are, in fact, political and social problems in the North. Hence the statement 'we do care' is simply an approach often reflected in a cultural name check.[332]

[330] see http://www.allmusicguide.com , 13/5/2003
[331] excerpt from Paul Mc Cartney's 'Give Ireland Back to the Irish' (1972)
[332] Hackett, 2003, 1

As a matter of fact, however, it will never be possible to trace the true motives behind each song.[333] Was a song written because somebody just thought it a good idea to write about current affairs or to gain attention for having written a peace song? Did the motive possibly arise out of a guilt complex or charity or even real concern? Did the songwriter feel the urgent need to make a clear statement or to go a bit further to encourage positive solutions with the help of a song? The truth is, we will never be able to tell; and in fact, it does not matter. It is much more important to realize that every song should be judged by the way in which it affects its listener. If the lyrics speak out to an audience, if individuals are emotionally moved by a song or even encouraged, then it is no longer necessary to argue about the initial motive of its creator.[334]

Despite this, there is little doubt that a songwriter's political consciousness goes back a long way. The first examples of popular songs about the Troubles confirming this statement have to include Paul McCartney's 'Give Ireland Back to the Irish'[335] and two songs on John Lennon's 1972 album *Sometime in New York City*. According to Rolston, the John Lennon song 'Sunday, Bloody Sunday' hardly managed to express more than naive or 'even embarrassing' sentiments.[336] The second song, 'The Luck of the Irish' contained the lyrics: 'Should you have the luck of the Irish, / You'd wish you was English instead.' Rolston regards this song as, 'one of the very few pop songs to explicitly condemn the British state's role in the conflict in Ireland.'[337] Another excerpt taken from the song will confirm Rolston's statement:

> Why the hell are the English there anyway?
> As they kill with God on their side!
> Blame it on the kids and the IRA!
> As the bastards commit genocide![338]

[333] for further information see Roland Barthes, 1977, 148

[334] ibid.

[335] banned by the BBC, see Rolston, 2001, 65

[336] ibid.

[337] ibid., 57

[338] ibid.

On the other hand, Boney M's dance beat 'Belfast', released in 1977, can be regarded as a clear example for what Rolston described as the limitations of a pop song. Looking at this particular song, it is even possible to agree with Harker, who argues that pop and politics do not, in fact, mix.[339] The underlying dance beat definitely stated the obvious; this was the Troubles 'going disco.'[340] Hence, the song text is kept simple, containing many repetitions and excluding any serious commentary or political statement.

The late 1970s also saw the appearance of the first punk bands in England. Arising as a response to rock music's decline into commercialism, this genre also appeared to be an ideal social statement fitting those times. The whole idea of punk music is probably best described in Greil Marcus' short definition: 'question everything.'[341] With this type of rebellion, punk musicians were perfectly able to deliver a strong political message through their music. They succeeded in clearly voicing their protest against current developments like unemployment, police harassment, and youth alienation during Britain's period of socioeconomic decline. The frustrations felt by young people living in Britain were not the only subject matter for songwriters in this genre. Before long, the conflict in Northern Ireland became an inevitable, even though only minor, theme for punk musicians. Bands like The Angelic Upstarts[342] and The Pop Group[343] voiced their criticism about British policy in Northern Ireland. Another band, The Au Pairs, reflected sarcastically on the situation of women prisoners in Armagh Goal in their song 'Torture'.[344] An entirely different approach was taken by the band Screwdriver. Their front member, Ian Stuart, became extremely influential regarding the development of right-wing punk through the 1980s. Rolston argues that their song 'Smash the IRA' remained the only punk song that revealed strong support for militant loyalism.[345]

[339] ibid., 50
[340] ibid., 55
[341] in Carruthers, 2001, 201
[342] 'Last Night Another Soldier', EMI 1980
[343] 'Who Guards the Guards?', Rough Trade, 1979
[344] Human Records 1981, see Rolston, 2001, 58
[345] White Noise, 1983, ibid., 58

To conclude on punk music, it is yet necessary to mention folk punk as a new direction taken by the Irish punk band The Pogues. Founded by Shane MacGowan in the early 1980s in London, the band is often credited with the creation of this new genre within punk music. According to Clayton-Lea and Taylor, MacGowan used an exemplary and original songwriting technique, and his song texts could be described as crude but fervently literary.[346] The song 'The Sick Bed of Cuchulainn' reflected a view of the Irish emigrant abroad that had probably never been touched upon in songwriting before.[347] Finally, hard-hitting political lyrics about the miscarriage of justice in the case of the Birmingham bombing and Guildford incident of 1974 could be found in the band's song 'Streets of Sorrow/Birmingham Six,' which was banned by the BBC under the new broadcasting regulations between 1988 and 1994[348]:

> There were six men in Birmingham, in Guildford there's four
> That were picked up and tortured and framed by the law.
> And the filth got promotion but they're still doing time
> For being Irish in the wrong place and at the wrong time.[349]

Throughout the 1980s and 1990s, political developments encouraged a number of artists to reflect on the Troubles in Northern Ireland more seriously. The band Police wrote the song 'Invisible Sun' in 1981, including the lyrics: 'There has to be an invisible sun, / It gives its heat to everyone.'[350] Due to the new broadcasting regulations in force in Britain at that time, the video accompanying this song was also considered to be problematic and thus was retracted shortly after its release.[351]

In 1983, U2's 'Sunday Bloody Sunday', one of the most sophisticated songs, was released. The lyrics, 'Broken bottles under children's feet, / Bodies strewn across a dead end street,' referred to the 1972 event in Derry in which fourteen unarmed civilians were shot dead by British

[346] in Clayton-Lea; Taylor, 1992, 45/46 ('literary' meaning poetic in this context)
[347] ibid.
[348] see Rolston, 2001, 65
[349] Pogue Mahone, 1988, ibid., 58)
[350] ibid., 56
[351] ibid., 65

paratroopers during what was meant to be a peaceful civil rights march. Although this song has always been easily read as supporting the pro-Republican side, U2 immediately distanced itself from such a reading. Whenever the song was performed live, Bono introduced it with the resolute statement: 'This is not a rebel song.' Furthermore, as symbolism has always played such a vital part in the Northern Irish context, it might also be interesting to add that the same singer later on ripped apart the Irish tricolour on stage. After discarding the orange and the green segments, he held up the white segment as the true sign for peace.[352] Over the years, U2 have continuously reflected on political issues in their songs. It is thus hardly surprising that this band has also found its own way of addressing political party members involved in the Northern Ireland peace process, such as John Hume and David Trimble. It was a few days before the Referendum, held after the Good Friday Agreement in 1998, when at a U2 concert in Belfast, Bono Vox brought the two politicians, David Trimble and John Hume, on stage. While performing U2's 'One', the singer stood between the two party leaders holding their hands aloft. The band's reputation and their willingness to tackle this political issue in their own way soon ensured positive media attention in favour of the campaign.

Another song that was released in 1983 was Bananarama's 'Rough Justice', which related to one of the group's road crew, Thomas Reilly from Belfast, who was killed at age twenty-two by the British army in August 1983. However, the song contained only a brief reference to the incident in the chorus. It is therefore rather doubtful whether the majority of listeners were actually aware of these significant lyrics: 'Innocent people passing by, / No time to run before they die. / Don't call that justice.'[353]

Love can overcome all conflict was the message in Spandau Ballet's 'Through the Barricades', released in 1986. The lyrics express a strong sense of hope:

[352] for more information see ibid., 56f.

[353] see Rolston, 2001, 55

Born on different sides of life, but we feel the same and feel
all of this strife,
So come to me when I'm asleep and we'll cross the line and
dance upon the street.
And now I know what they're saying as the drums begin to
fade, and we made our love on wasteland and through the
barricades.[354]

While driving in a taxi through West Belfast, country folk singer Nanci
Griffith found inspiration for her song 'It's a Hard Life Wherever You
Go', which soon featured on her 1989 album *Storms*. Typical images of
Belfast from the years of the Troubles, such as barbed wire, appear at the
beginning of the song. Being driven down the Falls Road by a taxi driver
named Seamus highlights the Catholic connection of the area. While a
sense of responsibility can be recognized in the lyrics, it is nonetheless
obvious that this is an outsider who cannot do anything about the
situation except to observe: 'I am the backseat driver from America / I
am not at the wheel of control'.[355]

The Simple Minds achieved great success with their song 'Belfast
Child' in 1989 and expressed their search for hope for a better future
in Northern Ireland: 'One day we'll return here when the Belfast child
sings again.'[356] In the background of the song, the traditional song 'She
Moved Through the Fair' is played. Underscoring pop songs with folk
and traditional elements has been common practice for a long time.
In an attempt to describe the personality of the place, to evoke purity
and authenticity, Irish traditional music motifs like the one in "Belfast
Child" have often been used in popular music.

Elton John's song 'Belfast' also includes a kind of Irish reel in which the
main melody of the song itself is incorporated. The singer's intention is
yet again to create an authentic atmosphere which enables the listener
to immerse himself in a 'celticized' emotion. In his lyrics, John adopts
the popular outsider's perspective of not being able to understand this

[354] ibid., 56
[355] in Hackett, 2003, 45
[356] in Rolston, 2001, 56

conflict: 'Deep inside my soul fights a war / I can't explain.'[357] The problem with this singer's perspective is, however, that he is English reflecting on the Irish in an all-too-familiar and typically English way. Centuries of turmoil between these two countries have contributed to the stereotyping of Northern Ireland as violent, hostile, and barbaric . . . a place that cannot be explained . . . a mystery. In comparison to the songs about Northern Ireland written by Paul McCartney and John Lennon, the songs of Elton John seem to be strongly influenced by this stereotype. In addition, according to Aaron Kelly, it is also worth noting that his song concentrates on the place itself, on the landscape, while fully denying its population. This is similar to a militarist-tourist view described by a British army officer in the 1960s, 'Beautiful country, shame about the people.'[358] This erasure of the Belfast citizens and their reduction to passivity in this song, Kelly continues, is extremely problematic. Thus, quoting Karl Marx in this context, 'they cannot represent themselves, they must be represented' is not at all far-fetched.[359]

> A jealous green streaks down this faulty diamond
> No bloody boots or crucifix
> Can ever hope to split this emerald island.[360]

Finally, Elton John's pronunciation of the word *Belfast* is clearly revealing. Whereas the vast majority of the Belfast inhabitants would pronounce their city 'BEL-fast' (stress on first syllable), the typical intonation used by the BBC and the Anglophile upper class living in the city itself is 'Bel-FAST' (stress on second syllable). By choosing the latter intonation while singing this song, Elton John is without doubt distancing himself completely, and thus gives evidence that his is an outsider's perspective based on stereotypes. According to Kelly, the singer's attitude could even be perceived as an insult by people living in Belfast due to the songwriter's ignorance of their lives as reflected in this song.

[357] in Hackett, 2003, 11
[358] in Hackett, 2003, 11
[359] Marx , ibid.,13
[360] ibid., 14

Another theme songwriters have continued to focus on is the reference to historical events. This is clearly illustrated in the case of the Cranberries' song 'Zombie', in which the central date of republican history, 1916, becomes an excuse for the continuation of violent republicanism today: 'It's the same old theme since 1916. / In your head, in your head they're still fighting.'[361]

History is also referred to in the case of the hard-hitting rap number 'Fenians' by Seanachie[362] in which the involvement of Irish-Americans in the fight for Irish independence is referenced. It became very fashionable in the early 1990s to incorporate rap and reggae styles into popular music. Because this style was closely associated with Bob Marley and regarded by many as a powerful critique of capitalism and colonialism, one could have argued that reggae would also encourage songwriters to use the Northern Irish context as a favourite theme. Whereas reggae originated in Jamaica in the 1960s, rap music emerged rather recently in the hip-hop subculture of black inner-city areas in the United States. Police brutality, gang fights, and ethnic wars were all elements of this African American youth street culture, and thus found reflection in their music. Of all the groups who incorporated reggae and rap elements into their music, only three took on the challenge of reflecting on the Northern Irish context. According to Rolston, Seanachie[363] and Black 47 from New York succeeded in mixing pop and politics. The latter chose an anti-imperialistic approach in their song 'Fire of Freedom'[364]:

> You can break down my door, you can even strip search me,
> Never gonna take away my human dignity.
> Beat me, shoot me, flame keep on burnin',
> Never gonna put out the fire of freedom.

[361] from 'Zombie', Island, 1994

[362] 1997, in Rolston, 2001, 63

[363] Seanachie's song 'Fenians' became very popular in 1997 when the band played at the annual open-air West Belfast Festival. According to Rolston, it became one of the most requested and most played songs on the local radio station Triple FM in 1997 (ibid., 64)

[364] EMI 1993, ibid.

English-based band Marxman, featuring the son of legendary Donal Lunny, combined their Marxist ideals with rap elements. Injustice felt by the Irish community and colonialism on a more global scale were reflected in their song 'Sad Affair':

> I had a dream of days to come
> When orange only meant the summer sun
> And not the knife that cuts apart
> A nation's soul a nation's heart.[365]

The symbolic theme of a woman representing Ireland has a long history in Irish drama (for example, W. B. Yeats and Augusta Gregory's play, *Cathleen ni Houlihan*), poetry (for example, Seamus Heaney's *Act of Union*), and song writing (e for example, the 1870s Irish ballad *Poor Old Granuaile*). It is therefore hardly surprising that this image has also been used in the fields of popular music. In 1996, The Golden Palominos released their song 'Belfast' in which the city itself is described in the form of a female personification. Despite the fact that Northern Irish women are very active in trade unions, women's groups, and community organizations, Susanna Chan argues that the majority of political and religious organizations in the North still exclude women from the public sphere.[366] Writing a song about Northern Ireland's capital and using that kind of symbolism is therefore rather problematic if not even extremely provoking. Once again the colonizer becomes the dominant masculine to which the feminine/colonized has no other choice but to submit to subjugation. The woman's body becomes the site of contested territory. No matter what you do to her—abuse her, rename her—this woman will remain a mystery to her masculine opponent. This song is a clear example for the reduction of a woman to her sex and is thus, indeed, provoking in the context in which it is used; namely, to reflect on Northern Ireland's capital:

> Sewn into her dress, she can't refuse
> (careful what you love, what you abuse).
> She knows violence, she knows peace

[365] 'Sad Affair' by Marxman, http://www.lyricseek.net , 18/1/2003
[366] S. Chan in Hackett, 2003, 37

Her hands for cuffing and she says nothing
And hooks her hands behind her knees.[367]

In James Taylor's song 'Belfast to Boston',[368] another outsider's perspective on the Northern Irish conflict is presented. It is a call to all sides involved in the Troubles to put the past behind, to forgive one's foes, and to start building a future based on peace and reconciliation. For Taylor, as for many other songwriters, the Troubles are a subject of the past, and it is there where this 'ancient hatred' should be buried. Many of the 'rifles buried in the countryside' had been sent over in the past from America to support the Fenian movement in the fight for Irish independence: 'May they lie there long forgotten / Till they rust away into the ground.' The message is clear: no more 'weapons, money, and vengeance', but a 'blessing of forgiveness' should now be sent across the Atlantic. This blessing could help to overcome all injustice. It might contribute to willingness for compromise, encouraging even enemies to eventually shake hands and 'take the devil for a countryman.' The suffering caused by a war between two religions has been going on for far too long:

Missing brothers, martyred fellows
Silent children in the ground
Could we but hear them would they not tell us
'Time to lay God's rifle down'[369]

While various themes have been frequently used in popular songs to reflect on the Troubles, it is worth noting that a method described by Rolston as 'lyrical drift' also helped to broaden the repertoire of songs about the conflict in the North. Lyrical drift occurs whenever the meaning of a song is taken out of its original context and is reinterpreted by an audience in a different political context. Tina Turner's 'Simply the Best' was not only used by the Ulster Volunteer Force throughout the 1990s to 'refer to the organisation's efficiency at assassinating nationalists', but continues to be a favourite song in loyalist clubs

[367] from Golden Palominos, 'Belfast', , ibid.
[368] on James Taylor, October Road, EMI, 2002
[369] ibid.

today.[370] In this connection it might be worth noting that, whenever musicians are asked to play in either loyalist or republican clubs and bars throughout Northern Ireland today, it is still of vital importance to have a few 'appropriate' songs in reserve. For republican bars, such songs would include 'The Fields of Athenry'; whereas 'Simply the Best' can be regarded as the favourite number in loyalist clubs. Many musicians have in fact stopped playing gigs because they can no longer cope with the pressure being put on them. Playing in a loyalist bar, for example, singers were demanded to sing this Tina Turner song with a small alteration in the text: 'Fuck the pope and the IRA.' The Boomtown Rats' number 'Rat Trap' can be regarded as another example of lyrical drift. This song was used by Irish National Liberation Army (INLA) supporters after Billy Wright, leader of the Loyalist Volunteer Force, was killed by members of the INLA in prison.[371]

There are many more popular songs that reflect the Troubles, and the selection of songs discussed so far serve only to give a rough idea about the vast amount of popular song material that exists on the subject. Although the peace process has begun, contemporary popular music artists continue to reflect on Northern Ireland occasionally in their creative work. The following remarks on Katie Melua's song 'Belfast', released in 2003, serve to prove this trend and will conclude the second part of this chapter. The young and talented singer/songwriter was born in Georgia in 1984. She moved to Northern Ireland in 1993 where her father had been offered to work as a heart surgeon in a Belfast hospital. Five years later, she moved to London with her family. According to Melua, she enjoyed her childhood in Northern Ireland and had great ambitions for her future:

I had a great childhood both in Georgia and Northern Ireland. I found the people in Northern Ireland extremely warm and made great friends at St. Catherine's primary school and Dominican College, Fort William. I went to catholic schools in Northern Ireland while my younger brother went to a protestant school. [. . .] I didn't always want to be a singer or songwriter. My ambition when I was thirteen was to be a politician or a

[370] Rolston, 2001, 55

[371] 'It's a rat trap, Billy, and you've been caught', for more information see ibid., 55

historian. I honestly thought I'd be able to bring peace to the world
If I ruled it![372]

Katie Melua's first album, *Call Off the Search* (2003), was released and
reached number one in January 2004.[373] The song 'Belfast', featured on
the album, sees the singer-songwriter returning to Belfast and describing
the city in a very unusual way. With all the songs that have been written
about Northern Ireland in the past, this is the first song that uses animals
to describe the division within the Northern Irish community.

> I've got a ticket,
> To the fast city,
> Where the bells don't really ring,
> Getting off the plane the cold air,
> Rushes like bullets through my brain,
> And I'm divided between penguins and cats,
> But it's not about what animal you've got,
> It's about being able to fly,
> It's about dying nine times,
> Aah x 2
>
> Walked on Broadway,
> Going up to falls,
> With the old man I used to know,
> The paintings on the walls of release,
> Are colourful but they are no Matisse,
> And I'm divided between penguins and cats,
> But it's not about what animal you've got,
> It's about being able to fly,
> It's about dying nine times,
> Aah x 2 [374]

In looking at the two animals—penguins and cats—presented in the
song, it can generally be stated that penguins do not have the ability

[372] in http://www.katiemelua.com, 25/11/2004

[373] ibid.

[374] in http://www.katiemelua.com, 25/11/2004

to fly. Cats, on the other hand and according to mythology, are said to have nine lives. People living in the North, it could therefore further be argued, have to have the strength to survive in these surroundings (like a cat) as they do not have the ability to fly away (like a penguin) and escape from the turmoil and violence all around.

3

Northern Irish Artists

Stuart Bailie argues that 'popular music in Northern Ireland has a history that's messy, maddening and just a bit remarkable.'[375] At the same time, however, he continues that Northern Irish musicians 'have excelled in the fields of pop, dance and rock and roll in defiance of the problems that geography and economics have thrown at them.'[376] Bailie believes that over the past thirty-five years, popular music has been a key medium in Northern Ireland, and some of the now-more-famous musicians are even reserved for important civic events, such as performing for presidents and the like. Artists like Van Morrison, Paul Brady, Brian Kennedy, and Juliet Turner, while articulating aspirations or even nightmares felt in Northern Ireland, have already taken on the world stage. In Bailie's opinion it is even more: 'They have taken advantage of pop's great democratic force by which a novice can create a fresh musical statement without academic training or heavy investment.'[377]

From a more general point of view, one should add that Irish rock and even pop music have long found a niche in global culture. British Prime Minister Tony Blair once stated that 'Ireland has also become a leader in popular culture, bringing us U2, The Corrs, Boyzone, Westlife and B*witched.'[378] One of the major reasons that so many Irish and Northern Irish artists gain so much popularity abroad is 'their ability to slot into a widespread definition of Irishness as mystical and spiritual.'[379]

[375] Bailie in Carruthers, 2001, 191
[376] ibid
[377] ibid
[378] in Paddy Logue, 2000, 13
[379] see in Rolston, 2001, 53

By now it is both difficult and even unwise in terms of marketability for Irish artists to ignore where they are coming from. Even various pop stars include a version of an Irish traditional song in their repertoire[380] or interweave Irish dance music in their hits.[381] It could thus be argued that, in an Irish/Northern Irish context, Irish traditional music and popular music cannot be separated as such. Looking at the musical career of artists from both the south and north of the island, there is, however, a clear distinction. Rock and pop singers from both sides of the country hardly ever describe themselves as Irish traditional music artists simply because they might include a version of a traditional Irish song in their repertoire. While some might have started their careers in Irish traditional music, they have since decided to move on to the rock and pop music scene. Irish traditional music artists, on the other hand, would not describe themselves as popular music artists. Even though their music has evolved enormously over the years[382] and new musical instruments have since been integrated into this genre, such as guitar and flute, it is still Irish traditional music these artists are playing. There is thus a clear distinction in the Republic of Ireland and Northern Ireland between being a traditional Irish music artist or a rock and pop artist. Irish traditional music is alive and well, and it is therefore hardly surprising that popular music artists from both sides of the country acknowledge this fact by incorporating elements from this tradition, which is part of their own cultural background, into their creative work.

Chapter III has already thoroughly examined traditional musical developments in Northern Ireland from around the mid twentieth century onwards. At this point, however, the popular music scene in the North will be examined in greater detail.

1950s and 1960s

Showbands became the predominant feature in the whole of Ireland around the 1950s and 1960s when the interest in both ceili dancing and

[380] e.g. B. Kennedy: 'Carrickfergus'; Boyzone: 'She Moved Through the Fair'

[381] e.g. The Corrs: 'I Never Loved You Anyway'; B*Witched: 'C'est La Vie'

[382] see Chapter III for more information

Irish traditional music went into decline. Traditional instruments were replaced with trumpets, saxophones, trombones, and electrical guitars. These big bands, usually including from eight to twenty musicians, often played cover versions of popular hits and country music. After mainly touring Irish village halls, most of the musicians grew to regard themselves as elite and started playing bigger shows, using more expensive equipment than the smaller groups. Rory Gallagher played with the Fontana Showband and was soon considered in the same league as rock guitar legends Jimi Hendrix and Eric Clapton. Another artist started his musical career in a showband in the 1960s. Bailie describes Van Morrison as 'one of the few totems people in Northern Ireland can be proud of.'[383] Morrison has always been passionate about the music he grew up with and especially enjoyed his father's rich record collection. He was very familiar with 'beat' music and the rhythm and blues phenomenon when it came to Belfast. It was therefore hardly surprising that, after spending some time with a showband called the Monarchs, he took the initiative and became front man of the legendary band Them. Their first chart hit was a version of 'Baby Please Don't Go' in 1965, soon to be followed by 'Gloria', which has since become a famous classic.

Van Morrison started his successful solo career in 1967 with the song 'Brown Eyed Girl'. The rest is history and can be traced from various literary sources that have been published over the years. *Astral Weeks*[384], Morrison's first solo album is today regarded as one of the great achievements of twentieth-century popular music. On the album, the singer reflects on childhood memories, the experience of mysticism, and the journey through adolescence to adulthood. Martin McLoone argues that this early Van Morrison album, which contains a cycle of songs about Belfast, remains one of the most evocative portraits of this city produced in any art form. According to the same author, Morrison's greatest achievement over the years has been to offer a very different vision of his hometown compared to the image of violence and conflict that continues to dominate the media. In other words, he creates 'a parallel Belfast of the imagination, insulated and isolated from the grim

[383] Bailie in Carruthers, 2001, 194
[384] 1968, Warner

and gruesome realities of the Troubles.'[385] While there have doubtless been many attempts in the past to reflect on the Troubles in Belfast in song, McLoone is convinced that Morrison's Belfast has a far greater artistic and social integrity.

> And meeting down by the pylons
> Playing round Mrs. Kelly's lamp
> Going out to Hollywood on the bus
> And walking from the end of the lines to the seaside
> Stopping at Fusco's for ice cream
> In the days before rock 'n' roll
> Hyndford Street, Abetta Parade
> Orangefield, St. Donard's Church
> Sunday six bells, and in between the silence there was conversation
> And laughter, and music and singing, and shivers up the back of the neck.[386]

Morrison continued his successful career throughout the years and has, up to now, released forty albums—a new album almost every year. His interest in Irish identity and traditional music re-emerged in the 1980s and reached its high point in his collaboration with the Chieftains on the album *Irish Heartbeat* (1988). Morrison's quest for spiritual answers has, over the years, also been a major inspiration for his songwriting. Songs like 'Lifetimes',[387] 'Full Force Gale',[388] 'Dweller on the Threshold',[389] and 'Ancient Highway'[390] to name just a few well reflect his personal interest in spiritual matters. As Morrison has always believed in the healing power of music, he also became very interested in some concepts of the Wrekin Trust. This organization was searching for methods to awaken people's spirituality and to bring the exposed spiritual energy into society. In 1987, Van Morrison performed

[385] Martin McLoone in Hackett, 2003, 52
[386] from 'Hyndford Street', on Hymns To The Silence, 1991
[387] on Wavelength,1978
[388] on Into The Music, 1979
[389] on Beautiful Vision, 1982
[390] on Days Like This, 1995

at a conference organized by the Wrekin Trust entitled The Secret Heart of Music: An Exploration Into The Power of Music to Change Consciousness.[391]

Starting off with *Astral Weeks* and looking at his presently latest album *Born to Sing: No Plan B*,[392] this singer and songwriter has, like no other Northern Irish artist, constantly dealt with his cultural background. From a more general point of view, it could be argued that Morrison turned his back on the troubled situation in Northern Ireland long ago and chose to live in exile most of his life. Nonetheless, through his outstanding talent as a songwriter, he has found a unique way of contributing enormously to the body of existing song material on Northern Ireland.[393] In 1993, Morrison received an Honorary Doctorate from Ulster University. Two years later, the singer performed before Bill Clinton's speech on Clinton's historic visit to Belfast and Derry. His encouraging song, 'Days Like This',[394] was well remembered after Clinton's visit and soon became the theme of peace chosen by the Northern Ireland Office in a million-pound peace campaign following the 1994 ceasefire. When the album *Across the Bridge of Hope* (1998) was released in tribute to the victims of the Omagh bombing,[395] a moving acoustic version of Morrison's 'Healing Game' was included. Rolston argues that Morrison's life-long search for identity through his music has ensured him the reputation of being one of the world's most thoughtful rock singers-songwriters.[396] This was further confirmed when, in 1994, Morrison accepted a Brit Award for his outstanding contribution to British Music.[397] Chapter VI will take a closer look at this artist's song material and will reveal various aspects regarding Morrison's Northern Irish background.

In 1964, Phil Coulter's song 'Foolin' Time' was recorded by the Capitol Showband. Coulter, who occasionally assisted during sessions with the

[391] see Turner, 1993, 155
[392] Blue Note Records, 2012
[393] for further details see chapter VI.
[394] on Days Like This, 1995
[395] 15th August 1998
[396] see Rolston, 2001, 53
[397] in Carruthers, 2001, 208

band Them, soon became most successful. His achievements in the music business are manifold. Besides delivering early Eurovision hits,[398] he has also supported and highlighted the careers of various groups and singers such as Planxty, the Bay City Rollers, and Sinead O'Connor. Recent years have seen Coulter making a series of *Tranquillity* albums, which have been very successful at home and abroad. For his latest albums, he was also nominated for a Grammy award in 2001. The fact that Coulter was born in Derry contributed to some of his most remarkable song material. 'The Town I Love So Well' is a lasting masterpiece in which he undeniably reflects on the shocking changes that his hometown saw during the height of the Troubles.[399] More specific information on this artist, his upbringing in Northern Ireland, and his songs about the Troubles can be found in Chapter VI.

1970s

In 1975, the UVF decided to plant a bomb in the van of the Miami Showband who were to travel from Banbridge to Newry at the time. Assuming they had been stopped by the police at an ordinary Ulster Defence Regiment (UDR) checkpoint, the band members soon found themselves standing in a line at the ditch with their backs to the van while their luggage was taken out of the car, examined, and reloaded. A few minutes later, the bomb exploded prematurely. In the fracas that followed, several band members were shot and killed.

> Peace to the souls of those who unlike my confrere
> Were true to their trade
> Despite death-dealing blackmail by fanatics and racists:
> You made music, and that was all: You were realists
> And beautiful were your feet.[400]

[398] e.g. 'Puppet on a String' (1967, Sandy Shaw), 'Congratulations'(1968, Cliff Richard), 'All Kinds of Everything' (1970, Dana)

[399] for further information see chapter VI.

[400] from Paul Durcan's poem "In Memory: The Miami Showband: Massacred 31 July 1975." in Ormsby, 1992, 202

Many musicians still recall this tragic event and how the Northern Irish music scene gradually became severely depressed during the 1970s. A lot of Northern Irish musicians soon experienced a kind of 'cultural cringe'. Many of them lost their confidence that they could achieve great success, and only a few musicians managed to play for an international audience. With international musicians, there was a similar problem. With a few exceptions like Rory Gallagher, who remained a regular visitor from the south of Ireland, or Led Zeppelin, hardly any international performers came visiting after the Miami Showband killings. Belfast city centre became deserted at night, and the interest in music as well as the infrastructure itself went into decline. The whole situation was doubtless a severe blow to the showband scene as well.

During this period, many musicians preferred to migrate to Dublin. This is where the music happened and was able to unfurl itself. At that time artists such as Christy Moore, Donal Lunny, Andy Irvine, and Paul Brady were already engaged in transforming the 1950s and 1960s sound[401] into the modern phenomenon of folk rock. Bands like Horselips, Planxty, and especially Moving Hearts succeeded in directing Irish folk towards rock and, in the case of Moving Hearts, even jazz. Without merely aping international trends, Irish bands gained international reputation and manifested what soon came to be known as 'Celtic rock'. Thin Lizzy, with front man Phil Lynott, was then probably the most famous band with Northern connections. Their version of the traditional song 'Whiskey in the Jar' reached number six in the British single charts in February 1972. Two of the players, Eric Bell and Eric Wrixon, were both from Belfast and had previously been part of Them's line-up. Gary Moore was another Northern Irish player who replaced Bell in Thin Lizzy; he later had a successful solo career returning to blues and making several records. Guitarist Henry McCullough, originally from Portstewart, started his career with the band Éire Apparent and toured with Jimi Hendrix in 1968. Since then he has played with Joe Cocker at Woodstock, joined Paul McCartney in Wings, and has also worked with several other artists like Roy Harper and Marianne Faithful.[402]

[401] as reflected in songs by the Clancy Brothers and the Dubliners
[402] Bailie in Carruthers, 2001, 197

Other singers from Northern Ireland who had remarkable success in the 1970s include David McWilliams from Ballymena with his hit 'The Days of Pearly Spencer'; Eurovision contender Clodagh Rodgers, originally from Newry; and Dana, a surprise discovery who won the Eurovision Song Contest with 'All kinds of Everything'[403] in 1970.

Between 1970 and 1980, another Irish band experienced huge success. Horslips were famous for their wonderful combination of traditional music with rock and pop. Their bass player was Barry Devlin from Omagh, who later also produced an early U2 session and still features in film and television today.

It was also around the late 1970s that punk rock arrived in Ireland. It soon encouraged many Irish and Northern Irish musicians to start anew. Beside the more general characteristic of youth rebellion, a new dimension was added to the punk music in Northern Ireland. It was through punk that some musicians discovered the challenge to write about social politics and about the cruel reality of living in Northern Irish towns in particular. While punk groups from Northern Ireland found it a lot more difficult to reflect on armed struggle, state repression, and violence in their songs than songwriters from outside the island, they still reflected on the problems surrounding them in song. A whole generation of fans was now again, through the new music, able to participate in the highly dramatic time in Northern Ireland. Although hardly ever a direct comment on political developments was made, punk music in Northern Ireland was viewed by many, especially outside of Ireland, as able to 'break down sectarian barriers' and to 'bring young people together.'[404] Punk music in Northern Ireland meant uniting young people in their expressed anger about society and voicing a plea for some space in these violent and repressive surroundings: 'They take away our freedom in the name of liberty. / Why can't they all just clear off? Why can't they let us be?'[405] More and more live venues opened in Northern Ireland throughout the late 1970s and early 1980s. Punk bands from outside the North usually showed no fear when it came to

[403] written by Phil Coulter
[404] in Rolston, 2001, 53
[405] from 'Suspect Device', Stiff Little Fingers, EMI 1979, , ibid., 59

playing in these new venues either. The music scene flourished once again, and the impact of Northern Irish musicians like The Outcasts, The Undertones, The Defects, The Tearjerkers, and Rudi was enormous.

Without a doubt, Stiff Little Fingers from Belfast became the most important band in the area of punk rock in Northern Ireland. Songs like 'Alternative Ulster', 'Wasted Life', and 'Barbed Wire Love' powerfully and shamelessly expressed the nightmarish situation these artists found themselves in.

> Take a look where you're livin'
> You got the army on your street
> And the RUC dog of repression
> Is barking at your feet.[406]

Another song, 'Suspect Device', even calls on the people of Northern Ireland to take responsibility for their own lives in a very provoking way: 'I'm a suspect device the army can't defuse / You're a suspect device they know they can't refuse / We're gonna blow up in their face.'[407] In addition, the band consciously makes use of a terminology Northern Irish artists had become very familiar with. *Booby traps* and *kneecaps* feature in the song 'Barbed Wire Love'. According to Muldoon, there is also a certain wit to the lyrics of that song, considering the rather conventional image of Ireland as a woman until then. A shocking fusion of sex and violence once poetically described by Seamus Heaney in his poem 'Act of Union' can now be traced from the lyrics:

> Blasted by your booby traps
> I felt the blow in both kneecaps
> Your eyes did shine. Your lips were fine
> And the device in your pants was out of sight.[408]

Perhaps Stiff Little Fingers realized at one stage that they had gone a bit too far with their provoking song material, and thus they soon turned to

[406] from 'Alternative Ulster' in Hackett, 2003, 10
[407] in Hackett, 2003, 9
[408] ibid.

more traditional rock songs. However, it was this group that paved the way and gave evidence that success was also possible for Northern Irish punk rock bands.

There was no other Northern Irish music at that time that expressed the devastating social and political dilemma as clearly as punk rock. As anger was expressed by Stiff Little Fingers, so it was also expressed by Rudi in 'We Hate the Cops' and by The Defects, whose song 'Brutality' reflected on a supposed stay at the Royal Ulster Constabulary (RUC) holding centre in Castlereagh. The Undertones, with singer Feargal Sharkey, produced the wry song 'It's Going To Happen' during the republican hunger strike. It soon became obvious that the song was meant as an allusion to the shocking developments at home. The Ruefrex from Belfast regrouped in 1985 and concentrated on articulating the unionist case. In their most significant song, 'The Wild Colonial Boy',[409] they ridiculed Irish-American support for militant Irish republicanism: 'It really gives me quite a thrill / To kill from far away.'[410] On the single sleeve, an ArmaLite in wrapping paper was pictured, hinting that it was ready to be sent home to Ireland. This song, despite its contradictory content, soon helped to raise enormous funds in America for the Troubles in Northern Ireland.[411]

1980s

In the 1980s there was again an important change in the music industry, and according to Bailie, this new period was all about 'branding, design, visuals, irony and post-modernism.'[412] While musical creativity flourished elsewhere, including acts such as Boy George, Duran Duran, and Simple Minds, the music scene in Northern Ireland seemed to

[409] Kasper, 1985, in Rolston, 2001, 59

[410] ibid.

[411] other songs tackling the Troubles by Ruefrex are 'Paid in Kind' (Kasper 1985) and 'On Kingsmill Road' (Flicknife), see ibid., 67

[412] Bailie, 1997, 206

decline once again: 'Belfast was back to the feast-or-famine syndrome,' according to Bailie.[413]

After the successful punk years in the North, attention was now again diverted to Dublin where U2 began a successful career. In addition, Bailie believes that U2 had an enormous impact on building up a music business infrastructure by deciding to work from their hometown. Since then, Dublin has gradually gained the recognition as an international centre for music. Meanwhile, the Northern band Silent Running had little chance to compete. Another band, The Adventures, were rather successful for a while and are still well remembered for some memorable songs and great harmonies. The catchy number 'Broken Land' (1984) not only entered the charts very quickly, but also became the most-played record on the UK's pop station BBC Radio 1 in 1988. Reflecting on a country being divided through conflict and the absurdity of this division, the song also expressed the belief that love can still overcome all: 'So much confusion to this plan / These times are not changing / show me the love to keep us together.'[414] Feargal Sharkey briefly continued with his career, as did two other Undertones, John and Damian O'Neill. Other 1980s musicians with Northern Ireland connections and of rather different importance include Jive Bunny and the Derry-based group Baltimora who scored a hit with 'Tarzan Boy' in 1985.

At this stage, however, it is important to note that, although most of the artists decided to leave their home at the time, they still contributed to keep the Northern Irish music and song tradition alive. Places like Belfast simply did not offer them enough opportunities, and for obvious reasons nightlife was not really great and concert venues were rather sparse. In other words, the preconditions for musicians did not at all feel right in Northern Ireland, and therefore, they decided to leave. Some left and never returned. Others left for a while and decided that they could get inspiration only back at home. Others returned and rediscovered their roots and cultural background and then left again in order to make a decision.

[413] ibid.

[414] in http://www.inlyrics.com/lyrics/A/Adventures/ , 2/2/2003

Some Northern artists, although they did not stay in Northern Ireland, still made contributions in their own right.

Andy White soon ascended to the status of important songwriter. He wrote in the style of Bob Dylan and could be found commuting between London, Belfast, and Dublin. Later, he worked in Switzerland and Australia. Over the years, White has been committed to contributing to but also to drawing from his native Northern Ireland. His first album *Rave on Andy White* (1986) was largely concerned with voicing the experience of growing up in 1970s and 80s Belfast. In his song 'The Walking Wounded' he reflects on the insanity of this conflict, referencing the day-to-day headlines in the news in which killers achieve fame, if only for a short moment in time:

> Whicker's city of car blasts
> There's violence in the air
> Suppressed beyond beliefs
> There's only violence for their heirs
> Herded into the queue
> For the last item News at Ten
> Those vital statistics beckon
> Condemning leaders condemn
> Famous for fifteen seconds
> The trigger pulls from the past
> Short paragraph tomorrow's paper
> Can't wait for the weather forecast[415]

Another song, 'Religious Persuasion', reflects the struggle to come to terms with the role religion has played in the conflict in Northern Ireland. The song finishes with a clear message to the religious groups: 'Someone's got to stand up or nothing's gonna change / Till religion is rearranged.'[416] Although he graduated from Cambridge and initially pursued most of his musical ambitions in London, White returned to his homeland in 1990 to write his third album, *Himself.* This rediscovery of his roots reveals itself

[415] excerpt from 'The Walking Wounded' in http://www.AndyWhite.com, 5/2/2004
[416] excerpt from 'Religious Persuasion', Rave On Andy White (1986), http://www. AndyWhite.com

in the sophistication of his music. For White, it was always important to write and record songs locally: 'You just can't write songs about running around on the tube—on the Circle Line—it just doesn't happen.'[417]

In 1981, Paul Brady's album *Hard Station* was released. This music saw the traditional folk singer moving on to the more general rock music base. Even though the album was a bit of a shock for traditional music fans, it soon ensured Brady international success. Later albums were successful as well, and some of his songs have since been recorded by artists like Cher, Carlos Santana, and Tina Turner. In the 1990s, Bob Dylan recorded 'Arthur McBride', one of Brady's earlier songs[418] and even called Brady a 'secret hero' on his 2001 album *Biograph*.[419] On one of Brady's own recent albums, *Oh What A World* (2000), he collaborated with Carol King and Ronan Keating.

Energy Orchard was a London-based band with Northern connections. The line-up included former members of the Bankrobbers and Ten Past Seven. Singer Bap Kennedy has since found himself more attracted to blues. His long admiration for Van Morrison was rewarded in October 2002 when he played as a supporting act at Morrison's concert at Belfast's Waterfront Hall. One of Kennedy's earlier songs, 'Sailortown', saw him creating a myth of his hometown Belfast that was similar to the one described on Morrison's album *Astral Weeks*. In another song, 'The Ghosts of Belfast', serious concern about the Troubles of the city is expressed during a fictitious conversation with a friend who might no longer be present. The ongoing struggle to overcome the city's troubled past is portrayed through the eyes of an individual who wants to be reconciled to a friend. It might not be easy for an individual to admit to make mistakes: 'I wish I could practice / The things that I preach.' However, 'You'll be a long time in the grave / And you can't live in the past.'[420] In other words, it is about time to lay the ghosts of the past to rest . . . 'to live with yourself' and move on:

[417] White in Fortnight, February 1990, 31

[418] on Andy Irvine and Paul Brady, 1976

[419] in Carruthers, 2001, 208f

[420] from 'The Ghosts of Belfast', on Domestic Blues (1999), see: http://www.bapkennedy. com, 5/2/2004

I've got my reasons
I've got my pride
My glass is half full
But it's cracked on the side
I wish I could take back
The things that I said
Never mind there's better times
Just up ahead.[421]

Brian Kennedy, Bap's younger brother, started his successful solo career also with Ten Past Seven in the early 1980s. Although gaining considerable local interest, Ten Past Seven failed to get a record deal in Belfast. According to Brian Kennedy, this was hardly surprising at that time 'because the message was loud and clear: London = success and Ireland = failure.'[422] In 1985 the band moved to London and became Energy Orchard. Although life in the capital as a musician was hard, Kennedy appreciated the experience: 'I was eighteen when I left Belfast. I'm twenty-three now, and certainly I've grown up a lot . . . I did a lot of soul-searching and a lot of finding out about myself. And I'm much more confident as a singer and a writer.'[423]

1990s

In the late 1980s, when Brian Kennedy began his solo career, his first solo outings found the singer mostly in small clubs and bars being accompanied by a pianist. His songs are tender and passionate, and seem to be markedly different from the melodic pop mostly associated with Irish groups. Kennedy's singing style, including his high tones, was soon appreciated and successful in Ireland. When Van Morrison discovered the singer, he recognized the talent and contributed to his first success abroad by taking him on several world tours and featuring him on many of Morrison's own recordings since 1994.

[421] ibid.

[422] Kennedy in Logue, 2000, 92

[423] B. Kennedy in Fortnight, March 1990, 31

Throughout the 1990s, Kennedy released a number of bestselling albums. His 1996 album, *A Better Man,* confirmed his reputation as a critically acclaimed singer-songwriter when it achieved quadruple platinum sales status in Ireland and led to an Irish Music Industry Award (IRMA) for best Irish male album and a Hot Press/TV Award for best Irish male artist.[424] In 1999, the duet 'These Days', featuring Ronan Keating, from Kennedy's newly released album, *Now That I Know What I Want,* reached number three in the national Irish singles chart and achieved platinum status. The year 2000 saw the artist making his Broadway debut in *Riverdance* in New York, singing new songs especially written for him by *Riverdance* composer Bill Whelan, and participating in a total of 290 performances in the Broadway production at the Gershwin Theatre. The same year also saw Kennedy entertaining President Bill Clinton at a New York Democratic fundraising dinner.[425]

In 2004, after the success of the first in 2002/3, a second BBC series of *Brian Kennedy On Song* featured the singer performing and reflecting on traditional Irish songs. Besides, following the great success of his first novel *The Arrival of Fergal Flynn,*[426] the multitalented artist published his second novel, *Roman Song,* in 2005.[427] Kennedy has since returned from England, and like many other Northern Irish singer/songwriters such as Van Morrison, Paul Brady, and Phil Coulter, decided to settle down in the Republic of Ireland. His upbringing in West Belfast, however, certainly shaped his perspective on various aspects of life and hence also inspired some of Kennedy's own songwriting.[428] Chapter VI will therefore return to this artist and take a closer look at his song material.

In 1994, Northern band Therapy? sold more than half a million records. Their noisy sound and shocking song material ensured success in Germany and many other parts of Europe. Inspired by American hardcore bands like Big Black, they 'dropped into an era getting ready

[424] from http://www.briankennedy.co.uk , 10/11/2004
[425] for further information see ibid.
[426] 2004, Hodder Headline Ireland
[427] 2005, Hodder Headline Ireland
[428] for further information see chapter VI.

for grunge and the new gospel for teen angst'.[429] Instead of dealing directly with the situation in Northern Ireland, they preferred singing ambivalent songs about serial killers, and delivered crazy lyrics such as 'I'm twisted, I'm bitter, James Joyce is fucking my sister.'[430] According to Bailie, the band's success is still ensured, and in his opinion Therapy? has 'prevailed through a series of misfortunes, outliving the faddish side of the business, periodically returning to the touchstone of punk.'[431]

From Downpatrick, Ash started their career in the late 1970s, but was later discovered by a London manager. Described as being a 'more tuneful and wistful variant' of Nirvana, the band first gained appropriate recognition in the mid 1990s. At that time, a huge demand for young energetic bands had been created by acts such as Oasis and Blur. Thus, Ash's first album, *1977*, entered the UK charts and became number one in 1996. With the album *Free All Angels*, the band made their comeback in 2001, and the single 'Shining Light' ensured that this album reached number one in the UK charts once again. In addition, a number of clever publicity ideas have also contributed to the band's great success. To give just one example, for their 2001 UK tour, they encouraged their fans to nominate playing venues by voting online.[432] Many of their songs clearly reflect some ideas the younger generation in Northern Ireland have been brought up with and come to believe in:

> We all live beneath a dying sun
> Used to believe in something, that's been shot to fuck
> I'm bored with this century yeah I'm sick of it all
> Here I am standing on the killing floor.[433]

[429] Bailie in Carruthers, 2001, 209

[430] ibid.

[431] ibid.

[432] see http://www.ash-official.com , 5/2/2004

[433] excerpt from 'Fortune Teller' on Nu-Clear Sounds, 1998 on http://www.musicsonglyrics.com , 5/2/2004

On 19 May 1998, Ash supported U2 at their concert in Belfast's Waterfront Hall, which, as mentioned earlier, was intended as a support act for the Good Friday Agreement and the Referendum.

Other bands like Butterfly Child, Snowball, and Joyrider made some successful singles over the years. Joyrider chose the title *Be Special* for their album, which can be regarded as an ironic allusion to the situation in the North. The Newry band, The Four of Us, made their contribution with their legendary hit 'Mary' in 1992 and were soon described in *Q* magazine as the, 'best straight rock band to come out of Ireland in years.'[434] With the album *Classified Personal* the band celebrated their comeback in 1999 and has since played regularly at different concert venues all over Ireland. While their 2001 album *Off the Record* can more or less be regarded as a 'best of' album, the band's album Heaven & Earth (2003) includes a great variety of new song material. Typical Northern Irish imagery such as 'Army checkpoints and thin white lines'[435] appears in some of these songs.

Kieran Goss gave his first performance at Queen's University Belfast while he was a third-year law student. Since then he has toured with famous musicians such as Elvis Costello, Christy Moore, and Nancy Grifith; he has also frequently performed in Germany. Even though the artist has spent much time abroad, he has also realized that he can find inspiration close to his home in Mayobridge, County Down, where he was born.[436] There are presently nine albums by the artist. Within nine months of its release, his 1998 album *Worse Than Pride* sold 30,000 units and attained double platinum status. In the same year the artist was voted best contemporary artist of 1998 by *Irish Music* magazine and signed a worldwide publishing deal with Peermusic.[437] Since then, Kieran Goss has not only become one of the top songwriters in Ireland, he is by now also regarded as one of the biggest-selling recording artists in Ireland and Northern Ireland. This was also evident when his album *Red Letter Day* went straight into the Irish album charts at number five

[434] Rob Beattie, Q magazine, 1992 at http://www.the4ofus.com, 7/2/2004
[435] in 'March 11ᵗʰ' on Heaven & Earth
[436] see http://www.kierangoss.com, 7/2/2004
[437] see ibid.

when it was released in 2000. Owen McFadden argues that one of Goss' fundamental approaches to music is his independence of the mind.[438] Concerning the singer's style of music, there is definitely more to his image as a folk musician. He draws inspiration from various sources such as James Taylor, Paul Simon, Prince, and U2. Goss explains these influences as follows: 'I wouldn't say that I'd be influenced directly by people like them, but I'd certainly buy their records, and when I write songs I suppose it reflects all that.'[439] While the last few years have seen Goss co-writing songs with some of the top songwriters in Los Angeles and Nashville, he has also continued to draw inspiration from his personal background. In his song, 'Reasons to Leave', co-written with Rodney Crowell, released on his album *Red Letter Day*, Goss reflects on emigration, a theme which still predominates contemporary Irish and Northern Irish songwriting.[440]

> Ireland's a dream
> Of hope for what the day will bring
> The land and the sea
> Is what I've come to trust
> All that I am
> Is telling me I should not go
> And all that I know
> Is they're telling me I must.[441]

In 1997, the Labour Party adopted the song 'Things Can Only Get Better' from the Northern band D:Ream for their general election campaign. The band, headed by Peter Cunnah from Derry, had topped the UK single charts with this song back in 1994. Basically, the song is about reconciliation and about learning from another when, for a long time, greed and prejudice have contributed to a serious lack of communication between two feuding oppositional groups. From a rather uncompromising 'I' perspective on the matter at the start of the song—'Learn to talk like me and be an angel too'—the focus shifts

[438] in Fortnight, February 1990, 31
[439] ibid.
[440] for further information on the subject see Chapter VI.
[441] 'Reasons to Leave', Cog Communications, 2000

towards the end, and a reconciling awareness gives rise to new hope: 'I've found the cause / and I think you can be my cure / So teach me . . . '[442]

The Divine Comedy is another successful band with Northern connections. Neil Hannon was educated at Portora Royal, the same school which famous writers such as Oscar Wilde and Samuel Beckett had attended. In addition, the fact that Hannon is the son of the Anglican Bishop of Clogher[443] soon ensured great media interest. After the band's breakthrough in 1996 with their album *Casanova*, a song from their 1998 album *Fin de Siécle* deserves special attention here. The finishing track, 'Sunrise', describes how the author was brought up in Derry and Enniskillen and remembers the Cenotaph Bombing. It is interesting to note that, in the first two lines of the song, the two significant versions of a Northern Irish town—Catholic (Derry) and Protestant (Londonderry)—are mentioned. For the songwriter, there is no longer a difference between the two:

> Who cares where national borders lie
> Who cares whose laws you're governed by
> Who cares what name you call a town
> Who'll care when you're six feet beneath the ground.[444]

The end of the song, however, gives rise to new hope for sustained peace in Northern Ireland. The war has been going on for too long, but with the new sunrise change is on its way at last.

The year 1996 saw the release of Juliet Turner's debut album, *Let's hear it for Pizza!* The single 'Take the Money and Run' from her album *Burn The Black Suit* immediately went for the highest new entry in Ireland's play list charts in April 2000. *Burn the Black Suit* was listed third in the album of the year (2000) category in Ireland's annual reader's poll in top music magazine *Hot Press*, just behind U2 and The Corrs. In the same toll, Juliet Turner came in fifth in the songwriter section getting more

442 from http://www.mmguide.musicmatch.com/artist, 18/2/2004
443 Brian Hannon is a retired Church of Ireland Bishop of Clogher (1986-2001), see http://en.wikipedia.org, 23/11/2005
444 In http://www.123lyrics.net/d/the-divine-comedy/sunrise.html, 18/2/2004

votes than Paul Brady, Neil Hannon, and Andrea Corr.[445] Since then, Turner has played with Bob Dylan, Tracy Chapman, and Sting, and has also been supported on stage by Brian Kennedy and Gabrielle. Although hardly any of her own song material has direct bearing on the Troubles, Turner is proud of her Northern Methodist roots and her childhood upbringing in County Tyrone.[446] Like Brian Kennedy and many other popular singer-songwriters from the North, exile was the only possible way she could achieve success in the music business. Her latest album, *Season of the Hurricane*, was released in 2004. In February 2005 she was chosen best Irish female performer at the Meteor Music Awards held in Dublin.[447] Similar to the songs of Belfast-born Brian Kennedy, Turner's songs reflect significant aspects with regard to contemporary Northern Irish songwriting. Her song material will therefore be examined in greater detail in Chapter VI.

It goes without saying that the American influence of house and techno music also made its way to Northern Ireland. Maurice and Noel Watson from Northern Ireland promoted many early house music events in London. In Belfast, DJs David Holmes and Ian McCready achieved major success with regular events such as the Sugar Sweet club nights at the Belfast Art College. Holmes, who later toured the world as a club DJ while simultaneously working on his own albums, is described by Bailie as 'the most progressive and reputable music maker in popular music' in Northern Ireland.[448]

Presently, electronic music and digital technology is booming in Northern Ireland. Electronic music enables many composers to work independently because they no longer have to rely on the well-established recording studios. According to Bailie, rock music is the real loser in this present situation. Between all the clubs and a number of people who now prefer and support sterile acts playing cover versions, it is presently extremely difficult for any real musician from Northern

[445] see http://www.julietturner.com, 28/1/2005
[446] in Pól Ò Conghaile. "The Northern Composure of Juliet Turner." Irish Independent. Dublin: 23/10/2004, 6-10
[447] see http://www.meteormusicawards.meteor.ie, 3/3/2005
[448] Bailie in Carruthers, 2001, 213

Ireland to make a living from his art. However, at the same time, Bailie mentions that some change might be on the way. The government has finally recognized the music industry, and that in turn has helped the local scene, encouraging a new music business infrastructure in Northern Ireland. Furthermore, Bailie argues that the Internet offers a great opportunity here as well and will shape the music business within the near future. Record companies will soon be the losers in this age of new media possibilities. By self-producing downloadable MP3 files, any musician can now enter the international platform without being dependent on any record company.[449]

Popular music has by now contributed greatly to establishing the arts as a significant element in modern Northern Irish society. Every form of art, it might be added, can be traced back to the community from which it arises. Furthermore, each form of art can also carry a political message, be it prose, poetry, painting, sculpture, theatre, or song. As far as popular songwriters from Northern Ireland are concerned, then, there is little doubt that their creative work was inspired by the violence surrounding them. Culture in general does, in fact, have an important impact on the life of many people in the North of Ireland: 'We look to our writers for truths which cannot be refuted and need not be defended, words that will help us go on living.'[450] It might be disputed that popular artists in Northern Ireland continuously have the ability to speak out to the masses or to even encourage individuals to move on in life. Nonetheless, like poetry, drama, or folk music, some of the popular songs discussed here have helped people in Northern Ireland to deal with sectarian murder and revenge attacks that predominated the news headlines during the Troubles. Popular songs, in their own right, have the ability to deliver a powerful message, not only to the younger generation, but also to everyone who is willing to listen. As far as the present status of popular music in Northern Ireland is concerned, there is little doubt that, although the music has gone through tough periods of decline, its future looks rather promising again:

[449] ibid., 214

[450] Susan McKay, ibid., 250

Popular music has sustained a great cultural vitality here over five decades. It has manifested risk and adventure with a youthful edge. It has delivered reliable fun, helping to normalise a place which in many ways is so conspicuously abnormal. And when things have been particularly bad, the rock and roll concept of an Alternative Ulster has been a rare comfort. As the guy from Derry once sang—things can only get better. They've certainly been a lot worse.[451]

[451] Bailie, ibid., 214

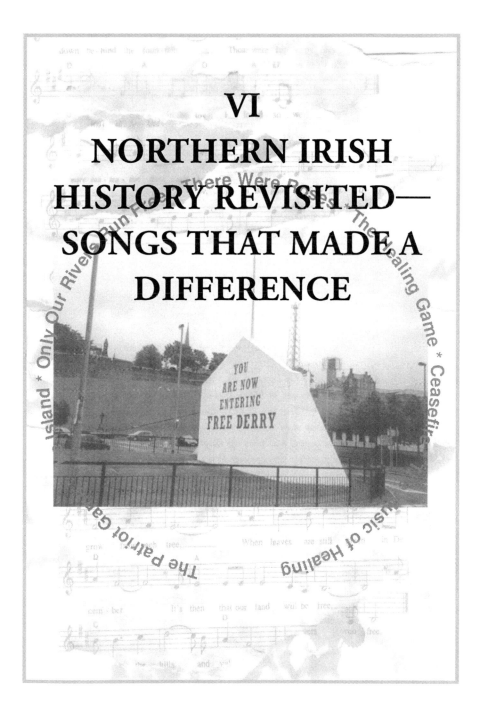

VI
NORTHERN IRISH HISTORY REVISITED— SONGS THAT MADE A DIFFERENCE

Peter Pan and Me
(Mickey MacConnell, 1980s) [452]

We knew we faced the power that comes from money
when we marched against the Empire's mighty schemes.
They were armed with Special Powers and legislation
while we were armed with youth and foolish dreams
but it seemed so right in Derry all that summer
when we took them on and built our barricades
we were an army dressed in faded jeans and sandals
too young and full of pride to be afraid.
And we believed in things like justice, truth and freedom.
And we believed in things like hope and liberty
and we believed that we could build a new tomorrow.
That's how it seemed to Peter Pan and Me.

But we soon learned the truth of street rebellion
as that city crumbled round us stone by stone.
Betrayed by those who promised they would help us
against tanks and troops and guns we stood alone.
For revolution is no game for foolish dreamers
for dreamers never know the price that must be paid
and before long we learned all power comes from a rifle
and we learned to bleed and die and be afraid.
And soon no-one talked of justice truth or freedom
and soon no-one talked of hope and liberty
for all we hoped was that we might go on surviving.
We grew up fast, young Peter Pan and Me.

So the Empire dealt us death and fear and prison
there's no mercy from that military machine.
So our street kids swapped their faded jeans and sandals
for hoods and guns with loaded magazines.
And the years have wrought their cruel retribution
and our brothers and our sisters bear the pain.
As both sides strive for their military solutions
and the politicians play their murderous games.
And among the dead lie justice, truth and freedom
and among the dead lie hope and liberty
so if you care enough to mourn brave new tomorrows
pull up a chair, join Peter Pan and Me.

[452] Spring Records, 1991

1
The Troubles Revisited

'The Patriot Game'[453]—The Beginning

The first songs about the Troubles appeared in the 1950s. It was at a time when the IRA had decided to start their armed battle against British Rule in Ireland. One of the first songs that was written around that time, and which soon became a major inspirational source for Irish Republicans, was 'The Patriot Game' by Dominic Behan. The event referred to in the song occurred in 1957 when a group of young IRA volunteers attacked the Royal Ulster Constabulary (RUC) barracks in Brookeborough, County Fermanagh, on New Year's Day. This attack was part of the Operation Harvest, a new IRA border campaign which aimed at reclaiming the six Northern Irish counties.

453 Dominic Behan, 1957/8

The incident turned out to be a disaster for the IRA; of the twelve men taking part, four were injured by gunfire. Two more, twenty-year-old Feargal O'Hanlon from Monaghan town and Sean South from Limerick, died during the operation. Both were left by their comrades on their escape for the border, and the two bodies were soon found by the RUC in a nearby barn.

> My name is O'Hanlon and I've just gone 16
> My home is in Mahnagh, that's were I was weaned
> I've read about heroes and I wanted the same
> Just to play out my part in the Patriot's Game.[454]

The Northern Ireland government tried their utmost to catch the fleeing ten gunmen. Up until then the IRA was regarded by people both north and south of the border as a useless fanatic organization with little relevance. Through the defeat of the IRA in this incident and the tragic loss of the two young gunmen, the organization it would be years before they would achieve a great following and victory.

> The funerals of IRA volunteers Feargal O'Hanlon and Sean
> South were to have a profound effect on Irish life at home
> and abroad, and they also tapped into a deep vein of Irish
> nationalism most thought had long ago died out. As a result
> of the deaths of these two young men, who lost their lives
> after taking part in terrorist action, republicanism was about
> to enjoy its most fertile period for decades.[455]

The renewed support for republicanism also contributed to the creation of new rebel song material. When, in the 1950s, the IRA had decided to take up the fight once more against British rule in the six northern counties, the majority of citizens were not really prepared to take up the gun personally. Having great sympathy for those who were, many found their own way of expressing their support, and the singing of old and new ballads helped to unite gunmen and sympathizers in their cause.

[454] from 'Patriot Game', in http://www.mattminglewood.com/Lyrics/lyric-patriotgame. html, 10/12/2004

[455] from Hugh Jordan, 2002, 22

But dark indeed would be the Foyles water,
And parched the land without ere leaf or sheen,
No bird to sing, no flower to bloom and cheer us
Should we break faith or bond with you, O Connie Green.[456]

When the grief-stricken mother of Feargal O'Hanlon appeared in photographs in all the newspapers, Dominic Behan penned 'The Patriot Game'. When the other gunman, Sean South was buried, 50,000 people followed his coffin to pay their respects, and soon another rousing ballad, 'Sean South' could be heard in Irish bars all around.[457] In the early 1960s, when following for republicanism gradually increased, these two songs became very popular.

With the deaths of O'Hanlon and South, the IRA had found two more martyrs in the tradition of Patrick Pearse and James Connolly who had been executed by the British after the Easter Rising in 1916. This construction of martyrdom constituted a perfect opportunity for the IRA to gain support for their violent attacks against British rule in Ireland.

Been nearly two years since I wandered away
With the local battalion of the bold IRA
I gave up my boyhood just to drill and to train
And to play out my part in the Patriot's Game.[458]

It is interesting to note that there are certain similarities between the patriotic spirit reflected in earlier rebel balladry, in particular during and after the 1916 Easter Rising, and the theme taken up by Behan in the 'The Patriot Game'. The motifs of blood sacrifice, the revolutionary gospel to die for Ireland, the image of the dead hero, and the glorification of martyrdom are all well reflected in the song. However, Dominic Behan soon distanced himself from the elitism of nationalism. He later made some alterations to the song so that it could no longer be

[456] 1950s nationalist ballad, writer unknown, in ibid., 29

[457] see ibid.

[458] from 'Patriot Game', in http://www.mattminglewood.com/Lyrics/lyrics-patriotgame.html , 10/12/2004

argued that he, being a former Irish republican himself, supported the IRA's continuing campaign of violence.

> Come all you young rebels and listen while I sing
> For the love of one's country is a dangerous thing.
> For it banishes fear like the speed of a flame
> And it makes us all part of the Patriot Game.[459]

'Only Our Rivers Run Free' [460]—Sectarianism and the Civil Rights Movement

'Only Our Rivers Run Free', the next significant song, appeared in the 1960s. It was written by Mickey MacConnell, who was born and brought up in Ballinalack, County Fermanagh, Northern Ireland.

> We were the only Catholic family within a predominantly Loyalist Protestant area. I was born in 1947 and my first conscious memories would have been political memories. My mother was a schoolteacher and my father was a shopkeeper. From when I was very young you would have been conscious of the tribalism that existed down that part of the country because that was a bad part of the country. My first real interaction would have involved being stopped as a small boy playing music going around to concerts by B specials who were a paramilitary force. They were bad basically, they were sectarian and I remember seeing my father being humiliated by these people when I would have been a small boy aged seven or eight. [461]

Then the 1950s IRA campaign came along, but according to MacConnell this attempted revolution was very amateurish and unsuccessful. 'The songs I would have been singing then would have

[459] ibid.
[460] Mickey MacConnell, 1965
[461] interview with Mickey MacConnell, Listowel 14.1.2005

been the songs from an early era, songs like Kevin Barry,[462] traditional sort of republican songs.'[463]

As a result of political developments and increased violence throughout the 1960s, a lot of songs were written during the 1960s and 1970s. According to singer/songwriter Joe Mulheron from Derry, they can be described best as odd songs for odd occasions. One good example for this was also the 'one off' 'Up Went Nelson', written shortly after Nelson's Pillar in Dublin's O'Connell Street was destroyed by the IRA in 1966. While the early 1960s saw the folk music revival reflected by groups such as the Clancy Brothers and the Dubliners, the repertory of rebel songs did not really include much new song material. Instead, songs in the tradition of Irish political songs and street ballads of the nineteenth and early twentieth centuries were taken up by these folk groups again. It was, however, an altogether new experience when, for the first time in the early 1960s, folk groups could be heard on Irish television singing old rebel songs such as 'Robert Emmet'. Although the huge variety of these rebel songs was then very much kept alive in the majority of Catholic households in the Republic of Ireland and Northern Ireland, it was still quite astonishing to hear these songs on television.[464] However, there were a few people who had difficulty with such songs, including Mickey MacConnell. As time moved on, he argues, the singing of old rebel songs from the nineteenth century and songs such as the ones mentioned by Mulheron above, seemed no longer justified:

> I always thought not very much worthwhile material came out of the North with the exception of Colum and Tommy Sands. There was good music, reflective music and then there was rebel rousing. I can see how it was a useful tool at the time of a rising consciousness and getting the troops behind the banner.[465]

[462] 1920s, on Clancy Brothers, Bescol, 1994

[463] MacConnell in interview

[464] Joe Mulheron in interview, Belfast: 23.1. 2003

[465] MacConnell in interview

It is important to note that the tradition of writing rebel songs, even though now greatly diminished, continues today. As negotiations about the future of Northern Ireland started and living conditions gradually improved in the North, rebel songs became less fashionable. Brian Moore, songwriter and authority on rebel songs, stated in an interview in Belfast in 2003 that nothing significant has ever been written again after the hunger strikes in the 1980s.[466] However, contemporary songs written by the Irish Brigade,[467] for instance, or the legendary Wolfe Tones, and especially when performed live, still have the potential to stir up old feelings of hatred against the British. As far as the Wolfe Tones are concerned, the name chosen by the band is significant in itself. Theobald Wolfe Tone was the famous Dublin Protestant who became known as one of the founder members of the United Irishmen, an organization founded at the end of the eighteenth century and very much associated with the 1798 rebellion. Even the title of the 2001 Wolfe Tones album is suggestive: *You'll Never Beat the Irish.*[468]

Going back to the 1950s and early 1960s, MacConnell argues that he is not aware of any song that was written during that time that was half as successful as Dominic Behan's 'Patriot Game'. To further clarify his opinion regarding the lack of good song material, MacConnell mentions the following story he heard from Paddy Devlin, one of the founders of the Civil Rights Movement. Devlin, a trade unionist, started a campaign against sectarianism in the 1960s and '70s. He tried to unite the trade unions against sectarianism and organized a big march in Newry at the time. According to MacConnell, a lot of well-meaning Protestants got together. However, once they had gathered with their trade union banners, they wondered what song they could sing together, 'and the

[466] Brian Moore in interview, Madden's Pub, Belfast: 23.1.2003
[467] working class, Belfast, Northern Ireland
[468] The Wolfe Tones, You Never Beat The Irish. Dublin: Celtic Collections, 2001.
In the title track, as in many other songs on the album like 'The Rebel' and 'United Men', cruel history is relived. What purpose such songs are supposed to serve in the twenty-first century, probably only Noel Nagle, Brian Warfield and Tommy Byrne of the Wolfe Tones are able to answer this question. Phrases such as 'A fat greedy king called Henry, / His dick was bigger than his brain, / Imposed on us his reformation / confiscations and usurpation', in the title track reveal the obvious.

only song they had in common, which again tells something, was 'Yes, We Have No Bananas',[469] a very old song, which means nothing.'[470]

In 1965, MacConnell wrote the song 'Only Our Rivers Run Free' when he was only eighteen years old. He had left school at fourteen and soon started doing jobs for his local paper. According to MacConnell, the song was basically a reflection on the social and political developments that were happening at the time:

> And it was largely triggered I'd say by the humiliation I had seen my father suffering as a small kid and by the fact that I had joined my local paper as a reporter and was reporting county councils, health boards and I was seeing for the first time and at first-hand how a sectarian state operated and I was confronted with the injustice of the Northern Ireland situation at that stage.[471]

The song itself had no actual bearing on the Troubles that were to follow, as it was written 'long before stones were thrown in Derry.' Instead, it reflected the claustrophobia and the bigotry people living up in the North experienced then:

> Oh, where are you now when we need you,
> What burns where the flame used to be,
> Are you gone like the snows of last winter,
> And will only our rivers run free? [472]

'Only Our Rivers Run Free' probably would have disappeared without trace had it been written a few years earlier or later, MacConnell argues. However, when the civil rights movement started, the organizers of the marches were looking for a song they could all sing. A song like 'Kevin Barry' did not seem appropriate. MacConnell explains that this song was

469 The song MacConnell is referring to here was written in the 1940s/50s and became very popular at the time.

470 MacConnell in interview

471 ibid.

472 from 'Only Our Rivers Run Free', Spring Records, 1992

'nakedly republican' and too sectarian. His own song 'Only Our Rivers Run Free' was different: 'Suddenly there was a contemporary sort of a song that did not mention Ireland but did mention things that greet them and it was safely enough generalized. So it became adopted for the civil rights movement and the rest is history.'[473]

> When apples still grow in November,
> When blossoms still grow from each tree,
> When leaves are still green in December,
> It's then that our land will be free.
> I wander her hills and her valleys,
> And still through my sorrow I see,
> A land that has never known freedom,
> And only her rivers run free.[474]

In 1971, Cathal O'Connell, folksinger and Mickey MacConnell's brother, performed in Leeds where he met singer-songwriter Christy Moore. Moore had just started up the Irish band Planxty,[475] and Phil Coulter was producing Planxty's first album at that time. Christy Moore was greatly taken by one song Cathal MacConnell sang. Soon afterwards Mickey MacConnell, who was working as a reporter for the Irish Press in Dublin at the time, received a phone call from Christy Moore who asked him if he could record his song 'Only Our Rivers Run Free'. MacConnell was absolutely delighted. Looking back, the songwriter explains how this was a perfect example of 'the right song, in the right place, at the right time, being recorded by the right man, being the right band.'[476] The song, written in 1965, had suddenly struck a chord. Phil Coulter, who recorded it with Planxty in 1971, still remembers his first encounter with the song:

> So they were singing that song during rehearsals and I hadn't
> heard the song before. But I had a sense that this was a song
> that was addressing that issue but in a pretty poetic way. The

[473] MacConnell in interview
[474] from 'Only Our Rivers Run Free', Spring Records, 1992
[475] for more information see Chapter III., 1.2. The Green Tradition Continues
[476] ibid.

images are not as brazen as, you know, my little Armalite. There are many of those but they don't actually add anything to the debate.[477]

As time passed and the situation changed, the song changed. According to MacConnell there are presently sixty-four different versions of the song, and it has been translated into over thirty languages. Audiences started interpreting different messages from the song and putting different subliminal themes into it. From a theoretical point of view, this can be explained in the following way: Once a text is written, it is no longer the author who is predominantly engaged in the process of creating meaning. According to Roland Barthes,[478] 'the death of the author' now enables any recipient to trace whatever meaning seems appropriate from a text. People who are listening to songs will therefore always have a very significant impact on creating the meaning of a song. While they all might share a system of various concepts, values and images,[479] the meaning of a song is only created during the process and time of reception. Thus, the creation of meaning always depends on the situation recipients find themselves in at that particular moment in time.[480]

MacConnell describes this process as follows: 'It's amazing how words can suddenly be used to fulfil a purpose. It's anything a singer or a listener wants it to be. That's basically what I intended and nothing more.'[481] Even at funerals you can hear 'Only Our Rivers Run Free' being sung, MacConnell stated in the interview. For him, 'it's a classical example how changing circumstances can imbue something with a message that was not necessarily there in the first place. Like I wrote the song when I was eighteen. What did I know when I was eighteen?'[482] For MacConnell the real strength of the song, however, lies in the fact that it

[477] Phil Coulter in interview, Dublin: 2004
[478] see chapter I.
[479] see Hall, 1997, 3
[480] for further information on the subject please find 2.Theoretical Aspects, included in chapter I.
[481] MacConnell in interview
[482] ibid.

became an anthem of the dispossessed, and that's precisely the context in which it was written.

> I drink to the death of her manhood,
> Those men who'd rather have died,
> Than to live in the cold chains of bondage,
> To bring back their rights where denied.[483]

MacConnell moved to the South in the 1960s and was appointed a senior reporter for the Irish Press group of newspapers in Dublin in 1969. Before moving down to Kerry in the mid 1980s where he started working as a journalist for the newspaper *The Kerryman*, MacConnell had also worked as a newspaper reporter for the *Irish Times* in Dublin for twelve years. Shortly after starting work with the Irish Press back in 1969, he was handed a notebook and was sent straight up to the North again to cover the Troubles. For many years, for two to three weeks of every month, MacConnell wrote political stories about the North for the *Irish Times*. A lot of his songs came out of that period, a great number of which were even written while he was staying in hotel rooms in Northern Ireland. This was his way of reflecting on political developments, and for him it became a kind of counterpoint to the serious reports he had to send back to Dublin:

> I'm a newspaperman, that's basically my job and as a newspaper man you are dealing with facts in black and white. So I always used songwriting as a therapy. You can take a situation and take a different stand on it. But I've been primarily a newspaper man, not a musician and songwriter. The songs are sparked off by the journalistic thing.[484]

However, the newspaperman himself admitted in the interview that he has always written songs. In addition, it should be added that quite a few of his songs have been recorded by other artists over the years. Even though none of his songs has since been able to top the success of 'Only Our Rivers Run Free', his reflections on political developments

[483] from 'Only Our Rivers Run Free', Spring Records, 1992
[484] MacConnell in interview

in song have continued right to the present and remained as direct throughout. His observations and the style in which they find reflection in his songs make up a craft hard to match by other songwriters from the North today. This is also reflected in the song 'The Little Drummer Boy', written by MacConnell in the 1970s: "Any time there is a regime," MacConnell argues, "the first people that are disposed of are the poets, the painters, the writers, the musicians."[485] This can be observed on television and all over the world today. "People in the arts who have an awareness and are capable of saying something and being listened to have to be eliminated first," according to MacConnell. This is also the destiny that awaits 'The Little Drummer Boy':

> So it's time to blind the ferryman and break the pipers hands
> And lock up all the singers that the people understand
>
> For there's a dangerous wind a blowing in this sad divided land
> It's time to kill the little Drummer Boy.[486]

Again, the song is very generalized, and hence can be adapted during any situation of political conflict imaginable. It is timeless, and yet, when it was written, it subliminally but clearly reflected something a person living in Northern Ireland during the 1970s could easily identify with:

> So I'm the Minister for Justice in a proud divided land
> I'm surrounded by rebellion, discontent on every hand.
> I'll have to bring in stricter laws, I'll have to make it wrong
> To forge rebellion in poetry and weaponry in song.[487]

Finally, in his song, 'The Lambeg Drummer', written in the 1980s, Mickey MacConnell creates a 'love across the barricades' story which, according to him, still features far too little in contemporary songwriting. In the North, every name becomes a cultural marker and reveals a person's background. For two people meeting on holiday and falling in love far away from their Northern Irish home, their names

[485] ibid.
[486] from 'The Little Drummer Boy', Elm Grove Music, 2000
[487] ibid.

serve as reminders: 'What a shame you're Mick, not Sam, said she / or Stewart, Cecil, Ian, Rob, or / Billy, Ivan, Jack or Bob.'[488] It might be okay to be in love in Greece and Rome and 'on through France and the dust of Spain,' but returning home, the barricades between these two lovers remain insurmountable: 'Christ I'll never love like that again. / All through that long grape-picking summer. / Now she's the wife of a Lambeg Drummer.'[489] The message is simple—a love relationship in the North is never meant to be two-coloured . . . never a combination of orange and green. Instead, one must stick with one's own crowd and not mix. This song, however, succeeds in delivering this message using a variety of images associated with Protestantism and Catholicism: 'Lambeg drum' and 'Fenian dream', 'Mick' and 'Sam', 'poor and hitching back home' and 'able to afford the plane', 'orange' and 'green'—such stereotypical images indeed do not mix in the Northern Ireland context. Like his comrades in the nationalist tradition, the man is accused by his Protestant lover of dwelling in the past and moan too much, while the woman is more focused on enjoying what the present moment offers: 'You're locked inside some Fenian dream / you long for things that might have been / but let's not waste what's left of the summer / before I wed my Lambeg Drummer.'[490]

'The Town I Loved So Well'[491]—The Trauma of Internment

On 9 August 1971, internment was introduced by the British government in Northern Ireland. Under this practice, British intelligence forces rounded up suspects and put them behind bars without benefit of trial. This procedure clearly indicated that the British government was aware not only of increasing IRA activity, but also of the possibility of an eruption of loyalist violence. Something had to be done. In the first six months of internment, over 2,400 people were arrested, and most of them were released after a short time in custody. The special experimental interrogation treatment used during internment was later characterized

488 from 'Lambeg Drummer', Elm Grove Music, 2000
489 ibid.
490 ibid.
491 Phil Coulter, 1971/72

as 'inhuman and degrading' by the European Court of Human Rights.[492] In retrospect, this operation must be regarded as highly inefficient. Widespread violence broke out in the immediate aftermath, and around 150 people were killed in Northern Ireland between the introduction of internment in August 1971 and the end of the same year.

An interesting story is attached to the writing of the song 'The Town I Loved So Well'. Phil Coulter happened to be on a visit in his hometown Derry when internment was introduced. According to the singer, Irish school teachers, people who taught Irish music or dancing, and people who played Irish games like hurling were dragged out of bed at four o'clock in the morning and arrested.[493]

After having witnessed the traumatic effects of internment, Coulter wrote the song 'Free the People'. This anti-internment song signalled a major change for Coulter, who for the first time ever in his life found himself writing a political song. Up until then he had always been a commercial songwriter. Professionally he was producing the Dubliners at the time and had especially admired Luke Kelly's voice, his integrity, and political awareness. Kelly refused to sing songs unless he believed they had something to say. Together with Luke Kelly, Coulter recorded his song 'Scorn Not His Simplicity'. This very emotional song is about Coulter's first son, who was born with the Down syndrome. Coulter explains how this song signalled a departure in his life and his work. For the first time he delved into his own personal experience, his own feelings, and his own heart in a song. This was not an easy task for the singer, but it marked a significant breakthrough and soon even made it easier to tackle some of the political issues he was very much concerned about.[494]

The song 'Free the People' might not be regarded as a great song, Coulter argues, as it was not thought out properly. However, it was written as his immediate reaction to witnessing the trauma of internment. Hence, it was a very angry but also very honest song.

[492] in McKittrick 2000, 68

[493] Phil Coulter in interview, Dublin: 2004

[494] ibid.

> Whatever the limitations or the failings of that song, I will always have a soft spot for 'Free the people,' because it helped me using my craft as a songwriter to address issues that were very real and not just songs that were geared to the pop music charts. Not that I had not been aware of the political climate in the North of Ireland. Coming where I came from and being a Catholic growing up in the 1940s and 50s in Derry, of course I was aware. But I always had separated my personal experience and history from my craft, which is my career, my songwriting.[495]

Up until then, Coulter was writing songs like 'Puppet on a String' or 'Congratulations' for the Eurovision Song Contest. Had he not written 'Free the People', Coulter continues, he would never have written the song 'The Town I Loved So Well'. He would never have revisited these places. He also had certain reservations about how this song would be perceived by the different communities living in the North. To tackle such sensitive political issues could have easily led to conflict. Around the same time, an anti-internment rally was organized in Dublin, with various politicians from the North participating such as John Hume and Austin Currie. 'Free the People' was chosen as the title for this rally and became the theme for the entire political protest against internment.

The singer returned to Derry on regular visits throughout the early 1970s, and he describes how he became aware of the changes that were happening to his hometown:

> I got caught up in a riot one day and saw the very heavy-handed approach of the riots with water canons, showering everybody and lashing out and this was my town, these were the streets where I grew up. This shit shouldn't be happening in my town. It really was very deeply moving for me. So I thought I had to write another song.[496]

[495] ibid.
[496] ibid.

Coulter started writing the song 'The Town I Loved So Well'. Again, Luke Kelly seemed to be the ideal singer to record it with. With Kelly's integrity and voice clearly in mind, Coulter was able to compose the melody for his new song within only a few days. Writing the lyrics, the songwriter admits however, took months, 'That's the longest songwriting exercise that I have ever embarked upon, but for very good reasons.'[497] Coulter is convinced that a song like 'The Town I Loved So Well' could only have been written by someone from the North of Ireland and more specifically by a person from Derry. He even goes a step further by arguing that it had to be a person of his own age who had experienced living in Derry before the changes. This person would be able 'to evaluate the trauma and the violence etcetera as some kind of an inevitable grinding that was going to make things different.'[498]

Coulter also explained how he was brought up in the surroundings of a political stalemate. Privileges and gerrymandering were enshrined in the constitution of the state. According to Coulter, something pretty dramatic had to happen before things were going to change. A person writing a song about this had to fully understand this whole background.

> But when I returned how my eyes have burned
> To see how a town could be brought to its knees
> By the armoured cars and the bombed out bars
> And the gas that hangs on to every tree.
> Now the army's installed by the old gas yard wall
> And the damned barbed wire gets higher and higher
> With their tanks and their guns oh my God what have they done
> To the town I loved so well.[499]

All along, the songwriter was aware that by using just a few 'wrong' lyrics, this song could easily tilt over and become just another rebel song. A great number of these were written by Northern Irish songwriters at that time; 'The Men behind the Wire' by Pat McGuigan for example:

[497] ibid.

[498] ibid.

[499] from 'The Town I Loved So Well', Polydor, 1973

Through the little streets of Belfast
In the dark of early morn
British soldiers came marauding
Wrecking little homes with scorn
Heedless of the crying children
Dragging fathers from their beds
Beating sons while helpless mothers
Watched the blood flow from their heads.

Not for them a judge or jury
Or indeed a crime at all
Being Irish means they're guilty
So we're guilty one and all
Round the world the truth will echo
Cromwell's men are here again
England's name again is sullied
In the eyes of honest men.[500]

For Coulter these were not only rebel songs, but also bloodthirsty songs, and according to him, they have not really weathered the test of time.

> Not to be self-congratulatory, but I think 'The Town I Loved So Well,' as history has proven has become the kind of a song that defines that era and maybe because I took so long over it. Maybe I was just so conscious of the importance of this song and the statement that had to be made . . . 'The Town I Loved So Well' for me is certainly not a rebel song. In my view, it's a love song, it's a love song about my place.[501]

In the interview, Coulter stated how he is still happy to talk about this song. He argues that, for people who were brought up and lived in the same surroundings, this song has become of major importance. It has, in fact, become an important part of that era and is now able to transcend

[500] 'The Men behind the Wire' (Pat McGuigan, 1972), note that P. McGuigan was interned simply for writing this song, for further info see: http://www.irelandsown.net/behindwire.html , 10/12/2004

[501] Coulter in interview, Dublin: 2004

time and place. Childhood memories of days gone by and specific places can be revisited in the song:

> Going home in the rain, running up the Dark Lane,
> Past the jail and down behind the fountain.

Views from the City Wall in Derry

Unionist/Loyalist coloured kerbstones,

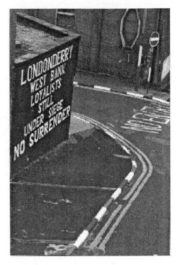

'Pass the Jail and down behind the Fountain'

(from 'The Town I loved so Well', Phil Coulter)

a Unionist/Loyalist Mural...

and the Tower of the Old Derry Jail in the Fountain District, Derry, June 2005

Photographs Katrin Pietzonka

Murals in the Bogside

Mural 'Annette McGavigan'

In memory of another young life
lost to the Troubles

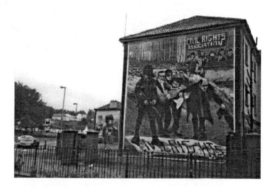

Mural 'Bloody Sunday', 30th January 1972

In the distance… a white dove symbolising peace,
Derry, June 2005

View of the City Wall in Derry

RUC Station within the city walls

View from the Bogside Derry, June 2005

Photographs by Katrin Pietzonka, 2005

Scenes from the Bogside

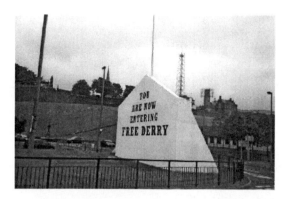

Free Derry Corner

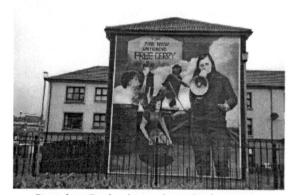

Bernadette Devlin during the civil rights marches

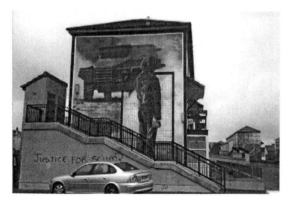

Mural 'Rioter', Derry, June 2005

Photographs by Katrin Pietzonka, 2005

> Those were happy days, in so many, many ways,
> In the town I loved so well.[502]

By mentioning different landmarks and districts in his hometown, Coulter consciously makes use of the sense of place phenomenon.[503] He also explains how the 'Dark Lane' (capital letters), was actually a specific street name in Derry. The mentioning of these specific places in the song is, according to Coulter, of major significance and proves what other writers have discovered before him; namely, that something specific can, in fact, become universal.

> In the early morning the shirt factory's horn
> Called women from Creggan, the Moor and the Bog
> While the men on the dole played a mother's role
> Fed the children and then trained the dog.[504]

In 2003, a very popular folk singer from Japan came on a pilgrimage to Ireland, and to Derry in particular, with seventy or eighty of her fans. Coulter, who has the BBC footage of that event, describes how this group of Japanese visitors went onto the walls of Derry while the folk singer sang 'The Town I Loved So Well' in Japanese. For Coulter himself, that was a moment of true revelation:

> There is an emotion, a sense in that song, which people in Finland, in Guatemala can relate to which is that whole thing about the recollection of your place, your town and how it changes through the passage of time. For most people it just changes because of progress. In my case it changed because of political reasons. But it's the theme that people can relate to, no matter where they come from.[505]

In a similar way Coulter reflects on his favourite memory of 'The Town I Loved So Well'. He went to Croke Park Stadium in Dublin for the 1993

[502] from 'The Town I Loved So Well', Polydor, 1973
[503] for further information see chapter I
[504] from 'The Town I Loved So Well', Polydor, 1973
[505] Coulter in interview, Dublin: 2004

All-Ireland Senior Football Championship Final when Derry was playing against Cork to an estimated attendance of 64,000. For generations the county anthem for Derry/Londonderry had been the traditional song 'Danny Boy'. For this particular match, however, by a vote of the players and the county board, it was decided that Coulter's 'The Town I Loved So Well' should be the anthem. To hear both the Derry and the Cork supporters singing that song was one of Coulter's most moving experiences, and he admits that tears were running down his cheeks. A year later, on 12 July, Coulter received a letter from a friend from Belfast. Robin Walsh, who had been director of programmes in the BBC studios at that time, informed Coulter how, at the height of the marching season in Northern Ireland, an orange parade had walked past his office in Belfast, playing 'The Town I Loved So Well'. This illustrates that, with its non-sectarian lyrics, this song has, in fact, passed over into the general public domain and is not perceived as a rebel song: 'No matter whether you'd be orange or green. It's been the same experience for people from Derry, Newry, Lurgan, or Belfast.'[506]

Finally, asked about whether he has ever thought about writing a second song similar to 'The Town I Loved So Well', Coulter admits that the only thing that stops him is the fact that this song has become such an iconic song—or even anthem—and, 'to be seen to be trying to compete with that [. . .] maybe I don't have the courage. Maybe I just want to let that stand as it is.'[507]

> For what's done is done and what's won is won
> And what's lost is lost and gone forever
> I can only pray, for a bright, brand new day
> In the town I loved so well.[508]

[506] ibid.

[507] ibid.

[508] from 'The Town I Loved So Well', Polydor, 1973

'The Island'[509]—Coping with the Reality of the Troubles

The song 'The Island' finds Paul Brady successfully combining the image of a romantic love ballad with the harsh realities of living in a religiously and politically divided society. Rolston criticizes, however, that a strong sense of irony was employed in the song, and that it "contrasts the miasma created by political violence with the bliss of 'making love to the sound of the ocean' on a deserted island."[510]

> Now, I know us plain folks don't see all the story,
> And I know this peace and love's just copping out.
> And I guess these young boys dying in the ditches
> Is just what being free is all about.
> And how this twisted wreckage down on Main Street
> Will bring us all together in the end
> As we go marching down the road to freedom.[511]

No matter how one regards this combination of political violence and love-making, it might be worth noting that Brady has continued to examine aspects of love in his writing over the years. For him, these are feelings and emotions most people share. Whereas a great variety of songwriters would agree that this song is probably the best political song that has ever been written about the conflict in Northern Ireland, Brady himself once described his own song as an 'accident.'[512] Born and raised in Strabane, County Tyrone, the singer turned his back on Northern Ireland in the 1960s and never regarded himself as particularly political. His plea for peace reflected in the song is, in fact, not like Brady at all, who generally opposes mixing art with politics: 'I don't actually ever feel that political art or art that is governed by political ideology or a slave to it is ever any good.'[513] Although he has great respect for politicians and every political achievement resulting out of compromise, he regards himself as not able to practice the art of compromise. He has always

[509] Paul Brady, Mercury, 1986
[510] Rolston, 2001, 61
[511] from 'The Island', Mercury, 1986
[512] William Henry, 2000, 31
[513] in ibid

believed in one particular vision of a truth and argues that an artist like himself does not owe anything to anybody.

Yet the song 'The Island' clearly reflects the Troubles in documentary terms and articulates one person's struggle to come to terms with this reality. Like no other song about the conflict in the North, 'The Island' succeeds in revealing what Williams described as 'structure of feeling',[514] a concrete expression of a group's consciousness in society at a particular period of time. For people living in Northern Ireland at that time, this was the reality they had to cope with, and this is how the majority of people felt:

> They're raising banners over by the markets
> Whitewashing slogans on the shipyard walls
> Witchdoctors praying for a mighty showdown
> No way our holy flag is gonna fall.[515]

Singer-songwriter Ciaran Wynne argues, however, that this song could also be regarded as being timeless.[516] Apart from 'skies of Lebanon', which could now easily be changed to 'the streets of Baghdad', women and children still continue to die all around the world today. Up in Northern Ireland, some factions of society 'are still at it', as described in the song back in 1985. In other words, not much has changed since the song was written twenty years ago.

Brady also uses themes and motives here that have had a long tradition in Irish traditional songwriting. As was common in Irish political songs throughout the nineteenth century, this late twentieth-century popular song reveals that to die for Ireland is still part of some people's ideology: 'Up here we sacrifice our children / To feed the worn-out dreams of yesterday / And teach them dying will lead us into glory.'[517] In a similar way, the song also draws its inspiration from the 'past in the present' concept. The song reflects that the past has not yet been overcome, and the future is still out of reach. What remains is a present nobody can yet

[514] see chapter I.
[515] from 'The Island', Mercury, 1986
[516] Ciaran Wynne in interview, Killarney: 2004
[517] from 'The Island', Mercury, 1986

make any sense of: 'And we're still at it in our own place / Still trying to reach the future through the past / still trying to carve tomorrow from a tombstone.'[518]

In an interview with Brady on BBC radio in 2002, Tony McAuley stated that in the early 1980s, Brady became part of a very selective group of singer-songwriters who tackled the theme of the Troubles. Brady himself stated that the timing for writing this song was difficult. There was the situation of the hunger strikes on a political level, and the music itself seemed to become politicized, reflecting either support for developments taking place at the time, or offence against them. Even friendships broke up over political issues then. Writing and performing the song 'The Island', Brady continues, was a perfect example. In comparison to other developments taking place in the traditional music scene at that time, Brady's approach was somewhat different, and many people found this hard to take.[519]

Reflecting on the song during the interview with the songwriter, McAuley described it as objective, disturbing, compassionate, angry, but also uncompromisingly honest.[520] The song is also intensely personal as is much of Brady's song material. Like 'Only Our Rivers Run Free' and 'The Town I Loved so Well', here was a song that again did not find the singer taking any side. Growing up in Northern Ireland, Paul Brady explains, one soon became aware of the political ambiguity all around. It was clear to everybody that a change would eventually have to take place, but as it did for many others growing up in these surroundings, it took Brady a while to figure out how this change could actually be brought about. In the early 1980s, Brady realized that the violence that was happening up in the North was not going to change anything.[521] This realization became the inspiration for 'The Island'. In addition, the fact that the ordinary person was rather helpless in this process of change led the singer to the belief that the least any individual could do was to treat all people as well as possible and to always make one's life a statement of love. In return,

[518] ibid.
[519] Brady in interview with Tony McAuley, Belfast: 2002
[520] McAuley in ibid.
[521] Brady in ibid.

that microcosm of love would hopefully grow throughout society and eventually help to bring change about.[522] This is a complex concept which the singer finds hard to explain; he therefore chose to write a song instead:

> It's very hard to describe the song 'The Island.' To me, it can't be explained in words, I mean, that's why I wrote the song and that's why it's a song. I could sit here from morning to night trying to say what the song is about. The best thing would be to listen to it.[523]

'There Were Roses'[524]—Coming to Terms with the Loss

The song 'There Were Roses' clearly reflects the songwriter's opposition to sectarian violence. Tommy Sands condemns the actions of the republican and loyalist paramilitary groups that caused so much sadness and grief in Northern Ireland over the years. Based on a true story, the song is about two friends who lived near the border in County Down.

> Though Allan he was Protestant and Sean was Catholic born
> It never made a difference for the friendship it was strong
> And sometimes in the evening when we heard the sound of drums
> We said 'It won't divide us. We'll always be as one.'[525]

In fact, the two friends cannot possibly understand why their different religion should have an effect on their friendship: 'For the ground our fathers ploughed in the soil it is the same / and the places where we say our prayers have just got different names.'[526]

However, neither side of the paramilitary groups in Northern Ireland could turn a blind eye on such a friendship. The protestant friend is

[522] ibid.
[523] ibid.
[524] Elm Grove, 1985
[525] Ibid.
[526] ibid.

killed by republicans, and before too long 'a car of death' driven by angry loyalists arrives at the house of the Catholic friend. It does not take them long 'to even up the score', and the victim is soon found shot dead and left in a ditch close to his home. The moral in this case, as in many others before and after, states the obvious: 'An eye for an eye was all that filled their mind / And another eye for another eye till everyone is blind.' There is not really a way out of this dilemma, because 'centuries of hatred have ears that cannot hear.'[527] History is referred to once again. The past in the present demands revenge and thus, leaves no room for forgiveness.

It took Tommy Sands ten years to write this song. According to him, it was important that, at the time this tragedy happened, people were offered an alternative way to come to terms with the loss. He attempted to address the pain in a song: 'I felt that a song had to be written and a voice had to be given to the people who didn't know what to say. The nerves were so raw, people couldn't talk about it and couldn't talk to each other.'[528] People who previously had been friends found themselves speechless, not able to communicate with each other any more. The idea was to unite the two sides of the divide in a song and to give them the means of expressing their grief together. Up until then, a song about the Troubles written by a Northern Irish artist always reflected on either the Catholic or the Protestant side only. This song, however, succeeded in bringing these two sides closer together, even if only while the song was sung. The grief and the pain was the same on both sides. How could this be better expressed and articulated than in a song? 'This was an example for two people who came from the same little community, suffered together and everybody suffered and basically that was a microcosm of the whole situation.'[529]

Tommy Sands still remembers vividly how he started writing songs about the Troubles. Looking back, he remembers his father singing songs about the 1798 Irish Rebellion. He soon realized that it was vital to continue to write songs about present developments and to pass them on to the next generation. He also wanted to express what was going

[527] Elm Grove, 1985
[528] Tommy Sands in interview, Limerick: 2004
[529] ibid.

on in the North at the time. It was in 1966 when he wrote his first song ever, including these moving closing lines: 'Ireland unfree shall never be at peace.'[530] The song was based on a quotation from Patrick Pearse and Donovan Rossa and commemorated the fiftieth anniversary of the Easter Rising. It basically posited that the Troubles would always go on until a lasting solution could be found. A lot of anger was expressed in the song, not only about political developments and the increase of violence, but also about useless murder, as in the case of Sean South of Garryowen. Talking about the song today, the singer admits that it was rather republican. He explains, however, that the song expresses the way he and many others felt at the time,[531] At around the same time, another song, 'I Hate To Hear People Cry', was written by Tommy Sands, which has since been recorded by many artists and also features on his own CD, *The Heart's A Wonder* (1995). Taking into consideration that this song was written in the 1960s, it should probably be regarded as the very first approach to plead for peace in a song when violence could be felt all around: 'I hate to hear people cry / One is for sorrow and two are for joy / And love is a dove that needs two wings to fly.'[532]

Almost four decades later, the singer had time to reflect. He is convinced that all these years ago he did not set out to write political songs by any means; rather, he intended to write about what was going on all around him.

> So I sang songs about the pretty fair maids in the months of May and June. But then it became July and people were getting killed in August and more people were getting killed. So it was time to leave the romantic songs until certain realities were sorted out.[533]

Then there came a time when it became very important for musicians in Northern Ireland to write political songs. After internment and throughout the 1970s, many songs were written to raise money for people who had lost their earners. In one of Tommy Sands' songs,

[530] ibid.
[531] ibid.
[532] from 'I Hate To Hear People Cry' (1960s), Green Linnet, 1995
[533] ibid.

'Everything Must Be Used', the approach was rather nationalist. A situation in which the whole island of Ireland was united was then seen as the ultimate solution: 'These things, those things, everything must be used. When the fighting is done and all Ireland is won, everything must be used.'[534] Nonetheless, Sands argues that these songs were written to express the frustration felt and to give a bit of hope to people whose lives had been seriously affected by the introduction of internment. Throughout the decades that followed, people had time to reflect. Anger and resentment expressed in earlier songs were not going to change anything. Instead, Tommy Sands started listening to both sides, and like Phil Coulter and Paul Brady, he arrived at the conclusion that his songs should always speak out to both communities. A lot of this came from Tom's experiences travelling around Germany, and in particular East Germany. Speaking to a variety of people over there, he realized that the unity of ordinary people is a very important issue. Aware of his role as a songwriter from Northern Ireland, he had to find common ground in his songs . . . something that both sides of the divide could identify with, or in his own words: 'I wanted to be able to sing my songs to everybody.'[535] It might also be worth noting, the singer pointed out, that Ireland became geologically united four hundred million years ago, and that since then there have been no major cracks to disunite Ireland. The people living together on the island, however, are still far from being united. The singer argues that it is his task, too, to initiate this unifying process: 'You have to start to unite them in your own backyard.'[536]

In addition, Tommy Sands is also convinced that, throughout the Troubles, Protestants have been the victims too. 'It is important that working-class people in the Protestant community realize that they have been injured as well by the system that was there.'[537] In the early seventies, Sands wrote another song, 'You Sold Us Down the River', from a Protestant perspective, and he tried to make people aware of this fact.

> You promised that you'd stand by me from the very start

[534] from ibid.
[535] ibid.
[536] ibid.
[537] ibid.

> And you told our sons and daughters to be loyal,
> You have no further use for me, you've gone and broke my heart
> And you sold us down the river in the end.[538]

Sands continues, however, that the Protestant community has only started to realize this now, twenty years later. So, in a way, he believes that a part of his idea to write songs also comes from the realization that people need to be made aware. If they cannot see what is there in front of their eyes, perhaps a song might help them to open their eyes to reality.

When, in the mid 1980s, talks between John Hume, leader of the Social Democratic and Labour Party (SDLP), and Gerry Adams, leader of Sinn Féin (SF), broke down, Sands, always concerned about political developments at home, accompanied the political correspondent of the *Irish News*, Billy Graham, for an interview at the Sinn Féin headquarters. A week prior to the event, Sands had met up with Andy Tyrie, leader of the Ulster Defence Association, who had shown great interest in his song 'You Sold Us Down the River'. These two meetings inspired him to pen down the song '1999'.

> Oh IRA and UVF this song is just for you
> As you sit down at the table now to see what you can do,
> At last you've come together after all the tears and time
> It's sad you didn't do it back in 1969.
> History calls you savages but I know it isn't true,
> For we grew up together and I am part of you
> We all had dreams and hopes and fears and someone else to blame,
> It took so long to realize our dreams were all the same.[539]

It seemed obvious that both communities in Northern Ireland were facing the same dilemma. There were the same problems on both sides, and it was up to the politicians to sit down, talk things out, and start solving the issues together for everybody's sake.

[538] from 'You Sold Us Down The River' from ibid.
[539] from '1999' (written in 1986), Spring Records, 1992

We felt the taste of hunger when the factory went away
And then they closed the hospital, they said it didn't pay,
And as the rich got richer and kept promising the sky,
All we got were promises and coloured flags to fly.
I remember well your little girl, she had ribbons in her hair
When she came to play that summer's day with the children
in the square,
To think they could be here today still laughing and alive
If strong men had been wise men in 1979.[540]

The song suggests that it might be in the year 1999 that some kind of political agreement will be reached. However, Sands argues that he had no specific knowledge then about when these political talks would start. For him, it was more the fact that he had seen both loyalists and republicans at such close quarters. He realized that there was a common ground and that it would be possible 'to build a better place for our daughters and sons.'[541] It was only a question of time until such talks would begin at long last:

It was always all or nothing; there was nothing in between,
Compromise was treachery, that's the way it seemed.
But now we're left with nothing but a future we must find
And count the cost of the chances lost in 1989.[542]

[540] ibid.
[541] Tommy Sands in interview, Limerick: 2004
[542] from '1999', Tommy Sands, 1986

2

A Different Perspective on the North— The Songs of Van Morrison

In the Shankill area of Belfast there is a mural that depicts loyalist paramilitary activities. The banner along the bottom reads: 'Wouldn't it be great if it was like this all the time?' This line is taken from the Van Morrison song 'Coney Island' and clearly reveals how this Belfast-born musician is, at times, still purposely catapulted back to his Protestant East Belfast roots. According to Radford, Morrison's decision to choose this line also reflects how he was manoeuvred into being 'associated by default with loyalist identity at its most ghoulish.'[543] Van Morrison has often been described as a romantic poet who is determinedly apolitical; however, it could be argued that he never totally ignored the conflict in his hometown. Some of his songs even conjure up a political landscape and reveal that self-absorption and lack of communication lie at the heart of Belfast's problems:

> No one's making no commitments
> To anybody but themselves,
> Hidin' behind closed doorways,
> Tryin'to get outside, outside of empty shells.[544]

Throughout Morrison's career, he has used images of Ireland and Irishness in a variety of ways, and he continues to refer to his Irish roots and even to the troubled situation in Northern Ireland. Various themes recur in his songwriting. Exile ('Got To Go Back'), the naming of places ('On Hyndford Street'), the reviving of childhood memories ('Madame

543 Radford, 2002, 78
544 from St. Dominic's Preview, Warner, 1972

213

George'), and even a sense of melancholia ('Take Me Back') all do indeed reflect an awareness of his cultural background, or at times might even reflect his concern about the situation in the North. Songs like 'I'm Tired Joey Boy', Bailie suggests, 'self-consciously pay homage to the style of the Glens of Antrim.'[545] The same can be said about other songs like 'Cyprus Avenue', 'Cleaning Windows', and many more in which his childhood days are captured in his references to barn brack,[546] pasty suppers, and wagon wheels.

 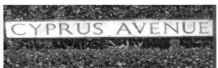

In other words, Morrison has hardly ever chosen to reflect on the Troubles directly; instead, he has found this unique way to come to terms with his own cultural background. This is further enhanced by the fact that, over the years, he has regularly and consciously made use of his Belfast vernacular. The phrase 'going over the city' (meaning 'going to the city'), to give just one example, is used frequently by people living in East Belfast and can also be found in some of Morrison's songs.[547] According to Tony McAuley, Van Morrison was, in fact, the very first Northern Irish singer-songwriter who chose to use the vernacular in his songs in the 1960s.

> Van Morrison was the first to use the language of popular every-day culture, the culture of his own city Belfast, the vernacular, the expressions, the attitude. He was the first singer, that I can remember ever came out of Northern Ireland who

[545] Bailie in Carruthers, 2001, 1991
[546] traditional cake baked in Ireland and Northern Ireland especially around Halloween
[547] e.g. 'Take Me Back' on Hyndford Street, 1991

used what we called attitude. He was the first singer to engage with popular street culture. So when he sang, he was singing actually about his own city and he was singing out of his own life and about his own life. So he was singing about St. Dominics weekend, Fitzroy Avenue, Madame George, cleaning windows, he was singing about Hyndford Street. He was exploring an emotional field. But he was using the physical background of his own life to explore that emotional field. He wasn't borrowing, he wasn't relying only on the sentiments of London, he wasn't relying on Liverpool, he was relying essentially on Belfast. And that makes it, I think, very important.[548]

In addition, Morrison was not merely a popular singer. He had a gospel, blues, jazz, and skiffle background. McAuley argues that he understood folk music in a rather bizarre way. Although he had no knowledge whatsoever of his own traditional folk music, he still sang in a way that a folk singer or a street singer would sing. He contested and used a very angry voice even in his love songs. By doing that, McAuley continues, Morrison was 'the red cart swimming against the tide: All popular music here was going one way. It was nice, you know, "Moon in June", "Love Will Last Forever", lots of strings were being used, and Morrison was the first angry man.'[549]

Inserting the ordinariness of Belfast into a global space is, according to McLoone, another of Morrison's great achievements. Many of his songs recall the banality of life in Belfast in the 1950s, 1960s, and 1970s when children on the streets were busy 'collecting bottle tops' and you could find 'scattered orange boxes against the Safeway's supermarket in the rain.' Details of daily life in Belfast were also captured in later songs, like 'Ancient Highway'[550] and 'Choppin' Wood'.[551]

Through the creative works of songwriters, the use of American place names like Nashville, Woodstock, and Highway 61 have made these places, in people's imaginations, more superior than they are in physical

[548] Tony McAuley in interview, Belfast: 2002
[549] ibid.
[550] On Days Like This, Polydor, 1995
[551] Down The Road, Universal, 2002

reality. In the same way, Morrison's approach has ensured that Belfast has grown into an imaginative space greater than the one-dimensional reality created by the media over the past few years.

Like so many Northern Irish artists, he chose to leave this troubled city, and the melancholy of this experience runs like a recurrent theme through some of his creative work:

> All that trouble all that grief
> That's why I had to leave
> Staying away too long is in defeat
> Why I'm singing this song
> Why I'm heading back home
> That's what makes the Irish heart beat.[552]

Yet, although he escaped, it might seem he is constantly drawn back, seeking inspiration and emotional sustenance in his hometown: 'He is caught between staying and escape, between belonging and exile, between rootedness and transcendence.'[553] It can also be argued that Morrison's Belfast has always remained the pre-Troubles city of his childhood, a place of simplicity, banality, and mysticism. Although he might be deeply rooted in this culture, the desire to escape has always been equally strong for Morrison. This escape took on various forms— the physical escape of living and recording in exile, an imaginative escape realized through listening to his favourite music on the radio, and the more sublime escape of experiencing a moment of total transcendence.

> Transcendent can mean a number of things really, but in my case it's where you switch off the mechanism; switch off what's referred to as the constant voice. That's what meditation is supposed to do—turn off the constant voice, all those thoughts you have.[554]

[552] from 'What makes the Irish Heart Beat', on Down The Road, Universal, 2002
[553] McLoone in Hackett, 2003, 53
[554] Van Morrison in Wavelength. (9/1993), 24

In 1994, people living in Northern Ireland at long last could feel the winds of change. Like many other songwriters, Van Morrison must have sensed that healing and reconciliation could no longer be gained through exile only, but could now be sought back at home.

3

Reflections on the Ceasefire (1994)

'Ceasefire[555]

On 31 August 1994, after a quarter of a century of the cruellest nightmares and the heaviest casualties—about 3,000 lives all together—the IRA announced that, as of midnight that night, 'there will be a complete cessation of military operations.'[556] Although among unionists and in republican areas this was a time of great uncertainty, one thing was nonetheless very clear: an entirely new phase had begun in the history of Northern Ireland. Six weeks after the IRA announced a ceasefire, Protestant extremists laid down their weapons too. A chance for a peaceful solution seemed now more likely than ever before. As the weeks passed after the ceasefire, there was a mixture of feelings including hope, fear, nervousness, and uncertainty. It soon became clear, however, that within the republican movement, the predominant emotion was one of relief. The generality of republicans welcomed the cessation. The majority of the unionist community welcomed the ceasefire too. Most of its political representatives, however, regarded it as an unsettling experience. The Protestant community was doubtless as nervous and uncertain about the future as its Catholic counterpart.

Meanwhile, day-to-day life in Northern Ireland steadily improved. Many cross-border roads that had been closed for a long time were reopened, and army patrols became less frequent. Shortly after the ceasefires, singer-songwriter Colum Sands travelled around the North with Jane Cassidy, performing for primary school children. Some schools,

[555] Colum Sands, 'Ceasefire', on All My Winding Journeys, Spring Records, 1996
[556] in McKittrick, 2000, 199

according to the singer, were still surrounded by tall security fences at the start of their tour. Within only a short period of time, these fences were lowered, and military presence in the North began to disappear. Change was in the air, and peace was about to become real at long last. Nonetheless, the singer argues that it would be naïve to believe that in today's world everybody wants peace. Especially for arms dealers engaged in the arms trade, an end to war would be disastrous: 'The merchants who deal in the weapons of war / Know that peace is the last thing they need.'[557] War for war's sake—making profit no matter what—is an attitude that, for some people, still remains unchanged:

> They feasted in Flanders Saigon Sarajevo
> To them every cause is the same
> And where boots trample reason and guns do the talking
> They'll set out their stalls once again.[558]

For the majority of people, however, every ceasefire marks a crucial time, a turning point in which agreements are reached that can lead to a peaceful future. For many women and children, this is also the time to come to terms with the grief often experienced because of the loss of a loved one. Now is the time for healing and to put the troubles of the past behind:

> And down in the valley the children are playing
> She watches them laugh in the sun
> A little girl's teaching her brother to walk
> And already he's trying to run
> And down in the valley the children are waiting
> Tomorrow a new day will start
> And she knows every time when she puts her arms round them
> The future is close to her heart.[559]

The song 'Ceasefire' clearly reveals the change of atmosphere people living in the North experienced when, after such a long time of incessant

[557] from Colum Sands, 'Ceasefire', on All My Winding Journeys, Spring Records, 1996

[558] ibid.

[559] ibid.

violence, peace was suddenly felt all around—'in the city, in the town and on the country roads wandering up and down.'[560] With a variety of very vivid images, the singer succeeds in reflecting on this vital event in the history of Northern Ireland and thus creates an historical document. While the feelings and emotions of relief shared by the majority of people are expressed, the song also functions as a reminder long after this moment has passed. Even when years have gone by and emotions might well have adjusted to what has become reality then, the atmosphere of that particular moment is still captured in the song. Whenever the song is played, an opportunity is thus created to relive this experience, to feel good once again, to seek renewed comfort, and to even allow the healing process to continue.

'Days Like This' and 'The Healing Game'

In a similar way, Van Morrison's song 'Days Like This' has taken on major relevance. Released in 1995, this song gained enormous popularity after the ceasefire. The singer performed it before Bill Clinton's speech on the president's visit to Belfast and Derry in late November 1995. This visit and the president's encouraging words about the new, hopeful developments towards peace in Northern Ireland were well remembered afterwards, as was Van Morrison's title track of his new album.[561] The song 'Days Like This' became so popular that the Northern Ireland Office soon used it as the theme of peace in their million-pound campaign to restore people's confidence in the province.

> When it's not always raining there'll be days like this
> When there's no one complaining there'll be days like this
> When everything falls into place like the flick of a switch
> Well my mama told me there'll be days like this [562]

[560] ibid.

[561] Days Like This , Polydor, 1995

[562] from title track of album Days Like This, Polydor, 1995

Two years later, the singer released the title track of his new album, *The Healing Game*,[563] which finds the singer reminiscing about his childhood upbringing in East Belfast. The video accompanying the song and photos on the album cover suggest that the singer and his crew went back to East Belfast to take the shots. While the music in the song creates an atmosphere that seems never ending, its lyrics also reveal that everything in life remains unchanged.

Here I am again
Back on the corner again
Back where I belong
Where I've always been
Everything the same
It don't ever change
I'm back on the corner again.[564]

In 1998, a tribute was held to honour the victims who died in the Omagh bombing on 15 August. According to an article in the *Wavelength*, a magazine dedicated to Van Morrison, it took only one phone call to confirm that the singer would attend the tribute.[565] Later the same year, the album *Across the Bridge of Hope* was released featuring Irish artists performing tracks for the Omagh Fund.[566] This album also included an alternative acoustic version of Morrison's song 'The Healing Game', which he had previously performed at the tribute. His truly emotive performance of this song during the event also brought to light the inherent aspect of healing that is evident in so many songs by the artist.

Sing it out loud
Sing it in your name
Sing it like you're proud
Sing the Healing game.[567]

[563] Exile, 1997
[564] ibid.
[565] in Wavelength (18/1998), 2
[566] White Record, 1998
[567] Exile, 1997

'The Music of Healing'

Over the last few years, a great deal of research has been done with regard to the effect of music on all kinds of healing. Interest in the influence of music has steadily increased, having first been extensively elaborated on in the publication *Music and Medicine*, a multi-author work edited by Dorothy Schullian and Max Schoen in 1948. Since then there has been a lot of academic interest in music's healing powers.[568] In fact, music therapy is now considered to be a fully accredited profession.[569] According to Barbara Crowe, who teaches music therapy at university level, music therapy 'can make the difference between withdrawal and awareness, between isolation and interaction, between chronic pain and comfort—between demoralization and dignity.'[570] As was mentioned in connection with Morrison's song 'The Healing Game,' some of the characteristic features of a song are also closely linked to the aspect of healing. Each song consists of a trinity between melody, lyrics, and voice/instrumentation. The melody functions as an engine that delivers words to express emotions. Once the engine stops, the same words can seem incoherent or even embarrassing. While the engine is running, however, voice, as the central instrument, and the words combine and can provide the listener with an experience of great relief and a feeling of transcendence away from everyday life. By creating this relaxing atmosphere, a song thus has the potential to contribute to the healing process. This is also evidenced in Van Morrison's song 'In the Garden' and explained by the songwriter as follows:

> I take you through a definite meditation process which is a form of transcendental meditation—it is not transcendental meditation—forget about that—you should have some

[568] for further information on the subject see: Ted Andrews, 2001 and The Journal of Music Therapy published by the American Music Therapy Association, Silver Spring, Maryland, USA (http://www.musictherapy.org, 18/12/2005)

[569] for further information on Music and Medicine and on the subject of musical healing see Penelope Gouk, 2000.

[570] Crowe on the subject of music therapy in http://www.musictherapy.org/quotes.html, 18/12/2005

tranquillity by the time you get to the end—it only takes about ten minutes to do the process . . . When you've got intimacy you've got more of a chance of taking people through this—this is what I am doing in this song.[571]

The healing power of music has also found acknowledgement in another area and has become of major commercial significance in recent years. It is not an exaggeration to say that music's ability to affect people's consciousness is practically used every day. For instance, music continues to be used most effectively if somebody wants to sell you a product. Playing nice relaxing music in a shop is a guarantee for good business. The 'feel good' effect manifests itself almost immediately. Customers are no longer reluctant to spend their time and money in this place, because the experience simply feels good. If music did not work in this context, it would not be used anymore. Phil Coulter, who is also known for his great variety of *Tranquillity* albums, recently referred to this subject and described his own musical contribution to it as 'Coulter-Geist' live on stage.[572] He stated that he was absolutely amazed at the number of souvenir shops, restaurants, and pubs in Ireland that are constantly playing his CDs, and to a great effect it might be added. Coulter is also convinced that music can be very therapeutic.

On the other hand, music can also be used effectively to create negative feelings. When it comes to closing time in Irish pubs, the playing of noisy, disturbing music usually makes people want to leave. Paramilitaries on both sides have, throughout the years, also successfully used a variety of songs to consciously create feelings of anger towards the 'other side'. Music's ability to influence people is not an entirely new concept. It is also evidenced in the fact that the 1746 Act of Proscription outlawed the playing of pipes.[573]

That music and songs can indeed be used with great effect has especially been proven right in the Northern Irish peace process. Attempts of cross-community interaction through art, including music, dance,

[571] Van Morrison in Brooks, 1999, 107
[572] Coulter in concert at the INEC, Killarney, February 2004
[573] for further information see Vallely, 1999, 17

poetry, and song have become increasingly popular in the North after the 1994 ceasefire.[574] The Citizen's Assembly held in 1996 and mentioned in Chapter IV, proved how music can succeed in initiating dialogue between people who thought it impossible to communicate with each other about their political opinions. What preceded the Citizen's Assembly was the Music of Healing[575] seminar held in Rostrevor in August 1995 for the first time and then chaired by Tommy Sands' 'good friend and neighbour,'[576] Mary McAleese, president of the Republic of Ireland from 1997 to 2011. Her experience of studying law in Belfast, along with her eloquence and involvement in politics, formed the ideal basis for what would soon develop into yet another successful step towards reconciliation. During the seminar, people from different political sides of the divide were encouraged to sit down together, although they would have found it extremely difficult to do so if the circumstances had been different. Among them were Francie Molloy from Sinn Féin and Roy Garland, a Belfast Unionist who had links with loyalist paramilitary groups. They were encouraged to talk about the common ground they all shared, and soon the dialogue became much easier, because music and song were all around them. Music functioned as a bridge, or could be compared to 'a boat they both could sail in, at least for a little while.'[577] For Mary McAleese, making the decision to chair this seminar clearly reveals that she saw the value of this project. She, along with so many other politically involved individuals, realized that music and song do indeed play a part in effecting political developments in the North. This is also evidenced in the fact that soon after she became president of Ireland, she invited Tommy Sands to present a number of Music of Healing events, featuring Irish uilleann pipes (the national bagpipes of Ireland) and orange Lambeg drums. In addition, the Music of Healing seminar first held in 1995 continues to be held as part of the Fiddler's Green Festival in Rostrevor, County Down, in August each year. The song that gave the seminar its title was

[574] e.g. projects organised by the BACS in East Belfast, for further information see Chapter III.

[575] For more information on the Citizen Assembly and the Music of Healing seminar see also Tommy Sands, 2005, 237-247

[576] Tommy Sands in interview, Limerick: 2004

[577] Tommy Sands in interview, Limerick: 2004

co-written by Tommy Sands and American folk legend Pete Seeger in 1995 and can be found on Tommy Sands' album, *The Heart's a Wonder*. In the album notes, Sands states that, as a result of the ceasefire, which brought a great sense of hope to Northern Irish society, ordinary people now have to learn to live together. According to the artist, music has the ability to heal some of the wounds in this process of reconciliation.

> Ah, the heart's a wonder
> Stronger than the guns of thunder
> Even when we're torn asunder
> Love will come again.[578]

Asked about the potential of a song to contribute to the healing process in Northern Ireland, Mickey MacConnell, however, states the following: 'I'm not a great believer in the theory, believing instead that songwriters and performers either write or perform songs which serve to reinforce prejudice and/or certain beliefs.'[579] MacConnell's own song material, as 'Only Our Rivers Run Free' and many other of his songs have illustrated, is very direct and political. However, even though he is doing quite a lot of work on the North himself and is getting mixed Catholic and Protestant audiences, he is not convinced that it is his task to contribute to the healing process: 'I think it's something musicians try to convince themselves of. I don't think it's the function of a songwriter to be overly concerned about healing. Well, I'm more a reporter and I'm inclined to report it as I see it.'[580] Mickey MacConnell thus distances himself from the whole concept of healing as supported by Tommy Sands, Van Morrison, and other artists. He argues that it is not a songwriter's function "to be overly concerned about healing."[581] Some songwriters, however, have chosen to focus on the healing aspect in their creative work—and with great success, it might be added. Songs like 'There were Roses', 'Days Like This', and 'The Healing Game' have proven that songs do indeed have the potential to contribute to the healing process in Northern Ireland.

[578] Green Linnet, 1995
[579] MacConnell in interview, Listowel: 2005
[580] ibid.
[581] ibid.

Even though MacConnell regards himself as primarily a reporter, it is worth noting that some of his songs are perceived by the audience in a very similar way to the way they receive the healing songs discussed here. The underlying structure of feeling in the song 'Only Our Rivers Run Free', for instance, expresses the feelings of a whole generation that was brought up in the surroundings of the Troubles. This is a song that, like Tommy Sands' 'There Were Roses', addresses the pain felt by the majority of people living in Northern Ireland in the 1960s and 1970s. MacConnell might not be concerned about the potential of songs to have an impact on the healing process in Northern Ireland; the way some of his songs have been perceived by the audience, however, suggests that his song material has definitely contributed to the healing process over the years.

'Absent Friends'

After 'Only Our Rivers Run Free' (1965) and 'Peter Pan and Me'(1980s), the song 'Absent Friends' presently marks the end of Mickey MacConnell's song cycle about growing up in Northern Ireland during the Troubles. According to MacConnell, 'Peter Pan and Me'[582] had 'brought the story a bit more up to date' when it was written in the early 1980s. In an interview with MacConnell in January 2005, he stated that he was not actually sure whether 'Absent Friends' marks the end of that cycle: 'I think there is probably a better song to be written.' Asked whether he has already written another song for the same cycle the songwriter said: 'I may have. I have written something, and I am looking at it, but I'm not convinced about it one way or the other. So, there might be another one.'[583]

In 'Absent Friends,' written around the time of the first ceasefire in 1994, two childhood friends meet again, and soon memories from the past become alive. 'In the days before the Troubles, before we grew to men,' suggests that the past was in fact a better place. The past is regarded as a lost phase of living in which happiness, security, innocence, and peace

[582] printed at the beginning of Chapter VI with kind permission of the songwriter

[583] MacConnell in interview, Listowel: 2005

were experienced.[584] Memories of 'youth and liberty and of a different better day' are strongly associated with this period of time before both people in the song went their separate ways: 'you picked up the ArmaLite, and I picked up the pen.'[585]

Reflecting on the past also brings back reminders that, ever since the Troubles started all those years ago, political change has yet to be achieved. Instead, many friends have been lost to this cause: 'And the greying ghost of freedom had whispered once again / About yet unfinished business and of many absent friends.'[586] The same song also speaks about love across the barricades, which the Troubles has made impossible: 'but there's not much chance for sweet romance in young hearts that have learned to hate.'[587]

In addition, 'Absent Friends' also brings back some sad memories. Childhood companion Big Joey started quite a remarkable career when he studied law at Queen's University Belfast. Soon after that, he could be seen 'one day serving beer in Brooklyn, next day U.S. Marines':

> How could they draft a Derryman to fight for Uncle Sam.
> Kindergarten in the Bogside—Graduation, Vietnam.
> And we all were very sorry he couldn't die at home
> Like all the other fine young men that you and I have known.[588]

Voices from the past keep haunting the person who addresses his friend Sean in the song, and the same person is wondering whether Sean can still hear these voices too. Many years have passed since the Troubles started, and yet the absurdity of useless bloodshed causing more of their friends to become 'absent' continues as they speak. Is it really necessary to let these voices keep coming back and to let this war continue?

Must the greying ghosts of freedom come whispering once again

584 for further information please find 'sense of place' in chapter I. (2. Theoretical Concepts)

585 from 'Absent Friends', on Joined Up Writing, Elm Grove Music, 2000

586 ibid.

587 ibid.

588 ibid.

About yet unfinished business and of many absent friends.
Must the bloodstained ghosts of freedom come whimpering once
again,
About yet unfinished business and of many absent friends.[589]

'Down by the Lagan Side'

Another song written after the 1994 ceasefire is Tommy Sands' 'Down
by the Lagan Side'.[590] Written to celebrate the opening of Belfast's
Waterfront Hall in January 1997, the song was also described by
Sands as a celebration of the two musical traditions in the North. The
harp as a symbol for the Irish musical tradition was represented by the
Belfast Harp Orchestra, while the song also incorporated a pipe band,
still—rightly or wrongly—regarded as representing the unionist side.
The opening of this new concert and conference venue more or less
coincided with the beginnings of the peace process in the North.
The song must, thus, have had an extraordinary effect when it was
first performed at the opening ceremony. According to the singer, the
atmosphere proved to be 'electrifying and memorable', and the audience
soon sang along in this new chorus full of hope: 'And when we dance,
we'll dance together / When we cry we'll hold each other / And when
we love we'll love forever / Down by the Lagan Side.'[591] In the song,
the songwriter also makes use of the very ancient Irish poetic form, the
aisling or vision poem: 'I thought she was a vision that stopped me with
her smile.'[592] Throughout the eighteenth century, this poetic form was
used as a vehicle for expressing political and social discontent and has
since become very popular in the Irish folksong and even popular music
genre. The woman represented in the song can also be regarded as the
key for a New Ireland at peace with itself. The two distinctive forms of
the traditional aisling, one in which the narrator is visited by a vision of
a beautiful fairy woman in his sleep, and the other in which the vision
of a woman presents an allegorical personification of Ireland, form a

[589] Elm Grove Music, 2000
[590] on To Shorten The Winter, Green Linnet Records, 2001
[591] from 'Down by the Lagan Side', on ibid.
[592] ibid.

symbiosis here. In addition, meeting this vision-like woman by the river also represents the attempt of dreaming a reality.

The songwriter himself argues that every reality has its origin in a dream. If the aim is to create a new reality, it is never enough just to think about it. Visualising a new reality, giving it pictures, imagining it, and dreaming about it is what it takes to make things change. Finally, the vision-like woman 'Down by the Lagan Side' is prophesying a new relationship in which love and happiness have overcome all the troubles of the past: 'And do you not remember we once walked side by side / And the bells of Belfast City sang harmony and pride / The past it has been taken but the future's yours and mine.'[593]

[593] ibid.

4

Moving On—Songs since 1994

Nearly twenty years have passed since the ceasefire was announced in 1994. To answer the question whether Northern Irish songwriters have continued to explore political issues in the North since then, two observations have to be taken into consideration. On the one hand, political songs for odd occasions are still being written today. They continue, as they have always done, to reflect on political events taking place in Northern Ireland. As it was in the eighteenth century when the first political songs[594] were written, the will to protest is still very much reflected. From the civil rights march (1968) to Bloody Sunday (1972), from the hunger strikes (1981) to the Drumcree crisis in 1996, this songwriting tradition continues:

> Ah, them people of Garvaghey, sure you
> Couldn't keep them happy,
> With all them shouting 'chuckey' though
> They never saw a hen,
> But with the RUC before us and their batons
> Waving o'er us,
> We will all join the chorus, 'happy days are
> Here again'.[595]

On the other hand, it can be argued that, ever since the 1994 ceasefire, songwriters have gradually ceased writing about the Troubles. Despite the impressive engagement by some Northern Irish songwriters, like Tommy Sands, to reflect directly on the peace process in song, the number of new songs having direct bearing on the Troubles is, in fact, diminishing.

[594] e.g. 'Shoot of Liberty', in Zimmermann, 1966, 42
[595] in Vallely (ed.), 1999, 367

During the first few months and even years after the ceasefire, the future for people living in the North seemed brighter, and there was a strong sense of hope. That very same hope, however, has since been replaced by feelings of neglect and anger at politicians once again. After all-party talks, the Good Friday Agreement, and the referendum in 1998, the opening of the devolved government in autumn 1999, and its dissolution three years later, the majority of people in Northern Ireland are still faced with the same dilemma. Sectarian murder attacks, although now less frequent, continue, while politicians from the North, the South, and Great Britain are still struggling to make the peace process work. Most songwriters are no longer interested in writing about these new developments and thus seek inspiration elsewhere.

Phil Coulter argues that people felt more passionate about writing songs about the Troubles before the 1994 ceasefire, and he is not really aware of any song of substance that has come about since then. This is his own point of view, but a vast number of artists from the North are of the very same opinion:

> I don't think you'll see Seamus Heaney writing too many poems about what it has been like after the ceasefire. I think for a lot of us from the North that passion has been dissipated and diluted. I think we are all getting just a little bit disillusioned and tired of the endless manoeuvrings and bickering and shifting of power from here to there. One step forward and two steps back. This is not the kind of stuff that inspires songwriters. What inspires songwriters, is people on the streets, you know, real events, real people, the rawness, the ritual violence that is happening and not this kind of endless talking and jogging for power and positions. That is just politics like in any other country. I don't feel inspired to write about that at all . . . I never thought I'd hear myself saying that but it is actually boring.[596]

[596] Coulter in interview, Dublin: 2004

According to two authorities on music from the North of Ireland, BBC broadcaster Tony McAuley[597] and singer-songwriter Phil Coulter,[598] there is hardly any song material worth examining in this period. Phil Coulter warned listeners to be careful not to try and make the words of a song fit or to read something into the lyrics which in fact might not be there at all. Most of the songs, again treating Tom or Colum Sands' enthusiastic engagement as an exception, have in fact no direct bearing on the Troubles. However, a more thorough analysis of the song lyrics reveals that certain themes and motifs have occurred repeatedly. It is therefore necessary to take a closer look at the song material that was written during the first ten years after this turning point in Northern Irish history.

Growing up or living in Northern Ireland led many artists, consciously or subconsciously, to develop a symbolic network of themes and images which by now can be recognized in a great variety of songs. The following part of Chapter VI will therefore take a closer look at some of the themes and motifs most frequently used by contemporary songwriters from the North. In addition, it is also of major significance to find out in how far a new generation of songwriters is reflecting on their experience of growing up in the North. It is helpful to examine song texts by contemporary Northern Irish artists, such as Brian Kennedy and Juliet Turner, who were both brought up in the 1960s and '70s at the height of the Troubles. They both left home to start careers abroad, have since been successful on the world stage, and have performed back at home on many occasions. They sing and speak with an unapologetic Northern Irish accent. Yet the question is, does any of their song material bear any reference to their Northern Irish backgrounds? Looking at their song material and listening to the two songwriters themselves, it is clear that they have had no intention to reflect on the Troubles in song. Juliet Turner said specifically in an interview with journalist Pól Ó Conghaile in autumn 2004 that she is not interested in writing about political issues.[599] In a short interview before he played at the INEC Killarney performance

[597] interview in 2002
[598] interview in 2004
[599] see Pol O Conghaile, 2004, 7-10

venue in April 2004, Brian Kennedy gave a similar reply. He had no interest in dealing with Northern Irish politics in his songs.[600] It soon became clear that these two artists, like many others from the North, had, by leaving their homeland, also left the Troubles behind. For obvious reasons, they no longer wanted to be associated with political developments back home; they had moved on, and they had left this part of their experience behind. Nonetheless, a study of their song material reveals that there are certain references that are closely linked to their cultural background. In addition, the structure of feeling that can be recognized in the following song material will help to reveal how the healing process and reconciliation are already well under way in Northern Ireland. Chapter VI mainly concentrates on the song material and includes a lot of relevant information the artists themselves provided in interviews over the last few years. The results of this examination will be shown in more detail in Chapter VII.

Finally, throughout the 1990s and into the new millennium, some songwriters from the South of Ireland have also continued to reflect on Northern Ireland in song. Three examples at the end of this chapter will therefore show how new political and social developments in Northern Ireland continue to engage songwriters from the South.

'The crowded streets of Brooklyn seem a long way from my home[601]

The song 'The Hills of South Armagh', written by Briege Murphy, reflects on the familiar theme of emigration and exile. Emigration, as described in this song, has been common in Ireland since the late seventeenth century, and the experience of emigrants has well been reflected in a vast number of songs ever since. Starting off with songs about the eighteenth-century migration of Northern Protestants and emigration as a result of the Famine a century later (for example, 'Skibbereen', 'Thousands are Sailing', 'The Rambling Irishman'), a modern perception of emigration remains one of the predominant

[600] Brian Kennedy in interview, Killarney: 2004
[601] from Briege Murphy, 'The Hills of South Armagh', on The Longest Road, Spring Records, 1995

themes in Northern Irish songwriting today. Whereas Brian Kennedy's song 'By the Mountain Road' expresses the grief of a person who has already emigrated: 'Every time I hear a train I think of all the years I've been away from home.'[602] a decision about staying or leaving still has to be made in Kieran Goss' 'Reasons To Leave':

> Reasons to leave
> Are money and finding better work
> Reasons to stay
> Are music and love
> Reasons to leave
> Are fortune and fame for what it's worth
> The reason to stay
> Is heaven on earth. [603]

The sentiments expressed in contemporary songs about emigration are very similar to the ones that can be found in older song material.[604] They continue to express the anger at having been forced to leave, and the strong wish to return home. This is also evidenced in Van Morrison's 'One Irish Rover' and 'Got to go back':

> Got my ticket at the airport
> Well I guess I've been marking time
> I've been living in another country
> That operates along entirely different lines
> Keep me away from porter or whiskey
> Don't play anything sentimental
> It'll make me cry
> I've got to go back my friend
> Is there really any need to ask why.[605]

[602] Brian Kennedy, 'By The Mountain Road', on A Better Man, BMG 1996

[603] from Kieran Goss (co-written with Rodney Crowell), 'Reasons To Leave' on Red Letter Day, Cog Communications, 2000

[604] e.g. the traditional song 'Skibbereen', written during the Great Famine (nineteenth[th] century)

[605] from 'Got to go back', on No Guru, No Method, No Teacher, Mercury, 1986

Writer Polly Devlin explains that, for people growing up in Ireland, emigration featured dominantly in everyday life: 'All our Irish prayers and songs daily delivered the same lesson; that we lived in a vale of tears, a stepping point on the hasty road to eternity. We were all poised on the point of eternal emigration.'[606]

In Briege Murphy's 'The Hills of South Armagh',[607] the beautiful description of nature in the place that once was home stands in clear contrast to the reality now experienced in exile:

> Where the grass is fresh and green where the air is pure and clean
> Where the gentle rivers kiss the mountain stream
> Although I've travelled far the hills of South Armagh
> Oh, the hills I'm roaming nightly in my dreams
>
> The view from my apartment is a junky's alleyway
> People speaking accents not like mine
> My old man's working in two jobs
> I don't see him much these days
> We'd be happy if we only had the time.[608]

Unlike many of the songs dealing with emigration, this song gives no reasons as to why home had to be left behind, and instead focuses on the experience and difficulties of living in the unfamiliar, faceless, large metropolis of New York ('The crowded streets of Brooklyn . . . '[609]). The singer might have drawn inspiration for this song from her own experience. She might have had to face similar problems while living in Spain with her children for a while. This song also has an air of melancholia and quiet resignation about it. In new surroundings it is difficult to socialize and to become friends with people who are not interested in anyone but themselves:

> People rushing onwards going to and coming from

[606] in Logue, 2000, 42
[607] on The Longest Road, Spring Records, 1995
[608] ibid.
[609] ibid.

You bid them time of day and they look the other way
And so you end up just like them and talk to no-one. [610]

In Juliet Turner's song 'Beyond the Backyard' emigration is seen as an alternative option to leaving the past behind and starting a new life: 'Lay down to rest all your ghosts in America, take up the new true blue you.'[611] Yet the past is not yet overcome: 'She's still clawing after clues' while she relives the past in the present: 'And it's where she used to fancy the Catholic boys on the bus / But it's hard to slip past the priests and disregard years of them and us.'[612] The phrase 'the inheritance encrusting her skin is pulling her down' hints at a person's individual upbringing but also reflects an awareness that someone living in Northern Ireland could easily identify with.

'Don't want to be tied down, desperate for home' [613]

In 1996, Juliet Turner's debut album, *Let's hear it for Pizza!*, was released. The album included the song 'Edward', which describes the experience of growing up in Northern Ireland. It contained the lyrics: 'And he won't sit down to talk as there's a Fenian in his seat. / But when his Catholic friend got killed his heart went missing.'[614] Talking about the cultural differences between the Republic of Ireland and Northern Ireland, Turner believes that being brought up in the North had a significant impact on shaping her outlook:

> Even though it's only a couple of hours up the road, it's very different to the Republic. You are steeped in religion from the minute you pop out. It's not just going to mass on a Saturday night to absolve your sins before you go out and create some more.[615]

[610] ibid.
[611] from 'Beyond the Backyard', on Let's hear it for Pizza! Stickey Music, 1996
[612] ibid.
[613] from 'Too Close For Comfort', on Let's hear it for Pizza! Stickey Music, 1996
[614] from 'Edward' on ibid.
[615] Turner in Pól Ò Conghaile, 2004, 7-10

As a child, Turner became strongly influenced by her local Methodist church. This is where she discovered her love of music. In addition, the faith that dominated her family and social life also made her respect the beliefs of others. However, because she is in the music business, she rarely talks about her faith: 'To admit having any sort of faith is immediately looked down on. You're immediately seen to be some kind of evangelical, fundamentalist idiot who's going to foist their religious ideas on other people.'[616] Asked about whether she has ever considered exploring political issues more overtly, she argues that art is far too easily hijacked for political or religious ends. She has 'no desire to be an ambassador for anything.'[617] Neither does she have any interest in tying herself down to any one ideology, as that would have a significant impact on her freedom to explore.

With regard to the power of songs to alter people's perspective on the Northern Irish situation, there is another important aspect which should be taken into consideration here. While a sense of political duty might have driven some songwriters to reflect on the Troubles, it could be argued that some others simply sought to deliver a peace song to gain wider recognition by the media. As mentioned earlier, most Irish and Northern Irish musicians have increasingly been affected by the dramatic commercialisation of their music. The majority of musicians can no longer resist the opportunities offered by recording companies, the media, corporate sponsors, and all kinds of marketing gurus. After all, without these institutions many musicians could never make a living out of their art. Thus, this attitude has to be accepted and is well justified up to a certain degree.

The danger with commercialism, however, is that there might always be a minority group of musicians, and especially songwriters, who no longer have scruples and simply write a peace song to get the attention of the media and to ensure them a few gigs. There is no way of really finding out how many of the now more-established musicians really resist such rather misleading challenges of success and continue to remain true to their musical gift instead. Juliet Turner's decision not

[616] ibid.
[617] ibid.

to release her version of the Julie Miller song 'Broken Things' after performing it a week after the Omagh bombing can be regarded as just such a brave and very courageous decision. At that time, there was a lot of pressure from the media and recording studios to release the song, and still this artist resisted. According to Belfast musician Paddy Walsh, her attitude showed great integrity.[618] This example also serves to illustrate how serious the impact of commercialism can be in its willingness and eagerness to make money out of a tragic event such as the Omagh bombing. However, the release of the album *Across the Bridge of Hope* (autumn 1998), mentioned earlier, is an example of the use of commercialism at its best and the way it should be. In this case, famous Northern Irish musicians got together to produce an album to collect money for the Omagh Fund. As long as such approaches towards the marketing industry continue, hope for the revival of the true values of music and song will remain. It might be worth noting that the recording *Across the Bridge of Hope* also featured the song 'Broken Things' sung by Juliet Turner. After resisting the pressure from the media a few months earlier, this time it was for a good cause, and Juliet Turner was more than willing to make a contribution to help the victims of the Omagh bombing.

> You can have my heart though it isn't new
> It's been used and broken and only comes in blue
> It's been down a long road and it got dirty on the way
> If I give it to you will you make it clean and wash the shame away. [619]

'Oh I just heard a melody and it almost made me cry,
my voice was filled with yearning . . .' [620]

People from many cultures have experienced a history of profound loss, as have the people in Northern Ireland. The theme of underlying

[618] Paddy Walsh in interview, Belfast: 2002

[619] from 'Broken Things' on Julie Miller's *He Walks Through Walls*. Hightone Records, BMG Songs, 1999

[620] from 'Captured', on Brian Kennedy, *Won't You Take Me Home*...BMG, 2000

melancholia runs through many songs written by Northern Irish songwriters. This is not an entirely new invention and can also be traced from many patriotic Irish songs of the nineteenth century. In these songs, Ireland is often represented as a lamenting woman; for example, as legendary Gráinne Mhaol.[621] One does not have to go far to find Irish songwriters who still express a great sense of melancholia in their creative work, be it Van Morrison,[622] The Adventures,[623] or Phil Coulter.[624]

According to Linda Phyllis Austern, a specialist in sixteenth-, seventeenth-, and early eighteenth-century musical-cultural relations, melancholia, described by her as 'one of the few disorders', has engaged poets, physicians, artists, and philosophers for many years: 'From the elite language of French psychoanalytic philosophy to the popular accessibility of modern American "alternative rock" music, melancholy still remains, at the end of the twentieth century, an "infinite sadness".'[625] The same author argues that especially 'during periods of violent change in political and religious institutions,' the disorder's influence on artistic imagination has always been particularly strong. Talking about melancholia and its specific musical expression in modern terms, Austern continues:

> The melancholy strain in rock has had a softer sound, a gentle longing for a distant place of comfort to which no living body can ascend the desire for a phantasmal object or missing part of self that no lover can fulfil. Through an indefinite sense of love and loss, such songs move beyond mere lovesickness and return to an overarching sense of melancholia.[626]

[621] e.g. 'Her head was bare, and her grey hair, Over her face hung down' from 'Granu Uile's Lamentation to Brave O'Connell', in Zimmermann, 1966, 56

[622] e.g. 'Melancholia'; 'Underlying Depression'; 'When The Leaves Come Falling Down'

[623] 'Broken Land'

[624] 'The Town I Loved so Well'

[625] Austern in L. Gouk, 2000, 117

[626] ibid., 132

Medical literature has by now also linked melancholy to love, describing melancholia as 'a great despairing cry for love.'[627] Soon music was regarded as the perfect cure and 'became the standard vehicle through which erotic melancholy was both relieved and represented.'[628] Throughout the twentieth century, and partly inspired by German philosopher Nietzsche, whose ideas reunited the human body with the mind, music has even 'come to serve as a scientific language of embodied emotionality.'[629] In addition, English court composer John Dowland's songs of sorrow, written in the late sixteenth and early seventeenth centuries, have recently been reconnected to an 'early modern cult of melancholy',[630] and even Shakespeare referred to melancholy and the effect of music in his creative work:

> When griping grief the heart doth wound,
> And doleful dumps the mind oppress,
> Then music with her silver sound
> With speedy help doth lend redress.[631]

The songwriting and singing style of Northern Irish artist Brian Kennedy can be regarded as a perfect example that melancholia is still reflected in contemporary song material today. Kennedy strongly believes that melancholia still exists and offers the following reason for its continuing presence:

> I suppose it's possible given that songs and poetry were really the only safe way to record history because for the longest time it was too dangerous to write anything down. It's interesting too how sometimes the most difficult words are easier to sing than to say. [632]

[627] in ibid., 118

[628] Ferrand, ibid.

[629] ibid., 128

[630] ibid., 124

[631] from Romeo and Juliet. Act 4, Scene 5 in http://www.onlineshakespeare.com/music. htm, 28/10/2004

[632] Kennedy in Logue, 2000, 95

Kennedy was born in 1966 and brought up in the Falls district of West Belfast. In his song 'Being Irish', the artist describes how, through external circumstances experienced in his childhood, he discovered his own identity without difficulty: 'When I was growing up on the Falls Road in Belfast, I was made violently aware that it was illegal to think of myself as anything other than a British subject.'[633] While he was in school, Irish was taught as a foreign language, and British history was much favoured. Despite this, Kennedy continues, 'It never occurred to me for a second that I was anything other than Irish, mainly because of the political situation I found myself in.'[634] By starting his musical career and moving to London, Kennedy left this political situation behind. More importantly, the artist had discovered an ideal medium through which he could express even his most severe emotions: 'For me, music replaced guilt as the petrol in the engine of change. Given that it is the language of emotion universally, songs are a safe place to visit how you really feel, regardless of the intensity.'[635]

Beside melancholia, fear is another theme of many songs written by contemporary Northern Irish artists. Thomas Kilroy believes that a modality of fear can be found at the root of Irish culture. Over the years, politics and education, especially by the two main churches, Roman Catholic and Presbyterian, have contributed to the source of that fear. According to Kilroy, this fear perverts and distorts moral values and inevitably leads to forms of tyranny and violence even under the circumstances of rather democratic politics. As a result, people experience a kind of disconnectedness and a severe insecurity.[636] Soon the scared individual faces a void, on the one hand reflecting what has been, and on the other afraid of what soon might be. This experience, then, stands in the individual's way to move forward, and every development that could lead to relief stagnates:

> When you sleep tonight
> Will you dream

[633] ibid.
[634] ibid.
[635] in ibid., 94/95
[636] Thomas Kilroy in ibid., 135-141

> About a brighter life, oh it's gonna last
> And we hope for more
> But my heart is so unsure.[637]

Hopelessness and helplessness solidify and reach a deadlock. The worst outcome of fear is created when the failure to change turns into a destructiveness of the self that, at that stage, can easily generate violence or lead to the destructiveness of others. Fear, however, can also have an obvious positive effect. If an individual manages to transform, he or she can overcome the void. Fear can give the individual an impetus for change, signalling that either retreat or escape from the rigidity of fear will be achieved.

Since 1994 there has been a gradual shift from pessimism to a more confident and optimistic perspective on life. A great number of songs by Northern Ireland artists reflect this new orientation. In the song 'Sunrise', written by the Divine Comedy and mentioned earlier, this is clearly reflected:

> From the corner of my eye a hint of blue in the black sky
> A ray of hope, a beam of light, an end to thirty years of night
> The church-bells ring, the children sing. What is this strange and beautiful thing
> It's the sunrise. Can you see the sunrise? [638]

While fear still exists, it is now used as a useful tool in the process of finding a resolution. The new motto is 'feel the fear, but do it anyway', as psychologist Susan Jeffers argues in her best-selling book.[639]

Talking about the reason that so many songs written by Northern Irish artists have gradually become more optimistic throughout the 1990s, Tommy Sands explains:

637 from Brian Kennedy, 'Life, Love & Happiness', on A Better Man, BMG 1996
638 from Divine Comedy, 'Sunrise' on Fin de Siécle, Import, 1998
639 for further information see Susan Jeffers, Feel the Fear and Do It Anyway, Arrow Books, London: 1987.

Before you can move out of a cave, you have to see a light to move towards and as a writer I know that there is a light there, I know there's a way out of this. So it's up to people like that to show that there is a light, to give people the opportunity to start moving. If there is no light and it's dark, where are you going to go? So that's the very conscious road of a lot of songwriters in the Northern Ireland context.[640]

This is also reflected in Brian Kennedy's song 'Life, Love & Happiness', released in 1996. A few months earlier, in November 1995, Brian Kennedy had joined Van Morrison in Belfast in a duet for President Bill Clinton who soon afterwards delivered his encouraging speech about the future of Northern Ireland, an event that was televised worldwide. While Kennedy's 'Life, Love & Happiness' again does not specifically pursue any political issue whatsoever, it does put across a very powerful and encouraging message. Like the simple but catchy chorus in Van Morrison's 'Healing Game', the lyrics in Kennedy's song are also simple, but at the same time contain very strong and encouraging words. These words are slightly altered and repeated throughout the song, and especially when sung in a live performance, can create a very motivating and affirmative statement. Before long, the audience joins in and is captured by this positive mental statement. Like a power boost, the positive thinking reflected in the song contributes to help the listeners handle life a little better, even if only for a little while. No matter what the external circumstances are, 'Don't give up again / 'Cause it's your life / Your love / Your happiness.'[641]

Finally, reflecting on his own cultural background in Paddy Logue's book, *Being Irish: Personal Reflections on Irish Identity Today*, Kennedy states that, 'When anything is denied and suppressed, it just increases the appetite for it. We've been on an emotional diet for too long.'[642]

[640] Tommy Sands in interview, Limerick: 2004

[641] from Brian Kennedy, 'Life, Love & Happiness', on A Better Man, BMG 1996

[642] Kennedy in Logue, 2000, 94

'So we've come to the border / But we've been down this way before . . . [643]

Throughout the troubled history of Northern Ireland, songwriters from the Republic of Ireland have continued to present their own perspective regarding this conflict in song. The final part of this chapter will therefore look at some of the material written by contemporary songwriters from the South. Some artists from the North, like Phil Coulter and Mickey MacConnell, have argued that, "to write about the North, you really have to come from the North." Otherwise, it will always be a "second hand experience"[644] only. However, as the following remarks by MacConnell show, in order to write a song about the Troubles, it is probably even better to leave the North:

> It is very easy for me to sit in Kerry and write songs about the North of Ireland, whereas it is a different thing if you are sitting in East Belfast or in Newry because there are different pressures, different strains on you. Plus the fact, that the North is very claustrophobic and it is very difficult by living and operating in the North to see what's further than your own immediate circle and the people you interact with all the time and the same messages that are getting reinforced and you are being bombarded with them all the time. The North

[643] from 'Northern Girl', on Ciarán Wynne, No Way Home, Mid-Atlantic Studios, 1999
[644] Mickey MacConnell in interview, Listowel: 2005

is such a terrible small place that it is very difficult to get a wider overview.[645]

Even while living in the Republic of Ireland, no matter how far away violence and sectarian killings often seemed from the tranquillity and peacefulness, war was just around the corner, and it was still ongoing, right there, at that time, and on the same island. Through political developments, detailed coverage through the media, and conversations with people who commuted between North and South on a regular basis, one was made further aware that a lasting solution for the North had yet to be found. No matter how ignorant a person brought up or living in the South of Ireland chose to be regarding the conflict in the North, there has never been an escape from up-to-date information.

Singer-songwriter Ciarán Wynne from County Kildare was brought up in the Republic of Ireland and explains that, before the ceasefire in 1994, all the headlines every morning were about sectarian killings in Northern Ireland. A few years later, in 1998, Wynne read an article in the newspaper about the sectarian killing of a young Catholic girl in Northern Ireland. She had been murdered while she was sleeping with her boyfriend, who was Protestant. The only reason she was killed was that she was a Catholic. Feeling deeply upset and angry after reading about this tragic event, Wynne wrote the song 'Northern Girl'. While writing the words, the artist literally tried to get inside the young man's head and to think how he might feel about this shocking loss: 'Don't try to tell me that it ain't right / Don't try to tell me that it ain't true / Cause they're never gonna stop me from lovin' you.'[646]

In an interview, the songwriter further stated that he was not a big fan of politics. For him politicians often acted like puppets on a string. According to Wynne, 'there is an awful lot of stuff going on behind the scenes' and everybody is aware of that by now.'[647] This is also reflected in the song. Politicians might try and tell the young man how to live his life, but he finds it rather difficult to agree with them. As far as he

[645] ibid.

[646] from 'Northern Girl', on Ciarán Wynne, No Way Home, 1999

[647] Ciarán Wynne in interview, Killarney: 2005

is concerned, no matter what politicians negotiate or whatever message they deliver through the media, they will never understand:

> There's politicians there on my radio
> They're telling me, which way I should go
> But they can't talk or think without a string
> They don't know anything.[648]

After experiencing what this young man has, it is difficult for him to come to terms with reality. Yet, he is trying to make some sense of it all. The songwriter, although he has never personally met this man, sees him as an ordinary person who, in his heart, wants peace. Unfortunately, his religion did not help him to find a solution. Nonetheless, perhaps talking to the people responsible for his grief could bring some understanding. Perhaps it could even lead him towards forgiveness and peace some day. Until then, however, grief, anger, and confusion will continue:

> And if they try to talk to me
> I will try to understand
> But how can I hear them Lord
> With their heads beneath the sands
> And I have seen the visions on the TV screen
> But I guess my religion has left me
> Somewhere in between. [649]

Another song, 'Independence Day', written in 2000, describes the loss of a brother through the ongoing fight for justice in Northern Ireland. The song was written by Ronny Moore, who was born in County Donegal in 1952 and now lives in County Kerry. While she listened to a person on the radio talk about losing his own brother in the Troubles, she realized that, as it had been with this particular incident, it was always the ordinary person that seemed to suffer the most. Moore describes her song as universal and non-partisan: 'It doesn't talk about who is right or

[648] from 'Northern Girl', on Ciarán Wynne, No Way Home, Mid-Atlantic Studios, 1999
[649] ibid.

who is wrong, and it does not really matter whether it is in Northern Ireland or anywhere else.'[650] For Moore, neither victim nor killer is to blame here; instead, she argues, 'it's some problem devised and designed and organized by the powers that be that send these people out to take revenge on totally innocent people.'[651] At the same time, the song acknowledges the fact that both sides have suffered in this ongoing fight: 'Well I can't say that you've not suffered / But tell me why my brother was sacrificed.'[652] Through 'peaceful insubordination' the 'brave hero' Mahatma Gandhi had 'won the right to freedom where gunmen failed.' Ronny Moore herself regards Gandhi as her hero: 'Anybody who has that strength of character, that quite confident strength is just something I really admire so much.'[653] Moore believes that a lot can be achieved by not accepting peaceful insubordination. Gandhi's own behaviour reflected this just insubordination and civil disobedience. 'But this thing of feeling that you have to blow the heads off everybody to get it your way has never worked in any society.'[654] Instead, it is the not taking action, according to Ronny Moore, that can have great effect. While she can understand how people in the North feel very frustrated about what has happened over the years, she finds it difficult to accept that a minority still feels the only course of action is the shooting and bombing of innocent people. Hence, the killing continues: 'The gunmen cry 'There will be others, / Till the flag flies on Independence Day.'[655]

Ronny Moore was born in 1952 and was brought up in Donegal, across the border from Northern Ireland. She left home when she started boarding school in Dublin in 1964. She was brought up fairly close to the Troubles and remembers how, in 1969, busses came over across the border looking for people to come in and help throwing stones in the city of Derry where, at that time, people were under siege in the Bogside.

[650] Ronny Moore in interview, 2005

[651] ibid.

[652] Ronny Moore, 'Independence Day', unreleased at the time of writing, printed with permission by the artist

[653] Ronny Moore in interview, 2005

[654] ibid.

[655] Ronny Moore, 'Independence Day', unreleased at the time of writing, printed with permission by the artist

'For years I have been listening to arguments and they were all true, they were all right, everybody's argument is right but where does it get you because my truth is different from yours?'[656]

> And you say that truth will vindicate you
> And the bible says it will set you free
> But there's one for love and there's one for hatred
> And there's a truth for you and a truth for me.[657]

While Ronny Moore's song is another perfect example of a song written by a so-called outsider regarding Northern Ireland, her personal background is somewhat different. Even though she was not living in the North as such, living just across the border in Donegal brought her close to the actual Troubles. However, in the interview with the artist, she made it very clear that, 'unless you are suffering from the Troubles yourself,' you cannot possibly succeed in making sense of it. After moving down to Dublin, she thus often became frustrated when people tried to comment on developments in the North:

> They assumed that the police were non-partisan, they assumed all these things. They talked about how people could get involved in the IRA without having any concept of what it is like to live in a house where three o'clock in the morning your door gets broken down, the floor boards of your house get ripped up just to look. You might have absolutely nothing got to do with it but your property is destroyed, people are frightened, kids are crying and what does that do to the young people living in the house. People don't understand, they can talk about it, they can read about it, but I think it's hard for anybody, myself included, to understand what that must really be like.[658]

[656] ibid.

[657] from 'Independence Day', Ronny Moore

[658] Ronny Moore in interview, Killarney: 2005

Finally, songwriter Ron Kavanagh, from Fermoy, County Cork, also reflected on the conflict in Northern Ireland in his song 'Reconciliation'. Even though the song was written back in 1991, it gained great popularity after the ceasefire and has been recorded by many artists ever since. The familiar metaphor of a couple whose love is not meant to be due to the political divide is used to great effect here. Left alone, with no support from friends, their love has to stand the test. After seasons of fighting, a new season has given rise to new hope, and with reconciliation in the air, wounds of the past can heal at last:

> Now there's a time to fight
> And there's a time for healing
> Just like the sun will melt the snow
> On clear bright April mornings
> Our fight has run its course
> Now is the time for healing
> So let us both embrace
> Sweet reconciliation.[659]

[659] from 'Reconciliation', Green Linnet, 1991

VII.
'AND THE HEALING
HAS BEGUN'[660]—
CONCLUSION

[660] from Van Morrison ,'And the Healing Has Begun', Into the Music, Warner, 1979

Don't beat the drum that frightens the children

Don't sing the songs about winning and losing

Sit down beside me, the green fields are bleeding

Sing me the music of healing. [661]

[661] from Tommy Sands, 'The Music of Healing', Green Linnet, 1995

Northern Irish society has come a long way since the outbreak of violence in the 1950s and the beginning of what is now generally known as the Northern Irish peace process. For many years, the conflict in Northern Ireland has been characterized by mistrust and ignorance. Along with ignorance about the other side, fear has constituted an obstacle in the process of initiating mutual understanding too. Reflecting on the situation of Northern Ireland's divided society back in 1991, Irish playwright and novelist Thomas Kilroy argued that 'the fierce power of this divisiveness is subliminal, hidden, which makes it extremely difficult to confront—but confront it we must.'[662] In today's world, where globalization has affected many different areas of life, a better understanding of foreign cultures is urgently required. Due to the continuing changes in Europe on the one hand and increasing regionalism on the other, it has become extremely important to encourage dialogue and mutual understanding. This can be achieved only by shedding more light on the unknown and the unfamiliar. Examining a society's cultural background and its conflicts has thus become of major significance. Only through a detailed explanation of a culture and its peculiarities can barriers that were created by prejudice and that have hindered cultural dialogue in the past be gradually abolished. In regards to the Northern Ireland situation, it is high time to stop reacting through prejudice. According to the Jesuit priest Anthony de Mello, 'We cannot see clearly if we are prejudiced. Understanding is required, not condemnation.'[663] In a similar way, it can be argued that understanding and acceptance have to go hand in hand for any reconciliation process to work. Talking about her song 'Independence Day', songwriter Ronny Moore stated in an interview that 'whenever a group of people come together and just insist that their way is right, the

[662] Thomas Kilroy in Longley, 1991, 137
[663] Anthony de Mello, 1990, 115

result is entrenchment of the other side.'[664] This entrenchment, although for a long time used as a characteristic feature to describe the situation in the North, has gradually lost its appeal.

Since the early 1990s, and especially after the ceasefire of 1994, there has been new hope, and an Ireland at peace with itself has been successfully promoted. Various organizations, such as the Ballymacarrett Arts & Cultural Society in the North or Co-operation Ireland in the South, have in recent years tried their utmost to get people together, helping them to lose their misconceptions about the 'other side'. In an interview with David Boland, Tony Kennedy, chief executive officer of Co-operation Ireland, talked about his organization's achievements and described recent changes as follows:

> What has been noticeable is that there is a greater willingness among the Protestant working class to travel across the border into the South. But we have also seen both sides prepared to be more open about their involvement—there were groups in the past which were involved in Co-operation Ireland but which would not tell others about their involvement. [665]

Kennedy is also convinced that it is the relationship between the two Irelands—the North and the South—that holds the key to lasting peace on the island. Through educating people and breaking down barriers during this period of relative non-violence in Northern Ireland, mutual understanding has gradually been achieved, and the spirit of peace has started to emerge and can slowly but surely be felt.

Paddy Logue, editor of *Being Irish: Personal Reflections on Irish Identity Today*, suggests that, as far as Irish identity is concerned, there were certainly more backward glances, blaming others for the Irish situation, escapism, and hypocrisy in the early 1990s. Today, however, this has changed. Now there is an orientation to the future and an acceptance of responsibility to deal with whatever that future brings. Confidence,

[664] Ronny Moore in Interview, Killarney, 2005
[665] Tony Kennedy in Sunday Tribune, 24 October 2004, 16

realism, and honesty seem to have taken over at last.[666] However, in his book/CD/event project *Belfast Songs*, published in 2002, Daniel Jewsbury argued that whatever achievements have been made regarding the peace process in recent years, it is still not enough: 'We haven't reached the truth and reconciliation stage yet, as is witnessed by the Tele's [*Belfast Telegraph*] continuing pique at the mounting costs of the Bloody Sunday Inquiry.'[667] Asked about his personal opinion on the present political situation in the North, journalist and songwriter Mickey MacConnell made the following statement in 2005:

> The war is over. When you see such diametrically opposed people as Ian Paisley and Gerry Adams, Adams prepared to go and sit down with Tony Blair, when you see Paisley prepared to sit down with Bertie Ahern in Dublin, basically you know the game is over. All that's happening now is the cosmetics. There is an election coming up in May, the British election. But it's all over; it has been over for a long time. But it also has to be remembered, I think that everybody who grew up in the North and certainly my own generation knows, that we are a fatally flawed and diminished generation of people because of the sectarianism we had to work our ways through. And when I look back now I look at the rearing I got and my childhood experiences and I was steeped in bigotry and sectarianism and that is something I have been consciously fighting all my life. But at least if you recognise that you have a tool to start doing something about it. [668]

Reflecting on the continuing impact of the media, MacConnell is convinced that this institution has always played a significant role and even succeeded in creating a kind of balance in the Northern Ireland situation: 'When the media isn't there, bad things happen. It's only when they bring the full spotlight, publicity, exposure to a situation that things actually get done.'[669] Not allowing the media to handle the Northern Ireland

[666] Logue, 2000, xxi
[667] Daniel Jewsbury in Hackett, 2003, 59
[668] Mickey MacConnell, Listowel, 2005
[669] ibid.

conflict would, according to MacConnell, have been a great mistake: 'God knows, the media has gone overboard in certain ways but on a scale of the good that has been done against the damage that has been done it's measurably weighted in terms of the good that came out of the scrutiny.'[670] MacConnell also described how everyone from his own generation who grew up in Northern Ireland was seriously damaged in many ways. The prime movers behind the conflict of the 1970s and 1980s would be of the same or nearly the same age as he according to MacConnell. Looking back now, the last thing these people want is their children and grandchildren to have to go through exactly the same. Reflecting on the past, they have realized that they cannot win: 'They know they can't beat the British army, and the British army can't beat them.'[671]

By bringing together and exploring the bulk of song material that has been written by songwriters from the North, this examination has provided a comprehensive insight into Northern Irish society from the outbreak of the Troubles to present developments. Throughout the Troubles, songwriters from the North have reflected in their creative work on the ongoing struggle for peace. Drawing on their own personal backgrounds, especially their upbringings in the North, they have succeeded in documenting the changes that have emerged in Northern Ireland over the years. These include political and social changes, but they also reveal how Northern Irish society itself has gradually changed due to the continuation of the conflict. During the research period for this book, it soon became clear that there was an abundance of resource material regarding the creative work of contemporary Northern Irish writers. However, as far as the tradition of songwriting in Northern Ireland is concerned, there were hardly enough literary sources available. For this reason, this book aimed at illustrating that song lyrics must equally be regarded as an ideal medium from which a society's cultural background and its conflicts can be examined. The great variety of song material that has been written by Northern Irish artists, be it in the orange or the Irish folk tradition, or even in the fields of rock and pop, can become an alternative element in the process of enabling cultural dialogue. The structure of feeling, as reflected in the song texts, continues to have a significant role in this process. By

[670] ibid.

[671] ibid.

articulating the consciousness of people living in the same society, this concept reveals significant information about specific periods of time. It has, therefore, also achieved to contribute to a better understanding of the Northern Ireland conflict.

Chapter III illustrates how, for many years, and right through the nineteenth century, song material from both traditions—the Irish and the orange—reflected similar feelings of sectarian hatred. These widespread feelings characterized Irish society long before the country became partitioned in 1921. Due to the ongoing fight for Irish independence, the division between individuals supporting either the Irish or the British cause remained very strong throughout. In the same way, the split between the two song traditions continued with songs revealing either a Protestant or a Catholic perspective. With the beginning of the twentieth century and the impact of new historical events such as the Easter Rising, the partition of Ireland, the civil war, and the setting up of Northern Ireland, this split became even more noticeable, and individuals living in the North were faced with a dilemma. Northern Irish society was divided from the very start, and people living in the North were better off staying within the boundaries of and remaining loyal to their own cultural background instead of trying to get involved with the other side. In other words, there was nothing in between; Irish or British—orange or green—was all there was. Crossing the line between these two would have had devastating consequences. For a long time, songs written by the Catholic and the Protestant community in Northern Ireland reflected this division very clearly. A lack of forgiveness for the loss experienced, along with anger and hatred against one another remained dominant aspects in much of the song material that was written back then. However, with the outbreak of the Northern Ireland conflict in the 1950s and 1960s, for the first time, and although at the start very limited in number, songs with a somewhat alternative message appeared.

In the song 'Patriot Game,' written in 1957, this one-sided approach of being either Irish or British was suddenly looked at in a different way. The whole concept of people defending and supporting their own cultural backgrounds, even if the final outcome was death itself, became seriously questioned. To die for one's country, once the ultimate heroic

choice an individual could make, suddenly was regarded as a dangerous thing. Although only uttered as a warning in the 'Patriot Game', a fresh thought about the division of Northern Irish society had been created. Nonetheless, as the conflict continued, a great number of rebel and loyalist songs expressing well-established feelings of sectarian hatred were written and sung on a regular basis too. As pointed out in Chapters III and VI, these songs were written throughout the Troubles and never failed their purpose of encouraging more sectarian violence. The situation for people living in Northern Ireland was to get worse, and this was also reflected in the majority of songs that were written around that time. The 'Patriot Game', however, although written in the tradition of a rebel song, became the first song that provided a new alternative answer.

Mickey MacConnell's 'Only Our Rivers Run Free' was written in 1965, and again, despite widespread feelings of anger and hurt, here was a song that portrayed this conflict differently. The song argues that, as long as a country is under foreign rule, freedom and peace cannot be achieved. However, feelings of anger and hatred triggered by the injustice and fighting become gradually replaced in the song. Overwhelming sadness and a questioning as to why living in Northern Ireland had to be like this become the two prevailing elements. By acknowledging that only an end to this conflict can bring about change, the song reflects a sense of hope that an alternative to the helpless and grief stricken way of living can soon be found. Even though this song also became classified as a typical republican song, only supporting the cause of the Irish, it took up the thought first reflected in 'Patriot Game' and articulated it in a very poetic way.

For the following years, the number of songs that revealed an alternative message to sectarian hatred gradually increased. With the introduction of internment, Bloody Sunday and the hunger strikes, the 1970s and 1980s were to mark the worst decades of the Troubles. This was also reflected in Phil Coulter's song 'The Town I loved so Well'. Northern Ireland had changed. Regular riots and street fights between Protestants, Catholics, and the British Army became a typical feature in everyday life. The full outcome of the Troubles gradually entered the consciousness of people who had to experience it: 'With their tanks and their bombs / Oh my

God what have they done / To the Town I loved so well.'[672] People living in the North at the time had become aware of and anxious about the continuation of useless bloodshed, the destruction of their homes, and the ongoing injustice. Fear and condemnation of the Troubles became more and more widespread within Northern Irish society. Paul Brady's 'The Island' and Tommy Sands' 'There Were Roses', both written in the 1980s, reflect that this awareness had become stronger. Nonetheless, the vast number of personal stories about loss and grief, as reflected in songs like these, still only managed to express helplessness for what was happening in the North.

With the ceasefires of 1994, the Northern Ireland peace process began. Songs such as Colum Sands' 'Ceasefire', Tommy Sands' 'Down by the Lagan Side', and even Van Morrison's 'Days Like This' and 'The Healing Game' expressed that a different way of living had most certainly began in Northern Ireland. The immediate effects these new promising developments in the North had on Northern Irish society were noticeable straight away, and thus also were clearly reflected in the songs written at the time. Like a breath of fresh air, songs suddenly stated the obvious. This war was over at long last, and it almost seemed as if all the accumulated feelings of hatred, anger, and pain were extinguished at once. Now was the time for healing, finding new happiness, and starting the long but urgently necessary process of reconciliation. However, the pain and the loss experienced by events in the past were very persistent, as might be expected, and did not simply vanish with the announcement of the ceasefire and the beginning of the peace process. Neither did the great volume of prejudice, fuelled by stereotypical thinking, disappear from one day to the next. What had begun was a long process of abolishing old concepts, ceasing to react through prejudice, and accepting that the only way to make the peace process work was through mutual understanding and forgiveness. Like every process, this cannot happen without a series of ups and downs along the way, and this is exactly what the songs that have been written since the 1994 ceasefire express. The war in Northern Ireland is over, but people must still travel a long and windy road before the peace process reaches

[672] from 'The Town I loved so well', Phil Coulter (1971)

its ultimate goal. People who were brought up in Northern Ireland and lived there throughout the Troubles share so many negative experiences that probably would be best described as nightmarish. Getting over these is not a thing that can easily be done. Feelings of fear, uncertainty, and anger will come to the surface again and again during this process of healing. Feelings of relief, happiness, and forgiveness, however, will equally be represented, and with enough patience, time, and willpower these feelings will become stronger, until some day, all that remains is a present that has left the troubles of the past behind.

The healing process has, in fact, begun in Northern Ireland. Feelings of intolerance or even hatred are gone from the majority of songs written by Northern Irish songwriters today. A tiny minority of the Catholic and Protestant population in Northern Ireland, however, still argue that the tradition of writing songs filled with vitriolic emotion, as composed on a regular basis in the past, has to be revived. Regardless of present developments, some individuals still believe that, without the writing and performing of loyalist or rebel songs, their identity will be threatened and possibly even extinguished by the respective other. What these individuals, including people from the South of Ireland as well, fail to understand is that there is no future in the continuation of this war in the twenty-first century. The majority of people—Catholics and Protestants alike from both the North and the South—have decided to focus on acceptance, understanding, and peace, and under no circumstances will the destructive ideas of a small minority be tolerated much longer. John Hume, founding member of the Social Democratic and Labour Party (SDLP) and joint winner of the 1998 Nobel Prize for Peace, made the following comments in 2000 about the future of Ireland, and by doing so also specifically reflected on recent developments in Northern Ireland:

> The talents and diversity of Irish people are our greatest strength. Our music and literary traditions are revered and respected across the world . . . In the world of music, U2 and The Corrs are heard alongside James Galway and Phil Coulter. These are the sounds and talents of the Ireland that enters the new millennium and in this new millennium we will continue to build a New Ireland based upon the strengths

of our people, and upon agreement and respect for our diversity. [673]

In a very similar way, Taoiseach (prime minister of Ireland) Bertie Ahern, one of the people featured in Paddy Logue's *Being Irish* remarked, 'Our whole history over the past 2000 years indicates that we are an adventurous and outward-looking people, seeking not to conquer, but to carry a message of hope and solidarity.'[674] While for a long time the reality of this conflict reflected widespread passivity and helplessness, now is the time for every person involved to start acting according to this message. Ever since the beginning of the peace process in Northern Ireland, a new opportunity has been provided to turn this message of hope and solidarity into a lasting reality. During a visit to Northern Ireland on 24 February 2005, Irish President Mary McAleese opened the £500,000 Community Hall of the Hannahstown Community Association in West Belfast. A cross-community choir and Irish dancers performed at the event. Speaking at St Malachy's College in Belfast later during her Northern Ireland visit, McAleese called for 'courage rather than chaos' when facing the future. In her speech she stated, 'It is time to close the door on the tradition of armed struggle' and 'to make a hope-filled, humanly decent start to the shared future that is the unarguable entitlement of the next generation.'[675] Ever since the 1994 ceasefire, artists in the North have also grasped new hope about their art having a deep impact on the peace process. Tommy Sands stated in an interview with Paul Byrne at the time that he felt very optimistic about present developments: 'There're bridges to be built, but at least we've stopped throwing each other into the river.' As far as the role of art in this context is concerned there is, according to Sands, little doubt that it makes its own contribution in the engine of change: 'I think everything changes things, even a nod of the head can change things. And art certainly does. Music, writing, painting, whatever. It's not going to change anything overnight, but it's chipping away at the granite.'[676]

[673] John Hume in Logue, 2000, 85

[674] Bertie Ahern ibid., 3

[675] article on Mary McAleese's speech by Marie Foy, in www.http://belfasttelegraph.co.uk/news/story.jsp, 25/2/2005

[676] Tommy Sands in P. Byrne, Irish Music magazine, 1995, 13

During the writing of this book, several events threw the political process in the North of Ireland into turmoil again. The end of 2004 saw what was described as one of the biggest cash robberies ever. On 20 December 2004, £26.5 million was stolen from the Northern Bank's Belfast headquarters.[677] Some of this money was later discovered in Counties Dublin, Cork, and Kerry. Leaders of the British and Irish government and the Police Service of Northern Ireland (PSNI) stated publicly that the IRA was responsible for this robbery. Sinn Fein and leaders of the IRA, however, denied any connection with it. On 31 January 2005, a Belfast man, Robert McCartney, was killed outside a Belfast bar while defending his friend who had been attacked by members of the IRA.[678] The manner in which he was killed horrified the public both North and South of the border. The bank robbery and the killing of Robert McCartney sparked off new doubts about whether the Northern Ireland peace process was ever going to work. One could almost argue that forgiveness, honesty, and trust are still far from becoming realities in Northern Ireland. Like any other process, the Northern Ireland peace process has been marked by various challenges, some of which nearly succeeded in making all past achievements look futile. Tragic events like these two more recent ones will always increase the danger of the peace process failing once again. However, the past few years have shown that the majority of people in Northern Ireland and the Republic of Ireland are determined to fight for the peace they had to wait so long for. While the 1994 ceasefires marked the beginning, the 1998 Good Friday Agreement saw all political parties involved, including the British and the Irish governments, making a commitment to work in this peace process together. On 28 July 2005, after nearly forty years of violence, the IRA declared an end to armed struggle. Its vast arsenal of weapons was later destroyed in the presence of independent witnesses.[679]

Despite all recent ups and downs in this reconciliation process, the situation for people living in Northern Ireland has most certainly changed for the better in recent years. Songs that were written by Northern Irish songwriters around the 1994 ceasefire and after do

[677] see www.http://news.bbc.co.uk, 21/12/2005
[678] see www.http://irishexaminer.com/text/story.asp, 17/2/2005
[679] Irish Independent, Dublin, 26/9/2005

indeed reflect these changes and state the obvious: the Troubles in Northern Ireland are over. Acceptance, mutual understanding, and forgiveness are no longer unimaginable in the Northern Ireland context, and the time for healing has begun at long last.

> Somehow the cycle of vengeance keeps turning
> Till each other's sorrows and songs we start learning
> Peace is the prize for those who are daring
> Sing me the music of healing
> Time is your friend it cures all your sorrows
> But how can I wait till another tomorrow
> One step today and a thousand will follow
> Sing me the song of healing. [680]

[680] from Tommy Sands, 'The Music of Healing' (Green Linnet, 1995)

Bibliography

1. Primary Sources

Adams, Gerry. *Before The Dawn: An Autobiography*. London: Heinemann in association with Brandon Book Publishers Ltd., 1996.

Carson, Cíaran. *Last Night's Fun: A Book about Irish Traditional Music*. London: Jonathan Cape, 1996.

Dawe, Gerald. *The Rest Is History*. Newry: Abbey Press, 1998.

De Mello, Anthony. *Awareness*. New York: Doubleday, 1990.

——————. *The Heart of the Enlightened*. London: Fount, 1997.

Feldman, Alan; O'Doherty, Eamonn. *The Northern Fiddler*. Belfast: Blackstaff Press, 1979.

Graham, Len. *Harvest Home*. Belfast: Arts Council of Northern Ireland, 1993.

Logue, Paddy. *The Border*. Dublin: Oak Tree Press, 1994.

——————. *Them and Us*. Dublin: Columba Press, 1999.

McLiam Wilson, Robert. *Eureka Street*. London: Secker & Warburg, 1996.

Murphy, Dervla. *A Place Apart*. Harmondsworth: Penguin Books, 1978.

Sands, Tom. *The Songman: A Journey in Irish Music*. Dublin: Lilliput Press, 2005.

Shields, Hugh. *Shamrock, Rose, and Thistle: Folk Singing in North Derry.* Belfast: Blackstaff Press, 1981.

Tóibín, Colm. *Walking along the Border.* London: Mac Donald Queen Ann Press, 1987.

Tunney, Paddy. *The Stone Fiddle.* Belfast: Appletree Press, 1979.

Walsh, Oonagh (ed.) *An Englishwoman in Belfast.* (Narratives) Cork: Cork University Press, 2001.

White, Richard. *Remembering Ahanagran: Storytelling in a Family's Past.* Cork: Cork University Press, 1999.

2. Secondary Sources

Andrews, Ted. *Sacred Sounds: Transformation through Music & Word.* St. Paul, MN: Llewellyn Publications, 2001.

Bailie, Stuart. *The Ballad of the Thin Man: The Authorised Biography of Phil Lynott and Thin Lizzy.* London: Boxtree, 1997.

Barthes, Roland. *Image, Music, Text.* New York: Noonday Press, 1977.

Bell, Derek; O'Conchubhair, Liam (ed.) *Traditional Songs of the North of Ireland.* Dublin: Wolfhound Press, 1999.

Bloch, Ernst et al. *Aesthetics and Politics.* London: Verso, 1980.

Boydell, Brian (ed.) *Four Centuries of Music in Ireland.* London: British Broadcasting Corporation, 1979.

Brady, Ciaran (ed.) *Interpreting Irish History.* Dublin: Irish Academic Press, 1994.

Brooks, Ken. *In Search of Van Morrison: An Investigation to Find the Man Within.* Andover: Agenda Limited, 1999.

Bruce, Steve. *Religion in Modern Britain.* Oxford: Oxford University Press, 1995.

Buckland, Patrick. *A History of Northern Ireland.* Dublin: Gill and Macmillan, 1981.

Cairns, David; Richards, Shaun. *Writing Ireland: Colonialism, Nationalism, and Culture.* Manchester: Manchester University Press, 1988.

Carruthers, Mark; Douds, Steven (eds). *Stepping Stones: The Arts In Ulster 1971–2001.* Belfast: Blackstaff Press, 2001.

Carson, Ciaran. *The Pocket Guide to Irish Traditional Music.* Belfast: Appletree Press, 1986.

Clarke, D.M.; Jones, C. (eds). *The Rights of Nations: Nations and Nationalism in a Changing World.* Cork: Cork University Press, 1999.

Clayton-Lea & Taylor. *Irish Rock—Where It's Come from—Where It's at—Where It's Going.* Dublin: Gill and Macmillan, 1992.

Cochrane, Feargal. *Unionist Politics and the Politics of Unionism Since the Anglo-Irish Agreement.* Cork: Cork University Press, 2001.

—————; Dunn, Seamus. *People Power? The Role of the Voluntary and Community Sector in the Northern Ireland Conflict.* Cork: Cork University Press, 2002.

Corcoran, Neil (ed.) *The Chosen Ground: Essays on the Contemporary Poetry of Northern Ireland.* Bridgend: Seren Books, 1992.

Coughlan, John (ed.) *The Swingin' Sixties.* Carrick Communications, 1990.

Cronin, Michael. *Translating Ireland: Translation, Languages, Culture.* Cork: Cork University Press, 1996.

——————. *Across the Lines: Travel, Language, Translation.* Cork: Cork University Press, 2000.

Crozier, Maurna; Frogatt, Richard. *Cultural Traditions in Northern Ireland. Cultural Diversity in Contemporary Europe. Proceedings of the Cultural Traditions Group Conference.* Belfast: The Institute of Irish Studies. The Queen's University, 1998.

Cullingford, Elisabeth Butler. *Ireland's Others: Gender and Ethnicity in Irish Literature and Popular Culture.* Cork: Cork University Press, 2001.

Dawe, Gerald; Longley, Edna (eds). *Across the Roaring Hill: The Protestant Imagination in Modern Ireland.* Belfast: Blackstaff Press, 1985.

——————. *How's the Poetry Going? Literary Politics and Ireland Today.* Belfast: Lagan Press, 1991.

Delanty, Greg; Ní Dhomhnaill, Nuala (eds). *Jumping off Shadows: Selected Contemporary Irish Poets.* Cork: Cork University Press, 1995.

Duffy, Noel; Dorgan, Theo (eds). *Watching the River Flow: A Century in Irish Poetry.* Dublin: Poetry Ireland, 1999.

Dunphy, Eamon. *Unforgettable Fire: The Story of U2.* London: Penguin, 1988.

Faolain, Turlough. *Blood on the Harp: Irish Rebel History in Ballad (The Heritage).* Troy, New York: The Whitston Publishing Company, 1983.

Fay, Marie-Therese; Morrissey, Mike; Smyth, Marie (eds). *Northern Ireland's Troubles: The Human Costs.* London: Pluto Press, 1999.

Foucault, Michel. *The Archaeology of Knowledge.* London: Tavistock, 1972.

Geddis, Paul W. (ed.) *Focus on Northern Ireland: A Statistical Profile.* London: The Stationary Office, 1997.

Penelope Gouk (ed.) *Musical Healing in Cultural Contexts.* Ashgate: Aldershot, 2000.

Graham, Brian. *In Search of Ireland: A Cultural Geography.* Article by Patrick J. Duffy. Writing Ireland. Literature and art in the representation of Irish place. *(p. 64–84)* London: Routledge, 1997.

Hackett, Stephen; West, Richard (eds). *Belfast Songs.* Belfast: Factotum, 2003.

Hall, Stuart (ed.) *Representation: Cultural Representations and Signifying Practices.* London: Sage, 1997.

Hinton, Brian. *Celtic Crossroads: The Art of Van Morrison.* London: Sanctuary Publishing, 1997.

Hobsbawm, Eric J. *Nations and Nationalism since 1780: Programme, Myth, Reality.* Cambridge: Cambridge University Press, 1999.

—————; T. Ranger (eds). *The Invention of Tradition.* Cambridge: Cambridge University Press, 1983.

Hooper, Glenn (ed.). *The Tourist's Gaze: Travellers to Ireland, 1800-2000.* Cork: Cork University Press, 2001.

Hughes, Eamon. *Culture and Politics 1960–1990.* Milton Keynes: Open University Press, 1991.

Jordan, Hugh. *Milestones In Murder: Defining Moments In Ulster's Terror War.* Edinburgh: Mainstream Publishing, 2002.

Kelly, Pat. *More Than a Song to Sing: Mystical Ideas and the Lyrics of Van Morrison.* Darlington: Rowan Press, 1993.

Lloyd, David. *Ireland After History.* Cork: Cork University Press, 1999.

Logue, Paddy (ed.) *Being Irish.* Dublin: Oak Tree Press, 2000.

Longley, Edna. *Culture in Ireland—Division or Diversity?* Belfast: Institute of Irish Studies. The Queen's University, 1991.

—————; Keberd, Declan. *Multi-culturalism: The View from the Two Irelands.* Cork: Cork University Press, 2001.

—————. *Poetry in the Wars.* Newcastle upon Tyne: Bloodaxe Books, 1986.

Matthews, Steven. *Irish Poetry: Politics, History, Negotiation:. The Evolving Debate, 1969 to the Present.* London: Macmillan Press, 1997.

Mc Carthy, Mary. *Passing It On: The Transmission of Music in Irish Culture.* Cork: Cork University Press, 1999.

McIntosh, Gillian. *The Force of Culture: Unionist Identities in Contemporary Ireland.* Cork: Cork University Press, 1999.

McKittrick, David; McVea, David. *Making Sense of the Troubles.* Belfast: Blackstaff Press, 2000.

McNamee, Peter (ed.) *Traditional Music: Whose Music? Proceedings of a Co-operation North Conference.* The Institute of Irish Studies. Belfast: The Queen's University, 1992.

Meek, Bill. *Paddy Maloney and the Chieftains.* Dublin: Gill and Macmillan, 1987.

Moulden, John. *Songs of the People. An edited selection of songs from the Sam Henry collection.* Belfast: Blackstaff Press, 1979.

Mulcahy, Michael; Fitzgibbon, Marie (eds). *Voice of the People: Songs and History of Ireland.* Dublin: O'Brien Press, 1982.

Mulhern, Francis. *The Present Lasts a Long Time: Essays in Cultural Politics.* Cork: Cork University Press, 1998.

O'Boyle, Sean. *The Irish Song Tradition.* Dublin: Gilbert Dalton, 1976.

Ò Canainn, Tomás. *Traditional Music in Ireland.* London: Routledge & Kegan Paul, 1978.

O'Conor, Nuala. *Bringing It All Back Home.* London: BBC Books, 1991.

Ò Dochartaigh, Niall. *From Civil Rights to Armalites: Derry and the Birth of the Irish Troubles.* Cork: Cork University Press, 1997.

O'Donoghue, Bernard. *Seamus Heaney and the Language of Poetry.* Hemstead: Harvester, Hemel, 1994.

O'Dowd, L. *The Coloniser and the Colonized.* Introduction by A.Memmi, 29-66. London: Earthscan, 1990.

Ò Giolláin, Diarmuid. *Locating Irish Folklore: Tradition, Modernity, Identity.* Cork: Cork University Press, 2000.

O Hallmhurain, Gearoid. *Irish Traditional Music.* Dublin: O'Brien Press, 1998.

Ormsby, Frank (ed.). *A Rage for Order: Poetry of the Northern Ireland Troubles.* Belfast: The Blackstaff Press, 1992.

Paxman, Jeremy. *The English: A Portrait of a People.* New York: The Overlook Press, 2000.

Porter, N. *Rethinking Unionism: An Alternative Vision for Northern Ireland.* Belfast: Blackstaff Press, 1996.

Power, Vincent. *Send 'Em Home Sweatin'.* Dublin: Kildanore Press, 1990.

Pierce, David (ed.) *Irish Writing in the Twentieth Century: A Reader.* Cork: Cork University Press, 2001.

Prendergast, Mark J. *Irish Rock: Roots, Personalities, Directions.* Dublin: O'Brien Press, 1987.

Radford, Katie. *Sounds Sectarian.* Belfast, Queen's University, 2001.

Rogan, Johnny. *Van Morrison.* New York: Proteus, 1984.

Rolston, Bill. *Music and Politics in Ireland.* in Harrington, J.; Mitchell, E. (eds.). *Politics and Performance in Contemporary Northern Ireland.* Amherst: University of Massachusetts Press, 1999, 29-56.

Rowley, Eddie. *A Woman's Voice.* Dublin: O'Brien Press, 1993.

Schenkel, Elmar. *Sense of Place. Regionalität und Raumbewußtsein in der neueren britischen Lyrik.* Tübingen: Max Niemeyer Verlag, 1993.

Shields, Hugh. *Narrative Singing in Ireland. Lays, Ballads, Come-All-Yes and Other Songs.* Dublin: Irish Academic Press, 1993.

Smith Thérèse; Ò Suílleabháin, et. al. *Blas: The Local Accent in Irish Traditional Music.* Dublin: The Folk Music Society of Ireland and the University of Limerick, 1999.

Storey, John (ed.). *Cultural Theory and Popular Culture: A Reader.* London: Prentice Hall, 1994. 2nd ed.1998.

Trelford, Guy; O'Neill, Sean. *It Makes You Want to Spit: The Definitive Guide to Punk in Northern Ireland.* The Punk Appreciation Society, 1998.

Turner, Steve. *Van Morrison: Too Late To Stop Now.* London: Bloomsbury, 1993.

Vallely, Fintan. *The Companion to Irish Traditional Music.* Cork: Cork University Press, 1999.

Vendler, Helen. *The Music of What Happens: Poems, Poets, Critics.* Cambridge Massachusetts: Harvard University Press, 1988.

_____. *The Given and the Made: Strategies of Poetic Redefinition.* London: Faber, 1995.

White, Harry. *The Keeper's Recital: The Music and Cultural History in Ireland 1770-1970.* Cork: Cork University Press, 1998.

White, Harry, Murphy, Michael (ed.) *Musical Constructions of Nationalism.* Cork: Cork University Press, 2001.

Williams, Raymond; Orrom, Michael. *Preface to Film*, London, Film Drama, 1954.

Wills, Clair. *Improprieties: Politics and Sexuality in Northern Irish Poetry.* Oxford: Oxford University Press, 1993.

Wolffe, John (ed.). *The Growth of Religious Diversity in Britain from 1945: A Reader.* GB: The Open University, 1993.

Zimmermann, George-Denis. *Songs of Irish Rebellion: Irish Political Street Ballads and Rebel Songs 1780–1900.* Geneve: Imprimerie La Sirene, 1966.

3. Journals

British Journal of Ethnomusicology. Volume 4, London: British Forum for Ethnomusicology 1995. Article by McCann, May. 'Music and politics in Ireland: the specificity of the folk revival in Belfast.'

Fortnight—An Independent Review of Politics and the Arts. Issue no. 281, Belfast: February 1990. Article by Simmons, James on Colum Sands. Edited by Wilson, Robin.

——————. Issues February, March 1990, June 1995, Belfast. Edited by Wilson, Robin.

James Simmons: article on Colum Sands in *Fortnight*, No.281, February 1990.

Irish Independent Weekend. Issue 23 October, Dublin: 2004. Article by O Conghaile, Pol. 'The Northern Composure of Juliet Turner', 7–10.

Irish Music magazine. Volume 1, no. 4, Dublin: November 1995. Byrne, Paul. Interview with Tommy Sands.

——————. Volume 2, no. 2, Dublin: September 1996. Article on Irish music by Ò Canainn, Tomás and Ò´Riada, Sean.

——————. Volume 5, no. 9, Dublin: May 2000. Article on Paul Brady by Henry, William.

Race & Class. 42 (3), London: Sage Publications 2001. Rolston, Bill. This is not a rebel song': the Irish conflict and popular music. 49–67.

The Irish Review. Issues 28, 29, Cork: Cork University Press, 2001. Edited by Barry, K.; Dunne, T. and Longley, E.

THE SHOP: A Magazine of Poetry. Issue 6. Cork: Cork University Press, 2001. Edited by Wakeman, J.

Ulster Patriot. Issue 2, Belfast: 1980s.

Wavelength. The Unofficial Van Morrison Magazine. Issues 9 & 10/1993, 1/1994–20/1999, Stoke-on-Trent: The Printing Crew. Edited by Gee, Simon.

4. Internet Sources

a) Individual Artists:

http://www.AndyWhite.com
http://www.ash-official.com
http://www.bapkennedy.com
http://www.briankennedy.co.uk
http://www.columsands.net
http://www.julietturner.com
http://www.katiemelua.com
http://www.kierangoss.com
http://www.paulbrady.com
http://www.the4ofus.com

http://www.tommysands.com
http://www.vanmorrison.co.uk

b) Newspapers:

www.http://belfasttelegraph.co.uk
www.http://news.bbc.co.uk
www.http://irishexaminer.com

c) Reference Material:

http://www.allmusicguide.com
http://archives.tcm.ie/thekingdom/2004/03/11/story12744.asp
http://www.battlehill395.freeserve.co.uk
http://www.cain.ulst.ac.uk
http://en.thinkexist.com/quotes/maurice-craig/
http://www.gallerypress.com/Authors/Ccarson
http://www.geocities.com
http://www.irelandsown.net/
http://www.meteormusicawards.meteor.ie
http://www.mmguide.musicmatch.com/artist
http://www.musictherapy.org
http://www.nicie.org/aboutus/
http://www.scottishloyalists.com
http://www.ulsterloyal.freeservers.com
http://www.ulsterloyalist.co.uk
http://www.uksprite.co/search/search/Regional/Europe/
United Kingdom/Northern Ireland/Society and Culture/
Religious and Sectarian Conflict/Loyalism/
http://www.onlineshakespeare.com/music.htm
http://en.wikipedia.org

d) Songtexts:

http://www.inlyrics.com

http://www.lyricseek.net
http://www.123lyrics.net
http://www.mattminglewood.com/Lyrics/
http://www.musicsonglyrics.com

e) Poems:

Craig, Maurice—'May the Lord in his Mercy be kind to Belfast' (1936), 'ballad to traditional refrain', never released, http://en.thinkexist.com/quotes/maurice-craig/ , 25/3/2003

5. Interviews:

Paul Brady (singer/songwriter), interview with Tony McAuley at BBC Radio Northern Ireland, Belfast: 28.12.2002
Darragh Connolly (traditional musician): Dublin: 12.4.1997
Phil Coulter (composer/singer/songwriter): Dublin, 12.10.2004
Brian Kennedy (singer/songwriter), INEC, Killarney: 24.4.2004
Mickey MacConnell (journalist and singer/songwriter), Listowel: 14.1.2005
Tony McAuley (BBC Broadcaster and singer), Belfast: Nov., Dec. 2002, January 2003
Brian Moore (singer/songwriter), Belfast: 23.1.2003
Ronny Moore (painter and singer/songwriter), Killarney: 14.2.2005
John Moulden (music collector and singer), Belfast: 24.11. 2002
Joe Mulheron (singer/songwriter), Belfast: 23.1. 2003
George Newell, at Ballymacarrett Arts & Cultural Society (BACS), 143 Albertbridge Road, Belfast: 24.1.2003
Tommy Sands (singer/songwriter), UCL, Limerick: 25.2.2004
Phonsie Travers (member of the Ballyshannon Folk Festival committee), Ballyshannon: 10.5.1997
Paddy Walsh (musician and singer), Belfast: 10.11.2002
Ciaran Wynne (singer/songwriter), Killarney: 20.1.2005

Additional Reference Material

Orange Song book. Belfast: Political Collection, Linnenhall Library (P7229).

Orange songs & ballads. Belfast: Political Collection, Linnenhall Library (P1527).

Orange and green ballads. Belfast: Political Collection, Linnenhall Library (P874).

Illustrations and Photographs

Cover Design Katrin Pietzonka and Authorhouse, Illustrations and Cover background Joanne Purser

p. 1 Illustration Joanne Purser,
 Cover background and Layout Matthias Scholz, Katrin Pietzonka (2007)

p. 29 Illustration Colum McEvoy
 Cover background and Layout Matthias Scholz, Katrin Pietzonka (2007)

p. 41 Claudy, Northern Ireland (Photograph Katrin Pietzonka, June 2005)

p. 43 Colum Sands, Tony McAuley and Ben Sands (from left) at Old Museum Arts Centre
 (Photograph Katrin Pietzonka, Belfast, 2002)

p. 45 Illustration Joanne Purser,
 Cover background and Layout Matthias Scholz, Katrin Pietzonka (2007)

p. 65 From Bunting, Edward, 1969 (1796, 1809, 1840). *The Ancient Music of Ireland.*
 Dublin: Walton's Piano and Musical Instrument Galleries (Publishing Department),
 Ltd. (Photograph Michael Sweetman, Belfast 2004)

p. 114 July 12th in Belfast in the Past (Photographs Michael Sweetman, Belfast 1960s)

p. 115 Illustration Joanne Purser,
 Cover background and Layout Matthias Scholz, Katrin Pietzonka (2007)

p. 137 Illustration Joanne Purser,
 Cover background and Layout Matthias Scholz, Katrin Pietzonka (2007)

Appendix

Sample Song List

Songtitle	Reference Material
Absent Friends (GTC)	Mickey MacConnell (NI), Spring Records, 2000
Alternative Ulster (RPNI)	Stiff Little Fingers, Rough Trade, 1979
A Nation Once Again (GTP)	T. Davis, 1842, in FB, Volume 1
An Orangeman's Testament (OTC)	Alan Harper, 1991, in JM
And the Healing has begun (RPNI)	Van Morrison, Exile, 1979
Barbed Wire Love (RPNI)	Stiff Little Fingers, Dutch East India, 1986
Belfast (RPI)	Boney M, Hansa, Ariola, 1977
Belfast (RPI)	Elton John, Polygram Records, 1995
Belfast (RPNI)	Energy Orchard, MCA, 1990
Belfast (RPI)	Golden Palominos, Restless, 1996
Belfast (RPI)	Katie Melua, Dramatico, 2003
Belfast Child (RPI)	Simple Minds, Virgin, 1989
Belfast Mill (GTC)	The Fureys (IRE), Crimson, 1998
Belfast to Boston (RPI)	James Taylor, Sony, 2002
Beyond the Backyard (RPNI)	Juliet Turner, Sticky Music, 1996

Billy McFadzean (OTC)	Platoon, Songs of Honour and Glory, 1998, see LM
Blinded by Rainbows (RPI)	Rolling Stones, Virgin, 1994
Bold Fenian Men (GTP)	Michael Scanlan (1836-1900)
Broad Black Brimmer (GTC, RS)	in SR
Broken Land (RPI)	The Adventures, WEA International, 2000
Broken Things (CFI)	Julie Miller, recorded by Juliet Turner, White Records, 1999
By the Mountain Road (RPNI)	Brian Kennedy, Bmg, 2000
Caledonian Heartbeat (OTC)	Roy Arbuckle on 'a clatter of fowk', 1999
Ceasefire (GTC)	Colum Sands (NI), Spring Records, 1996
Chase Them Home (OTC)	Platoon, see LM
Charge (RPNI)	Divine Comedy, Tristar, 1997
Come all ye young Protestants (OTC)	Platoon, see LM
Come to the Bower (GTP)	1863 traditional, on Dubliners, Transatlantic, 1966
Cyprus Avenue (RPNI)	Van Morrison, Warner, 1968
Daddy's Uniform (OTC)	Platoon, see LM
Days Like This (RPNI)	Van Morrison, Polydor, 1995
Different God (RPI)	Calum MacColl, recorded by Brian Kennedy, Sony, 1999
Dolly's Brae (OTP)	Traditional, in LI
Down by the Lagan Side (GTC)	Tommy Sands (NI), Green Linnet, 2001
Drag my bad name down (RPNI)	The 4 Of Us, EMI, 2000
Edward (RPNI)	Juliet Turner, Sticky Music, 1996
Enniskilling Dragoon (GTP)	1800s, in IB
Fanatic Heart (RPI)	Black 47, EMI, 1993
Fire of Freedom (RPI)	Black 47, EMI, 1993

Four Green Fields (GTC)	Tommy Makem, on Clancy Brothers, Sony, 1995
Forgiveness (RPNI)	Brian Kennedy, RCA, 2001
Fortune Teller (RPNI)	Ash, WEA, 1998
Free Belfast (GTC, RS)	in SR
Freedom Fighters (RPIRE)	Saw Doctors, Sham Town, 2001
Free the People (GTC)	Phil Coulter (NI), Chyme, 1986
Give Ireland back to the Irish (RPI)	Paul McCartney, Apple, 1972
God Save Ireland (GTP)	T.D. Sullivan, 1867
Good Friday Never Changes (GTC)	Colum Sands (NI), Spring Records, 1996
Got To Go Back (RPNI)	Van Morrison, Mercury, 1986
Gunrunners (OTC)	Platoon, see LM
Hands Across the Water (OTC)	Platoon, Songs of Honour and Glory, 1998, see LM
Hedges of Co.Down (GTC)	Tommy Sands (NI), Elm Grove, 1989
I'm gonna fall	Ash, Dreamworks, 1999
Independence Day (GTC)	Ronny Moore (IRE), 2000, unreleased at the time of writing and printed with permission by the artist (14.2.2005)
I Hate To Hear People Cry (GTC)	Tommy Sands (NI), Green Linnet, 1995
Invisible Sun (RPI)	Police, A&M, 1981
It's a Hard Life Whereever You Go (CFI)	Nancy Griffith, MCA Records, 1989
I Was Born Under The Union Jack (OTC)	John McKeague, Loyalist Songbook, 1971 in OLS
I wish I was Back Home in Derry (GTC, RS)	Words: Bobby Sands, in SR
James Connolly (GTP)	J. McBride, 1920s, in SR
John McBride's Brigade (GTP)	1900, in IP (p. 293)

Kevin Barry (GTP)	1920s, traditional, Clancy Brothers, Bescol, 1994
Lagan Song (OTC)	Brian Ervine, Best Cellars Studios, BACS, Belfast, 2000
Like the First Time It's Christmas Time (GTC)	Tommy Sands (NI), Green Linnet, 2001
Life, Love & Happiness (RPNI)	Brian Kennedy, BMG, 1996
Madame George (RPNI)	Van Morrison, Warner, 1968
March 11th (RPNI)	The Four of Us, Amberville Studio, 2003
1999 (GTC)	Tommy Sands (NI), Spring Records, 1992
Northern Girl (RPIRE)	Ciaran Wynne, Mid-Atlantic Studios, 1999
No Sleep til Belfast (RPNI)	Stiff Little Fingers, Kaz, 1988
One Irish Rover (RPNI)	Van Morrison, Mercury, 1986
On Kingsmill Road (RPNI)	Ruefrex, Flicknife, 1987
One (RPIRE)	U2, Island, 1992
One more Shot (RPNI)	The 4 Of Us, EMI, 2000
Only our Rivers Run Free (GTC)	Mickey MacConnell (NI), Spring Rec., 1992
Orange Wings (OTC)	Platoon, see LM
Paid in Kind (RPNI)	Ruefrex, Kasper, 1985
Peace in Erin (GTP)	Hugh McWilliams, 1831, HW
Peter Pan and Me (GTC)	Mickey MacConnell (NI), Spring Rec., 1991
Please (RPIRE)	U2, Island, 1997
Reasons to Leave (RPNI)	Kieran Goss, Cog Communications, 2000
Reconciliation (RPIRE)	Ron Kavanagh, Green Linnet, 1991
Religious Persuasion (RPNI)	Andy White, Decca, 1986
Revelation (RPI)	Jennings Waylon, RCA Records, 1972

Roddy McCorley (GTP)	Words: Ethna Carberry; music traditional, recorded by Kingston Trio, Capitol, 1962
Rough Justice (RPI)	Bananarama, London, 1984
Sad Affair (RPNI)	Marxman, Talkin' Loud, 1992
Sailing Through the Sky (GTC)	Tommy Sands (NI), Green Linnet, 1995
Sailortown (RPNI)	Bap Kennedy, Castle, 1996
Saint Dominic's Preview (RPNI)	Van Morrsion, Warner, 1972
Sean South (GTC, RS)	in SR
Shankill Road (OTC)	Platoon, Murphy's Party CD, 2002, see LM
Suicide Battalion (OTC)	Platoon, see LM
Sunday, Bloody Sunday (RPI)	John Lennon, Apple, 1972
Sunday, Bloody Sunday (RPIRE)	U2, Island, 1983
Sunrise (RPNI)	Divine Comedy, Import, 1998
Suspect Device (RPNI)	Stiff Little Fingers, One Way, 1983
Take it where you find it (RPNI)	Van Morrison, Warner, 1978
Talking to the Wall (GTC)	Colum Sands (NI), Elm Grove, 2002
The Age of Uncertainty (GTC)	Tommy Sands (NI), Green Linnet, 1995
The Aghalee Heroes (OTP)	Traditional, Ulster Music, 1997
The Auld Orange Flute (OTP)	Traditional, in IB
The Ballad of Billy McFadzean (OTC)	Platoon, see LM
The Ballad of Billy Reid (GTC, RS)	in SR
The Ballad of Bobby Sands (GTC, RS)	in SR
The Ballad of Long Kesh (GTC, RS)	in SR
The Battle of the Bogside (GTC, RS)	in SR
The Belfast Brigade (GTC, RS)	G. Thornbury

The Bogside Man (GTP)	Dave Scott
The Child Who Asks You Why (GTC)	Colum Sands (NI), Elm Grove, 2002
The Donegall Road (GTC)	Colum Sands (NI), Spring Records, 2003
The Dying Rebel (GTP)	R. Agnew, 1920s, Castle, 1994
The Ghosts of Belfast (RPNI)	Bap Kennedy, E Squared, 1998
The Harp that once (GTP)	Thomas Moore, 1800s, in IB
The H-Block Song (GTC, RS)	Francie Brolly, in SR
The Healing Game (RPNI)	Van Morrison, Polydor, 1997
The Hills of South Armagh (GTC)	Murphy, Briege (NI), Spring Records, 1995
The Kerry Eagle (GTP)	1847, in IP (p. 233)
The Island (RPNI)	Paul Brady, Mercury, 1986
The Lambeg Drummer (GTC)	Mickey MacConnell (NI), Spring Records, 2000
The Last House In Our Street (GTC)	Colum Sands (NI), Spring Records, 1989
The Little Drummer Boy (GTC)	Mickey MacConnell, Elm Grove Music,2000
The Long March to Derry (GTC, RS)	in SR
The Luck of the Irish (RPI)	John Lennon, Apple, 1972
The Magnificent Seven (GTC, RS)	in SR
The Men Behind the Wire (GTC, RS)	Pat McGuigan, ROL, 1972
The Men Behind the Wire (OTC, Loyalist Version)	Platoon, see LM
The Music of Healing (GTC)	Tommy Sands (NI), Green Linnet, 1995
The Orange and the Green (GTC, RS)	SR

The Patriot Game (GTC)	Dominic Behan (IRE), Kingston Trio, Capital, 1963
The Rebel (GTC, RS)	Wolf Tones (IRE), Celtic Collections, 2001
The Rising of the Moon (GTP)	1865, in FB, Volume 1
These Days (GTC)	Woods, Rosemary (NI), Spring Records, 1998
The Sash Me Father Wore (OTP)	in OL
The Shankill and the Falls (RPNI)	Bap Kennedy, E Squared, 1998
The Time has come (GTC)	Christy Moore, WEA, 1987
The Town I Loved so Well (GTC)	Phil Coulter (NI), Polydor, 1973
The Ulster Girl (OTC)	Platoon, Murphy's Party CD, 2002, see LM
The Walking Wounded (RPNI)	Andy White, Hypertension, 2001
The Wearing of the Green (GTP)	in SR
The West's Awake (GTP)	T. Davis, 1840s
There were Roses (GTC)	Tommy Sands (NI), Elm Grove, 1985
The Time has come (RPIRE)	Christy Moore, WEA 1983
The Times they are a-changing (OTC, Loyalist version)	Platoon, see LM
Things can only get better (RPNI)	D: Ream, Virgin, 1994
This is a Rebel Song (RPIRE)	Sinead O'Connor, Columbia, 1997
This is for Life (RPIRE)	Luka Bloom, WEA, 1990
Through the Barricades (RPI)	Spandau Ballet, EPIC Records, 1986
Through a Long and Sleepness Night (RPNI)	Divine Comedy, Tristar, 1997
Tom Williams (GTC, RS)	in SR
Town (RPNI)	Brian Kennedy, RCA, 1990
Ulster Badge (OTC)	Platoon, see LM
Ulster Girl (OTC)	Platoon, see LM

Unfinished Revolution (GTC)	Christy Moore, WEA, 1987
Unfurl the Orange Banner (OTC)	Brian Ervine, Best Cellars Studios, BACS, Belfast, 2000
United Men (GTC, RS)	Wolf Tones, Celtic Collections, 2001
U.V.F. Hero (OTC)	Platoon, see LM
You Never Beat The Irish (GTC, RS)	Wolf Tones, Celtic Collections, 2001)
Wake Up Dead Man (RPIRE)	U2, Polygram, 1997
Walking Wounded (RPNI)	Andy White, Decca, 1986
What makes the Irish Heart Beat (RPNI)	Van Morrison, Universal, 2002
Whatever You Say (GTC)	Colum Sands (NI), Spring Records, 1993
Who Knows Where The Wind Blows (GTC)	Tommy Sands (NI), Green Linnet, 1995
Will You Stand (OTC)	Platoon, see LM
Zombie (RPIRE)	Cranberries, Island, 1994

Abbreviations

Songtitle

GTP—The Green Tradition in the Past
OTP—The Orange Tradition in the Past
GTC—The Green Tradition continues
OTC—The Orange Tradition continues
RS—Rebel Song
LS—Loyalist Song
UST—Ulster Scots Tradition
RPNI—Rock/Pop Northern Ireland
RPIRE—Rock/Pop Republic of Ireland
RPI—Rock/Pop International
CFI—Country/Folk International

Reference Material

FB —*Folksongs & Ballads popular in Ireland.* Volume 1-4. Cork: Ossian Publications, 1989.

IB —*Irish Ballads.* Robertson, Fleur(ed.).Dublin: Gill & Macmillan, 1996.

HW —*Songs of Hugh McWilliams, Schoolmaster, 1831.* John Moulden (ed.) Ulstersongs, Portrush, 1993.

IF —*20 Songs of Irish Freedom.* Vol 1., Irish Records and Tapes, Dublin 8 (no year given).

IP —*Irish Political Street Ballads and Rebel Songs 1780-1900.* Zimmermann, George-Denis. Geneve: Imprimerie La Sirene, 1966.

JM —*John Moulden Collection.* Traditional Music Archive, 1991.

Katrin Pietzonka

LI —Lilliburlero. Craigavon: Ulster Society, 1988.

LM —Loyalist Songmaterial—Songs by the Loyalist band Platoon cannot be found through usual sources. They are only available through Loyalist Organisations. Some of their songs, however, can also be found in the Linnenhall Library Belfast, e.g. *Songs of Honour and Glory. As Performed by the Platoon Roadshow. UVF* (1998). Belfast:
Political Collection, Linnenhall Library (P8752).

PS —*The Words of 100 Irish Party Songs.* Cork: Ossian Publications, 1992.

OL —*The Orange Lark . . . and other songs of the orange tradition.* Ulster Society, Lurgan,
1987.

OLS —*Orange Loyalist Songs* (1972). Belfast: Political Collection, Linnenhall Library
(P669).

SR —*Songs of Resistance 1968-1982.* Dublin: Irish Freedom Press Book Bureau, 1982.

SI —*Songs of the Irish Republic.* C.F.N., 56 Grand Parade, Cork, 1972.

Lightning Source UK Ltd.
Milton Keynes UK
UKOW04f0756101214

242876UK00001B/60/P